The End of the Salon: Art and the State in the Early Third Republic examines the cultural forces that contributed to the demise of the most important series of art exhibitions in nineteenth-century Europe and America. Tracing the history of the Salon from the French Revolution, when it was taken away from the Academy and opened to all artists, to its abandonment by the state in the 1880s, Patricia Mainardi shows that its contradictory purposes, as both didactic exhibition venue and art marketplace, resulted in its collapse. She situates the Salon within the shifting currents of art movements, from modern to traditional, and the evolving politics of the Third Republic, when France chose a republican over a monarchic form of government. This book provides a rich overview of art production during the final decades of the nineteenth century, government attitudes toward the arts in the early Third Republic, and the institution of exhibitions as they were redefined by free-market economics. *The End of the Salon* demonstrates how all artists were forced to function within the framework of the major social, economic, and cultural changes taking place in France during the nineteenth century and, as a result, how art history and social history are inextricably intertwined.

THE END OF THE SALON

The End of the Salon

Art and the State in the Early Third Republic

PATRICIA MAINARDI

CAMBRIDGE
UNIVERSITY PRESS

Published by the Press Syndicate of the University of Cambridge
The Pitt Building, Trumpington Street, Cambridge CB2 IRP
40 West 20th Street, New York, NY 10011-4211, USA
10 Stamford Road, Oakleigh, Victoria 3166, Australia

First published 1993

Printed in the United States of America

Library of Congress Cataloging-in-Publication Data
Mainardi, Patricia.
The end of the Salon : art and the state in the early
Third Republic / Patricia Mainardi.
p. cm.
Includes bibliographical references and index.
ISBN 0-521-43251-0
1. Salon (Exhibition : Paris, France) 2. Art and State – France –
History – 19th century. I. Title.
N6850.M35 1993
709'.44'09034 – dc20 92-15566
 CIP

A catalog record for this book is available from the British Library.

ISBN 0-521-43251-0 hardback

CONTENTS

ILLUSTRATIONS AND TABLES

TABLES

PREFACE

This study of the end of the Salon proceeds from my previous book, *Art and Politics of the Second Empire,* in which many of the ideas taken up here were first introduced. That book closed with the liberalization of art institutions such as the Salon in the last years of the Second Empire. And yet it was always a disquieting experience for me to reflect on the sharp conservative shift in government arts policies that followed the French defeat in the Franco-Prussian War, especially when the accession of the Third Republic in 1870 should have reinforced the liberalization process begun during the previous regime. Eventually my disquietude led me to deeper exploration in an attempt to understand these events, for although the "return to order" of the early Third Republic seemed almost inexplicable a century later, by the 1990s we have become all too familiar with such turns of tide.

In the years that I have been working on this book, my research has been supported by a number of awards that I acknowledge here with gratitude: summer stipends from the National Endowment for the Humanities and the American Council of Learned Societies. The PSC-CUNY Research Foundation enabled me to do much of my research in France. The first draft was written at the Center for Advanced Study in the Visual Arts at the National Gallery of Art, Washington DC, where an appointment in spring 1990 provided me with ideal working conditions. Finally, a grant from the National Endowment for the Humanities in 1991 for a study of nineteenth-century French art institutions offered the opportunity for the final research and writing.
 I have "tried out" many of the ideas here as conference papers and lectures and have benefited greatly from the ensuing discussions. I could not ask for better audiences than I had at the Carnegie Museum of Art, Detroit Institute of Art,

PREFACE the Getty Center for the History of Art and the Humanities, the Institute of Fine Arts, the Metropolitan Museum of Art, the National Gallery of Art, the New York Studio School, the Toledo Museum of Art, or at the Conferences of the Colloquium in Nineteenth-Century French Studies, the Western Society for French History, the American Historical Association, and at the New School for Social Research's New York Area French History Seminar. An early version of Chapter 1 was published as "The Double Exhibition System in Nineteenth Century France" in the spring 1989 issue of *Art Journal*.

Several friends read all or parts of the manuscript at various stages and made many suggestions for improvement. My heartfelt gratitude goes to Louis Finkelstein, Constance Cain Hungerford, Miriam Levin, Abigail Solomon-Godeau, and, especially, to Herman Lebovics, whose enjoyment of interdisciplinary disputation has greatly improved this manuscript.

I have had many lively discussions with other friends whose generosity I would like to acknowledge here; they have contributed their ideas and their time and in various ways have made this book not just better but in many ways possible: Marie Aquilino, Elizabeth Brown, Rachel Esner, Madeleine Fidell-Beaufort, Judith Goldstein, Robert Herbert, Ann Ilan-Alter, Joel Isaacson, Frances Jowell, Nicholas Papayanis, Jane Mayo Roos, Jack Spector, and Richard Terdiman. At Cambridge University Press I was most fortunate to work with Beatrice Rehl, Richard Hollick, Sophia Prybylski, and Margaret Yamashita.

In addition to the friends already cited, I offer a special thank-you to those whose contribution was just being there and providing a level of normality through all the ups and downs of researching, writing, and production: Pamela De Simone, Wendy Fairey, Susan Koslow, Stephen Margolies, Sandra Kwock-Silve and Bernard Silve, and my parents Vonda and Louis E. Mainardi.

To all the institutions and individuals cited here I owe debts of friendship and gratitude. I hope this study is in some way equal to the task.

Patricia Mainardi
Brooklyn, N.Y.

INTRODUCTION

The Old Regime – indeed all of France's old regimes – emerged almost miraculously from the native soil torn asunder by disaster.
Daniel Halévy, *The End of the Notables*[1]

T HE preceding sentence opens Daniel Halévy's classic study of the first years of the Third Republic, when monarchy and republicanism vied for the future of France. But not only in politics was there an attempt to re-impose the institutions of the Old Regime; there also was another attempt, to impose "moral order" on the fine arts in the 1870s and 1880s through the reorganization of the state exhibition system. This book examines the aesthetic return to order, focusing on two events at the end of the official Salon system, the abandonment in 1880 by the state of the annual Salon, which was then turned over to a newly formed society of artists, and the replacement in 1883 of that exhibi-tion by the elite and exclusive Exposition nationale triennale. The Triennale, though intended to be a regular event, turned out to be the last official Salon held in France.

In this study I attempt to clarify the complicated events sur-rounding the state's abandonment of the official Salon system in the 1880s and to examine the Exposition nationale trien-nale, the last of a series of government-sponsored exhibitions that had continued for two centuries.[2] The Triennale, as it was called, was no ordinary Salon but an exhibition modeled on those of the Old Regime: elite, conservative, and *severe,* to use the word by which contemporaries often indicated their approval of such a guiding aesthetic ideology. Its intention was nothing less than a restoration of traditional aesthetic values, a "return to order" in art. These two exhibitions, the

popular annual Salon and the elite long-interval exhibition, had been linked in repeated proposals for a two-tier exhibition system ever since the Academy had lost control over the Salon in 1791 and its members then began campaigning for its restitution. Thus emergent at both its birth and its demise, this bifurcated exhibition system can be seen as spanning the history of the nineteenth-century Salon.

Stanley Hoffmann advanced a theory of France as a "stalemate society" with two competing models: a feudal agrarian society with a static social hierarchy based on status, deference, and tradition, opposed by an industrial society based on economic dynamism and rationality with social mobility and advancement based on competence and talent.[3] We might consider the two types of exhibitions competing during our period as examples of these two models, the "severe" exclusive Salon dominated by the Academy and based on tradition and privilege, versus the "free-market" exhibition through which artists hoped to gain fame and fortune. The last state-sponsored annual Salon, that in 1880, was the largest ever held in France. Raucous, chaotic, and indubitably commercial, it spawned several series of exhibitions that dominated the French art world for decades. The most significant aspect of the 1883 Triennale, however, was its complete failure, and this, coming at the end of almost a century of attempts to mount such a show, can be seen as symbolizing the collapse of a whole set of assumptions and structures around which the art system in France had been organized. The oblivion into which the show has since fallen can be seen as the triumph of what Herbert Butterfield called "the Whig interpretation of history": "to praise revolutions provided they have been successful, to emphasise certain principles of progress in the past and to produce a story which is the ratification if not the glorification of the present."[4] The Whig interpretation of art history, is, of course, modernism, and the history of the state's abandonment of the official Salon system can be dismissed as a tempest in an official teapot only insofar as the art history of the period is written exclusively through the Impressionist exhibitions of 1874 to 1886 and the shows of the Indépendants beginning in 1884.

Modernist art history has traditionally focused on the stylistic development of individual artists or of movements. In this reading, the determinant of art historical interest has been the progression toward abstraction, the elimination of subject matter, and the focus on exclusively formal qualities.[5] The familiar modernist litany of artists from David through

Cézanne credits each with a particular accomplishment along this trajectory. Even revisionist art history often accepts the essential paradigms of modernism by either promoting previously marginalized artists into its pantheon or renovating the standard interpretations of works by canonical artists. Nonetheless, any history of art that seeks to explain even the modernist movements must begin by describing the entire art system, including both its stresses and accommodations. As the historian Herman Lebovics pointed out, no group should be treated in isolation from the strata with which it conflicts or cooperates to make history.[6] By investigating the breakdown of exhibition practice in the official realm, we can better understand the full spectrum of its manifestations in later nineteenth-century France, including government-sponsored exhibitions, commercial gallery shows, those mounted by private societies and *cercles,* and those organized by the various modernist secession groups. It is my position that the production, distribution, and aesthetics of art in the modern period are tied together in complex ways that are just beginning to be examined. Modernist theory, insofar as it has been formalist, has impoverished our understanding of art by looking only at aesthetics.

Nineteenth-century studies' previous focus on the modernist avant-garde resulted in a lack of interest in official and, especially, aesthetically conservative institutions. Compare, for example, the vast quantity of literature on the 1874 Impressionist exhibition with the complete absence of commentary on its conservative counterpart, the 1883 Exposition nationale triennale. And yet, for most of the nineteenth century, it was official institutions and exhibitions such as this that defined the larger world of art. Counterinstitutions, such as artist-sponsored shows and the various secession movements, have long been understood as the dialectical response to official institutions, but apart from the 1863 Salon des refusés, little attention has been given to the ways in which official institutions responded to challenges by independent artists, who were obliged to earn a living by selling their work, who were neither members of the Academy nor part of the legion of "official" artists who regularly executed state commissions. In brief, we cannot understand the Triennale without knowing about the collapse of the official Salon or the collapse of the official Salon outside the rise of alternative exhibition types and venues or, especially, the secessionist manifestations of modernists outside this complex of events.

If this first level of contextualization can be identified as

the interaction of the various art institutions (the Salon, the Academy, societies of modernist and traditionalist artists), then the second, and often ignored, level of contextualization consists of the interaction of the art world with the state and politics. The history of the state's abandonment of the Salon system must be seen as a function of the larger political history of the period, for the events of that larger political arena inevitably found their analogues in the world of art. In the history of the Triennale – this failed attempt to reinstate the aesthetic values of the Old Regime – we can find the correlative to the resurgence of monarchist and clerical politics in the 1870s, the first decade of the Third Republic.

The key argument of my book is that we can see the major art institutions of nineteenth-century France, in this case the Salon, as subject to the same pressures that affected the political structure as a whole. This should be self-evident: Official art institutions were, after all, part of the government and were often run by the same ministries that handled education and domestic policy. That this phenomenon has not been previously remarked is evidence of the isolation within which art history has often been written. This study, then, goes against the grain of modernism. It looks at residues, not origins: the residue of classicism that, originally promulgated by the Academy, maintained through the nineteenth century an influence disproportionate to its institutional numbers, and the residue of the monarchic ideal of centralized government-directed control over the fine arts that even Republicans were slow to relinquish and that even to this day the French have not entirely given up.

The proposal for an elite long-interval exhibition, symbolizing an ideology of centralized government control over the arts and a restoration of academic aesthetic values, was ultimately defeated because a changed economic market for art consumption necessitated a new and commercially viable system of art distribution. These same circumstances had already transformed the annual Salon from the small didactic exhibition open only to Academicians under the Old Regime to the huge commercial event of its closing years. This book details the conservative attempt to retard that process, an attempt that was doomed to fail simply because it could not survive the countercurrent of new economic forces, namely, market capitalism, that were now determining French cultural life. Therein lies one of the essential contradictions of modernism, for although the various modernist manifestations in painting have been uncritically accepted as "good,"

4

they nonetheless also stand for art as commodity, for privatization, individualism, and commercialization. The Academic classical ideal, on the other hand, called for a noncommercial public art representing shared societal concerns. As Walter Benjamin observed, modernism is undeniably tied to the assimilation of art into a commodity culture.[7] This being so, there is even more reason to investigate the demise of the state-sponsored Salon, the prime distributor of art commodities in nineteenth-century France.

Among the many recent challenges to the hegemony of formalist modernism in art history, the least considered area has been that of institutional history. In view of the considerable influence of Michel Foucault, this is a surprising lacuna, for art institutions should certainly be included among the "practical systems" he found worthy of investigation. In the absence of any sustained effort to look at the institutional crises that beset the nineteenth-century French art world, all these events have been appropriated and misinterpreted as struggles over aesthetics – the only operative principle in a formalist reading. This is almost inevitable, for although recent revisionist scholarship has dismantled much of the infrastructure of modernism, it has not yet succeeded in replacing its paradigms. Our inability so far to do this has resulted in revisionist challenges' being perceived, and even accepted, as just so many anomalies, to use Thomas Kuhn's term, all to be ultimately disregarded or marginalized.[8] Thus it has been to no avail that numerous scholars have repeatedly demonstrated that the legendary exhibitions of heroic modernism, whether the Salon des refusés or the Impressionist exhibitions, actually contained only a few artists recognized by the modernist canon (Figure 1).[9] Without a new paradigm to explain what was at issue here, revisionist insights have remained largely unassimilable and thus irrelevant.

Although new paradigms for late nineteenth-century art production can hardly be constructed in a day, much excellent work has already been done by a number of scholars who have investigated the relations between art and the state. Pierre Vaisse's *thèse d'état,* "La Troisième République et ses peintres,"[10] must be cited as a major contribution to our understanding of these crucial issues, for it provides a comprehensive survey of government patronage and programs during the period. More recently the sociologist Marie-Claude Genet-Delacroix, in another *thèse d'état,* "Art et État sous la IIIe République," applied what the French call *prosopographie* – a sociological analysis of individual careers – to

members of the Third Republic art administration, giving us, in addition, an excellent picture of the functioning of the various agencies of government.[11] Daniel Sherman focused on one of these agencies, the national museum system established during the revolutionary period, and traced its development through the nineteenth century.[12] In her *Republican Art and Ideology* Miriam Levin examined the ideology underlying Republican pronouncements on the arts and stressed the primacy of educational and technological advances in its program.[13] Debora Silverman's *Art Nouveau in Fin-de-Siècle France,* though dealing with a period after that of my book, nonetheless noted the Republican concern for the decorative arts in the earlier period and situated them within the context of art and industrial production.[14] Interestingly, four out of five of these scholars come from disciplines other than art history, which might explain their ability to step outside the modernist canon to examine other facets of art production.

Like all valid theories, formalism can be used as a tool for explaining some issues; it should neither be discarded entirely nor permitted hegemony. Other paradigms must intervene, however, to explain other problems, and one of these paradigms should certainly be economic. Institutional history can be used to construct a political and economic model within which artists of all persuasions can be shown to function. The brave adventure of the Impressionists, for example, in mounting their own shows is seriously diminished in importance when their strategy for reaching their public is seen as commonplace in the period, shared by groups as diverse as the Société des aquarellistes français and the Union des femmes

1 Poster advertising the fifth Impressionist exhibition, 1880.

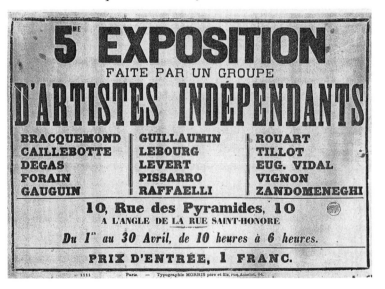

peintres et sculpteurs. An examination of career strategies adopted by different groups of artists would, then, dismantle the institutional underpinnings that have contributed so much to the heroic cast of modernism.

The connections of politics to art and the role of art institutions in the production and valorization of art are issues both too complex and too subtle to explore in their entirety in a single study. Instead I have adopted here a strategy used by historians of complex issues, and I have chosen to write about a microcosm that illuminates a complex macrocosm. Were we to look more comprehensively at the development and the demise of institutions as issues inextricably bound up with modernism in a larger sense, we could then hardly ignore the collapse of the official Salon, the major art institution of nineteenth-century France and indeed the largest and the most important exhibition in Europe and America.[15] The century-long debate over the Salon makes sense, on a more manageable level, of the issues of politics and art in France both in the nineteenth century and, in some ways, today too. Thus by focusing on the fate of the Salon, this study leads readers through the major issues at a level of narrative and abstraction that allows for reflection and that, I hope, will encourage other such studies to focus on the issue of art and the world of power.

What can be learned by studying events that failed, that led to no glorious present? Perhaps we have had to await the closing years of the twentieth century to feel the resonance of a government attempt to direct the arts after a period of relative laissez-faire. Certainly the recent wave of British and American conservatism coming after a period of liberalism has given us new insights into the historical past, ones that would not have been accessible previously. The relationship of individual freedom and moral order was not resolved with the events of the 1880s but remain as a set of imperatives always available for art, for artists, and for governments. To study the brief flowering of one such moment is thus valuable, especially as modernism gives way to postmodernism and the optimism and certainties of the former no longer hold sway.

PICTURES TO SEE AND
PICTURES TO SELL

The administration has always let itself vacillate between the complaints and warnings of those who believe that they have the mission of safeguarding and elevating art, and the lamentations and claims of the masses of artists who avidly demand to be given the most convenient and advantageous means of earning a living. From that proceeded these variations in the organization of the Salons, these hesitations, these continual reversals whose details would take too long to enumerate here.

Duranty, 1877[1]

W HEN the French state abandoned the Salon to the artists' control in 1880, intending to replace it with a new series of elite long-interval exhibitions, this decision was neither fortuitous nor the direct result of specific policies or events. It was, rather, an attempt to resolve a century of contradictions within the institutions of art that could no longer be contained. The collapse of the official Salon system in the 1880s marked the end of a century-long bitterly waged battle fought among the Academy, the government art administration, and independent artists, in various combinations, to define and to control the exhibition system. But in order to understand the significance of these events, which were intended to signal a return to order in French art, we must first look briefly at the history of the official Salon itself, the major exhibition of contemporary French art, sponsored by the state and held from 1699 to 1880 (Figure 2).

The standard modernist history of the French exhibition system reads it as proceeding from the closed Salon of the Old Regime, in which only Academicians could show their work, through the 1789 Revolution when, in principle at least, it was opened to all artists. The exhibition system's continual rejection of those artists who have since become canonical, from Delacroix to Cézanne, has rendered it so irrelevant to

historians writing in the modernist idiom that as a result there has been no study of the history of this institution central to the lives of French artists, both those honored by it and those excluded from it.[2] Nineteenth-century art history has instead been written largely in Hegelian terms, with the vital force of history increasingly shifted away from the Salon, which, as the century progressed, has been seen mostly in terms of its exclusions. In this reading, art historical significance is displaced from the Salon itself, first onto the private exhibitions mounted by individual artists such as Courbet in 1855 and then to the series of exhibitions organized by independent groups of artists such as that of the Impressionists beginning in 1874 and the Indépendants in 1884.[3]

What this account ignores is the stresses within the official exhibition system itself as it was forced to accommodate both a steadily growing number of artists and increasingly diverse styles of art. Out of this matrix proceeded all the various solutions sought by different groups of artists, whether Academicians or avant-garde. Although it is widely recognized that the Salon system failed to serve the interests of modernist artists, it should also be noted that as the century progressed, the official Salon – enormous, crowded, and badly installed – served less and less the interests of any artists. If modernists in self-defense founded secession movements to organize their own exhibitions, the fashionable artists of the *juste-milieu*, who tried to steer a middle course between

2 A. Hadamart, *The Salon of 1699, Grande Galerie, Louvre,* Bibliothèque nationale, Paris.

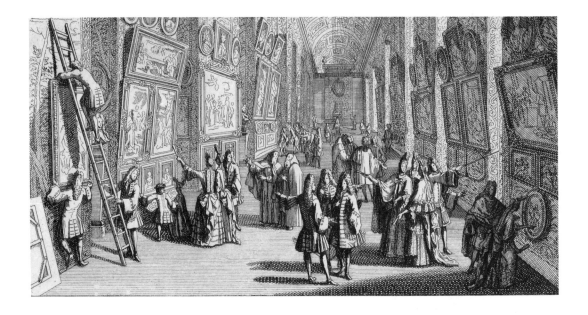

modernism and tradition, increasingly turned to the shows of private societies, called *cercles,* and to commercial galleries.

But what about the conservatives, the Academicians, and official artists who were still attempting to follow the Grand Tradition? In a sense this group of artists was most in need of government-sponsored exhibitions, for their work had few patrons apart from the state. They were, if anything, even more critical of the Salon, which they saw as a degrading marketplace, but where were they to turn for survival? For them the much-desired solution was often a program of Academic restitution specifying either the suppression of the open Salon or, failing that, the parallel establishment of their own elite exhibition modeled on the exclusive Salons of the Old Regime.

A more coherent approach to the history of late nineteenth-century art might be, then, to see how all these groups were forced to respond to the same pressures and problems by inventing different ways of finding and of reaching their audiences. By examining the various attempts of aesthetic conservatives to resolve the problems they saw in the Salon system, I shall try to restore the balance seriously skewed by modernist art history.

The prehistory to the events of the 1880s is that of the Salon itself, the government-sponsored annual, sometimes biennial, exhibition of contemporary art. Until the 1789 Revolution, the Academic Salon enjoyed a monopoly over French artistic life and careers; only members of the Academy could participate, and alternative exhibitions, such as the Salons de Saint-Luc or the Exposition du Colisée, were suppressed.[4] The Academy had been founded in 1648 and was maintained as a government agency; its members received salaries and studios, and state commissions were originally reserved for them.

The exhibitions themselves were originally an unwelcome obligation forced on Academicians by the state as an extension of Colbert's attempts in the seventeenth century to centralize and control cultural and intellectual life. The Academicians had, however, elevated their status from that of artisans by rejecting all hints of commerce, and so in the Academic Salon artists did not exhibit "pictures to sell," as they were called, but "consented to show to a limited public some pictures commissioned in advance for a specific destination." These would be "pictures to see."[5] In reality the Academicians worked in a variety of modes because government support,

though prestigious, was rarely adequate. Nonetheless, they persisted in defining themselves as much as possible as history painters. Think, for example, of Greuze, the most famous genre painter of his time, attempting – and failing – to gain admittance to the Academy as a history painter, or, somewhat later, the legendary story of Ingres's responding to a caller's question, "Is this the residence of M. Ingres the portraitist?" by angrily slamming the door in his face.[6]

HISTORY PAINTING

The fate of the Salon cannot be considered apart from its early function of exhibiting to the public major works of history painting commissioned in advance by the state from members of the Academy, its official agency in charge of aesthetics. Sculpture, of major importance during the neoclassical period, had steadily declined in popularity and, in the nineteenth century, was often all but ignored by critics and public alike.[7] After the Revolution, when the Salon was wrested from Academic control, history painting maintained its status as the most elevated category of art because it was indissolubly allied to the major institutions of power – intellectual, religious, and political – and it was conceptually inseparable from the Academy, which continued to proclaim its importance, or the church and state, which were its chief patrons.

The Republican program for art throughout the century repeatedly claimed for it a didactic and public role. In 1799 this role was defined as follows:

State authority can put conditions on its gifts, and in fact it ought to do so. If it encourages history painting and statuary, it is actually because it expects these arts to provide the settings for national festivals and decadary temples; it is because these eloquent and tangible signs should especially inform the citizen, from the palace to the farm cottage, of his glory, of his duties, and of public or private virtues, by either recalling fine actions or immortalizing the deeds of great men.[8]

By the Third Republic, the Republican aesthetic program emphasized education more than duty, as can be seen in an 1875 report to the Chamber of Deputies on the fine arts:

Their right to State protection is recognized not only because they provide exquisite and rare pleasures for some delicate souls but also because they truly fulfill a general need, in developing in the entire country the feeling and love of beauty, which a nation cannot ignore without risking both the progress of its civilization and its glory.[9]

The Salon was originally intended to serve as the showcase for this art, and although the Academy's monopoly over it was ended in 1791, the residue of that relationship can be discerned throughout the Salon's history in the next century.

Despite Academic and state support, however, history painting was never really popular. Conservative nineteenth-century critics blamed the middle classes empowered by the Revolution for its eclipse, but even under the Old Regime, private collectors had preferred genre, landscape, and portraiture.[10] The Salon jury itself, instituted in 1748, was originally composed exclusively of history painters and was intended to strengthen that branch of art production and to combat the popularity of the lower categories.[11] Jean Locquin has charted the vicissitudes of history painting as a function of the political economy of successive eighteenth-century regimes: When subsidies were available, it flourished, but when government commissions grew more scarce, artists turned once again to the minor categories that could ensure their livelihood (Figure 3).[12]

Several studies have confirmed the same phenomenon during the revolutionary decade from 1789 to 1799.[13] Directors of fine arts for two centuries raised and lowered prices for the various categories of art. Sometimes this was a form

3 Pietro Antonio Martini, *The Salon of 1787 at the Louvre,* Bibliothèque nationale, Paris.

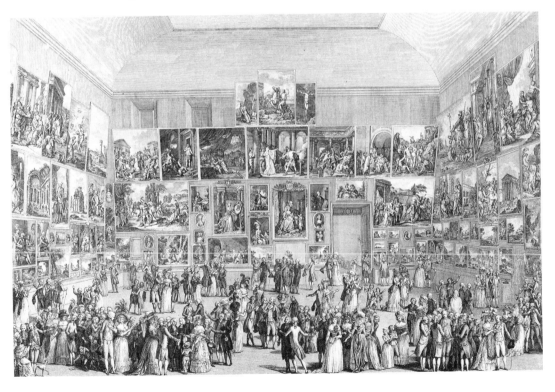

13

of political economy, as when Lenormant de Tournehem in 1747 lowered the price of official portraits to discourage them and instituted, as did the Republic in the 1790s, competitions for history painting with cash prizes.[14] Sometimes, however, it was just an economy, as in 1800–01 when despite the official rhetoric supporting history painting, the government budget for works of art was reduced by 60 percent, resulting in a resurgence of portraiture.[15] In a decision of unparalleled consequence for the future of history painting, Vivant Denon, the director of museums, convinced Napoleon in 1804 that instead of continuing the custom of allowing a committee of artists to award commissions after each Salon to the most distinguished exhibitors, for a projected work of the artist's own choosing, it would be more advantageous for the state to give inexpensive honoraria as awards while purchasing finished works from among those already on display.[16]

In this one gesture, the Salon became a store, and artists became free-market small producers. As Denon had already lowered the set fees for history painting and official portraits, the result of all these decisions was a drastic deterioration in the attractiveness of history painting as a career.[17] Throughout the nineteenth century, artists complained that they could not afford to specialize in history painting, and government administrators preferred to extol its elevated nature rather than to make it economically feasible. By the 1870s most government commissions were for so little that only minor artists accepted them.[18] As a result, few artists could survive by means of history painting alone; most, even Academicians, had to produce smaller easel pictures which were sold to private collectors through the Salon. The reformed postrevolutionary Salon, though as much an official institution as the Academy, now represented the major challenge to Academic hegemony by providing a site for other, less legitimized, bids for public attention. As a result, the Salon cannot be considered apart from the fate of history painting and the political economy that supported it.

Although there was always a great variety of opinions on the appropriateness and level of government support for Grand Art, as it was called, everyone agreed that such art could not otherwise survive. In 1798, the critic Chaussard explained: "A revolution in our customs in the distribution of apartments has caused the disappearance of the resources that the genius of history painting could expect from this quarter. . . . It is from the government alone that history painting and

statuary can and ought to obtain encouragement."[19] Under the Consulate, the Institute was ordered to prepare a series of reports on the progress of the sciences, letters, and arts since 1789. The report on painting was delivered in 1808 and stated: "We believe that it is important to encourage in particular the most elevated categories of art. . . . It is the degree of perfection of history painting that establishes the level for all the secondary variations of this art."[20]

This symbiotic relationship between the state and its artists resonated with greater and greater urgency throughout the subsequent decades, but never more strongly than during its three republics when art was pressed into service in a didactic role. During the Second Republic, in an 1848 report to the minister of interior, the government's fine arts administrator, Charles Blanc, wrote: "The state has an obligation to commission monumental painting, destined to live as long as the buildings it decorates, encouraging it to regain the dignity and sobriety of Italian fresco." The "secondary arts" of landscape, genre, and still life, he felt, were the province of private collectors and thus not the responsibility of the state.[21] These same sentiments were stated during the Third Republic by Agénor Bardoux, minister of public instruction in the 1870s: "We would not be able to comprehend a France without Grand Art, nor Grand Art without France."[22]

In 1831, during the July Monarchy – almost the center of our period – the art critic and later curator of the Louvre, comte Horace de Viel-Castel, articulated the rationale for this symbiotic relationship between Grand Art and the state; his argument was the standard one used throughout the century:

Painting is divided into two categories: history painting and genre painting. In genre we include landscape, seascape, portraits, and all painting that, because of its size and the nature of its subject matter, does not at all belong to history painting. The other divisions included in the art of design and with which we should concern ourselves are sculpture, architecture, and engraving. Among these five classifications, only two – which by their nature are placed outside the encouragement and support of the public – seem to us to have any right to demand the solicitude of the government: These are history painting and sculpture. The others, such as genre painting, architecture, and engraving, as they continually receive support and encouragement from the public – because society feels a need for their productions, for their luxury, their pleasure, or their utility – seem naturally destined to live on their own, to be sustained solely through their own strength and without any royal or ministerial protection. . . . Grand historic painting and sculpture cannot survive without the indispensable patronage of royal protection.[23]

Some critics went even further, claiming, as did Louis Peisse in 1843, that "art today cannot remove itself from royal and state patronage except through an act of suicide."[24] The mutually dependent relationship of state and Grand Art, then, continued from the Old Regime through the numerous revolutions of nineteenth-century France to survive, virtually intact, into the Third Republic, when Castagnary wrote in 1878: "The Republican state, no more than the monarchy, can imagine abandoning painting and sculpture."[25]

The circumstances surrounding the termination of Academic control over the Salon in 1791 revealed from the beginning the stresses that would result a century later in the collapse of the state-run exhibition system. The first proposal to open the Salon proceeded from the Commune des arts qui ont le dessin pour base, the artists' group led by David and Restout dedicated to reforming the art system and, not incidentally, to suppressing the Academy.

In a long report presented to the National Assembly on April 19, 1791, the Commune des arts proposed that public exhibitions be open to all works except those contrary to public morals. In return, however, "every five years, in order to assure artists already renowned the esteem of their fellow citizens and to establish the great reputations in the most definitive manner, there should be a solemn exposition."[26] The first of these recommendations, for an open Salon, was adopted by decree on August 21, 1791, and stated: "All artists, whether French or foreign and whether or not they are members of the Academy of Painting and Sculpture, will be equally entitled to exhibit their works in the part of the Louvre designated for this purpose."[27] The second recommendation from the Commune des arts, for an elite quinquennial exhibition, was never adopted, for ensuring artists' livelihoods was a far more pressing concern to the successive governments of the revolutionary decade than was establishing the great reputations.[28]

This imperative soon led to the shifting of the biennial salon of the Old Regime to a new annual status in 1796. "The field has grown," wrote Bénézech, the minister of interior, in announcing the change, "a much larger number of talents have come into it."[29] In fact, the first open Salon of 1791 contained 794 entries, more than twice the number in the last Academic Salon of 1789. This exhibition continued to grow throughout the century (Table 1). As a result, Bénézech wrote, "It would be too restrictive for French production, for the progress and encouragement of the arts, to be limited as [it

was] before the Revolution to a single public exhibition in two years." The preface to the 1796 Salon catalogue alluded to some of the immediate problems: "Some people feared that by opening a Salon exhibition for the fine arts every year, this period of time would prove to be too frequent and disastrous." The critic Polyscope explained:

The painters of the old Academy complained about it: Their former statutes permitted the opening of the Salon only once every two years. These gentlemen are strongly attached to their former statutes. . . . Their resentment against the regulations decreeing an annual exhibition has been so strong that this year hardly any of them have displayed their works to their fellow citizens.[30]

This "Academic strike" right at the inception of the new open Salon foreshadowed a century of dissension, for the periodicity of the exhibition had been tied to the production demands of history painting. In 1802, when a second Academic strike resulted in the Salon's being returned to biennial status, one critic noted:

Some people claim that this exhibition takes place too frequently, that by participating annually a painter would not be able to finish a history painting in such a short period of time, but these people, who themselves are artists, have not exhibited in ten years. . . . Moreover, do only history painters exist? Those of the former Academy who used to exhibit exclusively, did they make the salons very interesting?[31]

The newly reformed Salon was the site where artists who did not enjoy state support could show their works, find their customers, and make their reputation. Bénézech even had the catalogues list artists' addresses so that prospective patrons might find them more easily, an innovation that survived repeated political change. In 1827, during the Restoration, the critic Jal noted that "there are very many artists who exhibit in the Salon solely to earn a living; they want their address in the catalogue even more than they want the admission of their pictures."[32]

This conflict between "pictures to see" and "pictures to sell" arose, then, as soon as the Salon was taken away from Academic control. But as Bénézech realized, for the majority of newly enfranchised artists the Salon had to serve a commercial as well as an aesthetic function. This situation did not meet with Academic approval. Seeing the reformed Salon as encouraging small marketable easel pictures, hastily produced for a growing bourgeois market, Academicians complained incessantly about a deterioration in quality and lobbied constantly for a return to a small, infrequent show

Table 1. *The Salon, 1789–1870*

Year	Entries	Opening date	Location
1789	350	August 25	Louvre
1791	794	September 8	Louvre
1793	1043	August 10	Louvre
1795	735	10 vendémiaire an IV (Oct. 2)	Louvre
1796	641	15 vendémiaire an V (Oct. 6)	Louvre
1798	536	1 thermidor an VI (July 19)	Louvre
1799	488	1 fructidor an VII (Aug. 18)	Louvre
1800	541	15 fructidor an VIII (Sept. 2)	Louvre
1801	490	15 fructidor an IX (Sept. 2)	Louvre
1802	569	15 fructidor an X (Sept. 2)	Louvre
1804	701	Ier jour complémentaire an XII (22 Sept.)	Louvre
1806	705	September 15	Louvre
1808	802	October 14	Louvre
1810	1123	November 5	Louvre
1812	1298	November 1	Louvre
1814	1369	November 1	Louvre
1817	1097	April 24	Louvre
1819	1702	August 25	Louvre
1822	1802	April 24	Louvre
1824	2180	August 25	Louvre
1827–28	1834	November 4	Louvre
1831	3211	May 1	Louvre
1833	3318	March 1	Louvre
1834	2314	March 1	Louvre
1835	2336	March 1	Louvre
1836	2122	March 1	Louvre
1837	2130	March 1	Louvre

with a "severe" choice of works of unquestioned value. In truth, they wanted a return to history painting as the highest category of art and the recognition of Academicians as the exclusive practitioners of that art. E.-J. Delécluze, a student of David and the most influential conservative critic of the period, beginning in the 1820s campaigned tirelessly against the annual Salon on the grounds that it endangered the standards of the French school.[33] In 1855 he wrote:

It must be acknowledged that the exhibitions in the Louvre, created to serve the interests of those who make painting into a trade, have contributed much more powerfully to diminish the importance of this art. Since their institution, the Salons of the Louvre have, year by year, assumed the character of a bazaar at which each merchant is obliged to present the most diverse and bizarre objects to provoke and satisfy the whims of the customers.[34]

Others, however, lobbied for an annual Salon. One of these was the opposition journal *La Liberté,* whose motto was

Table 1. *(continued)*

Year	Entries	Opening date	Location
1838	2031	March 1	Louvre
1839	2404	March 1	Louvre
1840	1849	March 5	Louvre
1841	2280	March 15	Louvre
1842	2121	March 15	Louvre
1843	1597	March 15	Louvre
1844	2423	March 15	Louvre
1845	2332	March 15	Louvre
1846	2412	March 16	Louvre
1847	2321	March 16	Louvre
1848	5180	March 15	Louvre
1849	2586	June 15	Palais des Tuileries
1850–51	3923	December 30	Palais-Royal
1852	1757	April 1	Palais-Royal
1853	1768	May 15	Menus-Plaisirs
1857	3487	June 15	Palais de l'Industrie
1859	3894	April 15	Palais de l'Industrie
1861	4102	May 1	Palais de l'Industrie
1863	2923	May 1 (+ 687 Salon des refusés)	Palais de l'Industrie
1864	3473	May 1	Palais de l'Industrie
1865	3559	May 1	Palais de l'Industrie
1866	3338	May 1	Palais de l'Industrie
1867	2745	April 15	Palais de l'Industrie
1868	4213	May 1	Palais de l'Industrie
1869	4230	May 1	Palais de l'Industrie
1870	5434	May 1	Palais de l'Industrie

"Death to the Institute": "The Institute does not like frequent exhibitions, where its members have little to show; the Institute finds hardly to its liking the new and pernicious measure of an annual Salon that incessantly creates new reputations."[35] The Academy saw the Salon as promulgating what it called "a vicious equality" and repeatedly proposed that the Academicians-only Salon of the Old Regime be restored.[36] By 1870 its position had remained unchanged, and the architect Baltard could still make an impassioned speech at the Academy attacking the annual Salon because it "compromises the dignity of art and artists and corrupts public taste."[37]

The issue of the salon's periodicity was important because its frequency was seen as encouraging either small inconsequential "pictures to sell" or large important "pictures to see." The polarity seemed to be always between history painting and easel pictures, with genre chiefly representing the latter. Across the century, Salon awards went consistently to history painters, a subject for continuous critical

comment. In 1799, Chaussard asked, "Don't genre artists have any rights to the honors of national awards? The Institute seems to have decreed that these be awarded only to history painting."[38] In 1876 Gonzague-Privat noted that the lower categories rarely were awarded first-class medals, which still went principally to history painters, and the following year Duranty pointed out that although landscape and still life made up more than one-third of the 1877 Salon, state acquisitions from that Salon included only four landscapes and no still lifes.[39]

THE SALON AS METAPHOR

The extension of political discourse into aesthetic issues was widespread during the nineteenth century, and beginning with the Revolution, there followed a century of proposals to reform the Salon in the image of one or another program of political ideology. The language in which the Salon was discussed immediately set up a contradiction between privilege for the few and rights for the many. This strategy insisted that the world of art was a microcosm of the larger world of politics and that art institutions would have to be brought into alliance with political ones, thereby not permitting the aristocratic world of privilege to exist in art while it was being successfully challenged elsewhere. One common strategy was to link the right to exhibit with the freedom to publish. As early as 1791, amidst the agitation for an open Salon, an artists' petition elicited the following decision from the Constitutional Committee of the National Assembly:

The equality of rights that forms the basis of the constitution has permitted all citizens to express their thoughts. This legal equality should permit all artists to exhibit their work. Their pictures – those are their thoughts – and their public exhibition – this is the permission to publish. The Salon of the Louvre is the press for pictures, provided only that morals and public order are respected.[40]

Quatremère de Quincy took up this cry, asserting in regard to the open Salon: "It would be in the Republic of the arts what freedom of the press is in the state."[41] Proposals to revise the Salon system came from equally as many conservatives, who wanted to create an "aristocracy of art," as from opposition artists, who wanted to bring the Salon into alignment with democratic institutions, thus creating a "Republic of the arts." Nor is it coincidental that these two cultural

models were identical with the major political alternatives of nineteenth-century France, a monarchy or a republic.

In 1791, the Club révolutionnaire des arts was already referring to the Academy as "the political aristocracy of the arts."[42] By the early 1830s, such an equation of Academy and aristocracy was standard, made all the more inflammatory as the Academy served exclusively as the Salon jury. In 1832, Jules Raimbaud, writing in the radical journal *La Liberté,* described the Institute as "aristocracy in the arts, nothing more," and the following year, Gustave Planche, the respected critic for *L'Artiste,* labeled the Academy "the official aristocracy of painters, sculptors, and architects" with all the privileges thereof, privileges that he was not alone in determining to wrest from them.[43] By 1875, Castagnary noted that nothing had changed; there were still, he wrote, two classes of artists: "an intolerant and jealous aristocracy composed of members of the Institute, winners of the Prix de Rome, bemedaled and decorated artists, all together 1,155 persons," and "the tumultuous commoners, estimated at four to six thousand independent workers."[44]

Every political debate of nineteenth-century France found its analogue in the Salon. A statement such as "The majority, they are mediocrity or even worse. Give them universal suffrage and you can be certain that they will rise to the height of the gutter"[45] while actually referring to the Salon jury electorate, clearly shared the ideological constructs of the French political Right just as much as the constant references in the Salon debate to liberty and equality reflected Republican principles. We today are so accustomed to accept unquestioningly the value of "freedom" that we must be reminded that such certainty was by no means unanimous in the previous century. The Academy and the entire French political Right, for example, consistently attacked "liberty" in all its many manifestations, seeing it as leading inevitably to anarchy and disorder. As late as 1883 the president of the Academy, the composer Charles Gounod, stated: "Although it is commonly accepted that what is called individuality means independence and that independence means liberty, that is a profound error." He went on to contrast freedom, unfavorably, with truth and concluded with the rhetorical question, "Is a drunk free?"[46] The arguments of generations of political progressives that universal suffrage in the Salon system must inevitably follow its imposition in the political system failed even minimally to convince those, such as the Academicians, who opposed the concept in all spheres of life.[47] Cultural

institutions were no less contested than political ones, and usually over the same issues.

THE DOUBLE EXHIBITION SYSTEM

Accompanying the debate over the annual or biennial status of the Salon was another level of debate trying to compromise by creating two separate exhibitions. The 1791 proposal to open the Salon to all artists while counterbalancing it with an elite long-interval exhibition was the first attempt to set up what we might call a "bicameral" exhibition system that sought to accommodate both the privileged and the proletarian classes of artists. For almost another century, artists, critics, and administrators tried to resolve the two contradictory purposes of the government-sponsored Salon by proposing variants of this double rhythm of official exhibitions, one show to be annual or even permanent and the other to be held at longer intervals, a triennale, quinquennale, or even décennale. The more frequent one would be inclusive, the less frequent one would be exclusive; one would exhibit "pictures to sell," and the other would show "pictures to see." In the politicoaesthetic language of the nineteenth century, the first would serve the "democracy" of art, the other would serve its "aristocracy."[48]

Although such proposals for a double exhibition system have often been mentioned in the art historical literature, they have never been studied as a unique phenomenon with its own history through the century, across aesthetic movements and across political regimes, culminating in the events of the 1880s with the two-tiered collapse of the official Salon system.[49] It is my thesis that although the Salon can be studied in terms of its jury system or its awards, the issue of its periodicity from its inception to its demise evoked the most revelatory discussions of not only the proper relations of art and the state but also the very purpose of art itself.

When in 1791 the revolutionary government permanently stripped the Academy of its monopoly over the Salon, by opening it to independent artists, it destroyed the traditional identity of art production with the Academy. Out of this came the bifurcation of interests which led to a century of proposals for a double exhibition system. Independent artists hoped that such a system would liberate the annual Salon from its obstructionist jury. For them, throwing a sop to aesthetic conservatives in the form of an infrequent exhibition would

be a small price to pay for such a benefit. For Academicians, an infrequent "severe" show would provide a vehicle for the presentation of their own, increasingly beleaguered, aesthetic point of view. For most of the century, however, they were unwilling to coexist with the annual Salon, which they saw as no better than a marketplace or bazaar. Their real agenda was to eliminate the annual Salon altogether and replace it with their own long-interval elite exhibition modeled on the Academic Salon of the Old Regime.

The proposed double exhibition system was an attempt to compromise between the demands of the various constituencies of artists and their opposed conceptions of the purpose of and market for art. Having arisen in 1791 with the liberation of the Salon from Academic control, the proposal resurfaced during periods of greatest stress between the Academy and the demands of independent artists and died along with the Academic system of art. It could have no meaning outside the challenge launched by the growing numbers of artists, the development of the lower categories of genre, landscape, and still life, and the rise of the middle classes who provided a new and expanding market for these pictures so despised in the Academic canon. Such an exhibition structure had not been necessary in the eighteenth century; only a serious threat to Academic hegemony could result in the repeated proposals for this reform.

We might see in these conflicts and the continued difficulties of resolving them a microcosm of larger issues affecting the political structure of nineteenth-century France. The relationship of the two classes of artists and the language consistently used to discuss them reflected the real problem of the relation of the privileged social and economic classes to the lower strata of *le peuple*. The many proposals for a "bicameral" exhibition policy, with separate shows for the "elite" and the "masses" of artists (not even a middle class), can be seen as reflecting the evolving legislative relationship between the two parliamentary houses, the Chamber of Peers (later the Senate) and the Chamber of Deputies.[50]

The upper legislative body traditionally represented entrenched and traditional authority. Until late in the century, its members were appointed for life, as were the Academicians, who also came to stand for privilege, entrenched power, and authority. The privileged class of artists usually made up exhibition juries while being themselves exempt from its decisions; for them any long-interval exhibition limited to "pure" and elevated art was preferable to what they saw as

the commercialism, mediocrity, and vulgarity of the annual Salon. Not surprisingly, these same highly charged political adjectives – *commercial, mediocre,* and *vulgar* – were consistently used in the political discourse of the Right to describe the lower classes of society.

It is no accident that the debate over the Salon structure reached a crisis in the early 1880s when the French legislative system was also being reconsidered. A single chamber in the Assembly had always been the Republican goal, for it was widely recognized that the purpose of the bicameral system was to establish an upper house of privilege to hold in check the universal suffrage of the lower house.[51] During these years, the relation of Senate to Chamber of Deputies and the system of life tenure for Senators was severely, and in 1884 successfully, challenged. At the same time the world of art abandoned its own "upper house," namely, the whole system of Salon exempts, *hors concours,* and limited suffrage in jury election.[52] Within the annual Salon itself, the recurring issue of elite privilege was usually resolved by means of a bicameral structure in which certain classes of *privilégiés,* Academicians, winners of the Prix de Rome, and members of the Légion d'honneur formed the electorate for the jury and were usually exempt from its judgments, whereas the masses of artists found themselves unrepresented, governed by a jury that they had not elected.

A constellation of terms describe the concept of the long-interval exhibition which, as we shall see, was a metaphor in the service of conservative politics. This language identified the Décennale (or Quinquinnale or Triennale) with enduring and elevated values, and the annual salon with democracy, the market economy, and whatever deterioration of ideals and standards it was feared that might lead to. For conservatives, the true purpose of the long-interval exhibition was to superimpose on the widening range of aesthetic principles characteristic of the nineteenth century the Academic vision of one sole legitimate arena for art that would be its exclusive domain, insulated from the growing influence of the marketplace.

The sociologist Pierre Bourdieu identified a process, often repeated in French culture, of the elite's abandonment of any institution if, through democratization, it could no longer signal the distinction of that privileged class.[53] In this case, once the Salon was open to all artists, it lost its function for Academicians. The institution of a more prestigious, infrequent, government-sponsored exhibition limited to Academicians,

such as the Triennale, could then serve the double purpose of reestablishing an elite in art while at the same time devaluing the more open annual Salon and the artists who exhibited there.

The bicameral exhibition system, proposed repeatedly and decreed often, was actually instituted only twice during the century, in 1810 and 1883. The first such exhibition, a décennale, was proposed by Napoleon in 1804 to glorify his own regime; it came less than twenty years after the Revolution and the liberation of the Salon from Academic control.

The Prix décennaux that Napoleon instituted were to be awarded every ten years, beginning in 1810, for the purpose of encouraging science, literature, and art and "preserving the superiority of France in the new century."[54] The jury was to be the Institut de France (the retitled Academies), reinstated as the supreme arbiter of French cultural life after having been briefly suppressed during the revolutionary period.[55] The prizes in art were to be awarded to the best history paintings, thus acknowledging it as the highest category of art, synonymous with the French school. Implicit here was the conviction that "the superiority of France in the new century" could be maintained only through history painting and judged only by the Academy.

Although this first Décennale took place at the same site and the same season as did the annual Salon, unlike that event, it contained works only by Academicians, selected by the Academy and discussed in its own jury report. This, the first instance of the two-tiered exhibition system, openly reinstated the Academy as the elite of the reformed and more democratic Salon, and it reinstated history painting as the most elevated category of art.

This alliance between the state and the Academy soon ran into problems, however, for the recommendations of the Academic jury for the Prix décennaux were set aside by Napoleon, who had his own favorites. The Institute preferred Girodet's *The Deluge* to David's *Sabine Women,* and David's *Coronation* to Napoleon's favorite, Gros's *Pesthouse at Jaffa.*[56] As a result, the prizes were never awarded, and the subsequent collapse of the Empire ended plans to continue the Décennale as a regularly scheduled event. This experience should have augured poorly for future collaborations between Academy and state, but because both parties continued to derive benefits and advantages from the alliance, it continued to function sporadically throughout the century.

In the fifteen years of the Restoration, from 1815 to 1830,

only five Salons were held (Figure 4). Having lost their monopoly over the Salon, the Academicians now wanted to hold it as infrequently as possible. Throughout the nineteenth century we can see in the periodicity of the Salons an indication of the Academy's influence. Whenever the Academy held power, there were few and small Salons; when it was out of favor and the community of independent artists was more powerful, the Salons were frequent and large. Although the main effort of artists during the Restoration was simply to establish even one Salon on a regular basis, the advantages of a double rhythm exhibition system were not completely forgotten.[57] In 1827, for example, the *Journal des artistes* published an anonymous proposal to establish two Salons, one for Academicians and well-known artists, the other for everyone else. In what would rapidly become a familiar argument as the century progressed, its author claimed that the single Salon as presently constituted had to exist for both the high-minded benefit of art and its practical benefit for artists' careers. Nonetheless, the different admission criteria for each group (the first being exempt from jurying) were offensive and unjust. How much better to separate what were, in effect, two shows! Failing that, privilege should be abolished,

4 François-Joseph Heim, *Charles X Distributing Awards to Artists at the End of the Exposition of 1824,* 1825, 1.73 × 2.56. Louvre.

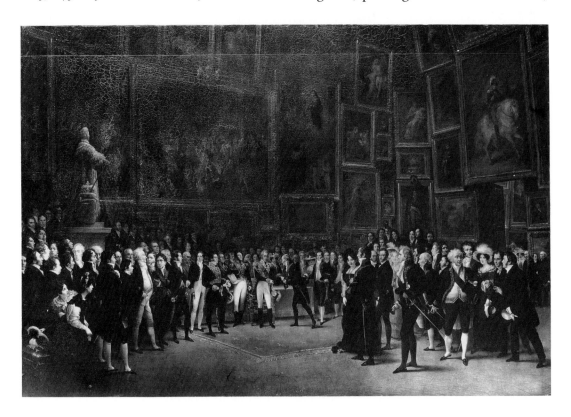

and everyone should go before the jury. As one might expect during the Restoration, this proposal met with a negative response, the editor commenting that the exhibition of the "commoners' " would be "shameful."[58]

At the beginning of the July Monarchy, massive petitions from artists caused the Salon to be returned to its annual status, despite conservative opposition.[59] With the increasing fear of alienating large constituencies, the rule of government by consensus began. Louis-Philippe did what his successors would continue to do, that is, seek a compromise between the Academy, still the official government agency in charge of aesthetics, and the increasing number of artists who were not members and fell outside its control. His compromise was to make the Salon annual, but its jury, the Academy, which, ever mindful of the challenge to its authority, then began rejecting large numbers of works by artists as prominent as Delacroix. Criticism that the Salon, by becoming annual, had turned into a bazaar or a picture shop was widespread in conservative circles during this period and continued through the century as an infallible indicator of conservative politics.[60] It was an economic system – market capitalism – and a political system – parliamentary democracy – that was the true target of such attacks.

Until his death in 1867, the prime spokesman for the conservative artists was Ingres, whose own work was identified with throne and altar, thereby contrasting these institutions with the new market economy. Mediocrity would be the result of democracy in both art and politics, the conservatives predicted, for art was by its nature aristocratic and elitist. Cultural legitimacy was (and still is) considered in France to be a function of political legitimacy, and the charge that art and art institutions have become decadent is always a veiled attack on the current regime.[61]

I am proposing that this politicoaesthetic language, of bazaars and picture shops, of mediocrity and aristocracy, was inseparably linked to the question of the Salon and the long-interval exhibition, each of which encompassed a different political stance. The classical purpose of art espoused by the Academy and implicit in history painting and the long-interval exhibition was to educate, and its habitus was the church, the public monument, the museum, or aristocratic private gallery. Contrasted with this was the bourgeois penchant for art as interior decoration or commodity: Its habitus would be, according to the conservatives, the bazaar, the marketplace, the boudoir, and the annual Salon. In reality,

however, it was the bourgeois living room and, as capitalism developed, the auction house and commercial art gallery.

"Collections and expositions date from the decadence," Ingres himself stated, often comparing the Salon with a bazaar or picture shop:

In order to remedy this overflow of mediocrities that has resulted in there no longer being a French school, this banality – which is a public misfortune, which afflicts taste, and which crushes the administration whose resources it absorbs without advantage – it would be necessary to give up expositions; it would be necessary to declare courageously that monumental painting alone will be encouraged. The decoration of great national monuments, of churches whose walls are thirsty for paintings, would be decreed.[62]

This remained the conservative view throughout the century, but in view of the growing numbers of artists whose productions served the interests of the middle classes, it was increasingly unrealistic. One might criticize bourgeois taste, but from 1830 onward one could not deny the growing political and economic power of that class.

The warfare that existed during the July Monarchy between the Academic Salon jury and the community of independent artists led to another proposal for a Décennale, which was put forward by the sculptor David d'Angers in 1838.[63] Adopting the Republican strategy of identifying the freedom to exhibit with the freedom of the press – now guaranteed by Louis-Philippe's constitutional monarchy – David suggested a system of two exhibitions. One would be permanent, renewed every six months; there would be no jury and each artist would be able to show two pictures. "To exhibit would no longer be a privilege but a right," he wrote. There also would be, he proposed, a solemn exposition every ten years, a Décennale to include the best works produced during that period as well as those purchased by the state. He did not assume that the two categories would be identical.

David d'Angers and the circle of artists around him – Barye, Delacroix, Daumier, and Rousseau – all were popularly identified with the political Left and the opposition to the Academy, although David himself was a member. His constituency of independent artists is apparent in his suggestion that all government commissions, traditionally for elevated subjects by Academicians, be excluded from the permanent exhibition. "Those works would be better seen and appreciated in the installations for which they were intended," he wrote, adding almost parenthetically that "there would be the additional benefit of not having them occupying the best

and largest places in the show." Beneath the grandiose language of his proposal, David was laying claim to the Salon for the masses of artists while throwing to Academicians a sop in the form of an "elevated" show once every ten years. For there could be no doubt that his description of the Décennale in the language of solemnity, purity, severity, and choice works implied a show by and for Academicians. This was, after all, their rhetoric.

Nothing came of this proposal, but David d'Angers continued to insist that the Salons be permanent, offset by a solemn long-interval exhibition.[64] His plan for a two-tiered exhibition system resurfaced during the Second Republic when a new factor was introduced, namely, the bourgeois state that wished to minimize government expenditures on art. Economics entered often into the question of the Salon's periodicity, for although such concerns were rarely acknowledged, these exhibitions were expensive to organize. Under every monarchic regime, the Salon was subsidized by the civil list, that is, the king or emperor's annual salary. During the Republics, budget committees had to approve, often unwillingly, the expenses incurred by such events. The cost of the Salon's installation, its medals, awards, commissions, and purchases all were unavoidable expenses that the state, king, or emperor had to pay, as the protector of the arts. The prospect of an infrequent salon thus represented an attractive opportunity for successive government art administrations and budget committees to replace the expensive annual Salon with a smaller and less frequent event that would relieve the government of both an annual financial drain and, as the artists' complaints became more insistent, a constant problem. Nonetheless, despite its expense and their complaints, the interests of most of the artists, by now an extremely vocal constituency, were served by the large annual Salon. In addition to its economic function, the annual Salon was a free public spectacle, one of the few in France.[65] As it was immensely popular, attended by several hundred thousand people each year, every proposal to diminish its size or importance in any way led to demonstrations by artists and to protests by the public.

During the Second Republic, the hard-pressed Budget Committee repeatedly tried to cancel the annual Salon. In 1849: "The committee proposes the idea of suppressing the annual exposition. A triennial exposition would be preferable. To serve the interests of artists, the Salon is being turned into a permanent bazaar."[66] And in 1850: "In examining the

29

general budget, the committee expressed the opinion that the exposition should be biennial, that expositions held more often were too burdensome, more damaging than useful to the interests of art."[67]

The artists responded by electing a Fine Arts Committee that included David d'Angers. Not surprisingly it proposed a variant of his two-tiered exhibition system: One show would be permanent and commercial, the other biennial, "and by that token more solemn and more worthy of the dignity of art."[68] The Budget Committee, however, deliberately misinterpreted the artists' intention as a desire to suppress the Salon altogether, and so it rephrased the report of the Fine Arts Committee as follows: "In the interest of art, the Committee expresses the wish to see an end to annual expositions. It finds preferable the former custom of mounting expositions of painting and sculpture at longer intervals."[69]

In the uproar that followed, both proposals were abandoned and the Salon temporarily maintained its annual status. "The unfortunate situation in which artists have found themselves after the Revolution and the wishes that they have generally expressed have for the moment rendered annual exhibitions necessary," stated the Budget Committee's report for 1850.[70] The 1850 Salon had been delayed so long, however, that it ran into 1851 and was forced to serve for both years, as had the Salon of 1827–28 under the Restoration. Budget committees and Academic forces, each for their own reasons, had united against the annual Salon.[71] This alliance of mutual interest would play a crucial role during the Third Republic.

Despite the opposition of Second Republic budget committees to the Salon's expenditures, the double exhibition proposal was, theoretically at least, soon taken up by that most aristocratic of art administrators, Philippe de Chennevières, then still a minor functionary in the Louvre. In his *Lettres sur l'art français en 1850,* he also proposed the bicameral system, in his case a biennial Salon restricted to bemedaled and decorated artists and an annual Salon for everybody else.[72] Chennevières's focus, however, was on the "aristocratic" and not the "common" Salon, and his attempt was to rescue and encourage an elevated art from what he saw as the deleterious effects of democracy.

With the declaration of the Second Empire in 1852, there began a continuous stream of double exhibition proposals from all camps, accompanying the insistent demands for Salon reform.[73] By this date Academicians and conservatives in

general saw the suppression of the Salon, constantly increasing in size, as a lost cause and were willing to compromise just to be rid of it, especially if they could be compensated with a government-sponsored elite exhibition of their own. In 1857, as part of Napoleon III's strategy of encouraging all powerful institutions to rally to the empire, his art administration reinstated the Academy as the Salon jury (as Louis-Philippe had done before him) and returned the Salon to the biennial status it had held under the Old Regime.[74] As part of the academic *revanche*, beginning in this year the Salon catalogue included a section listing the *monuments publics*, or commissioned works for public buildings, works that, either because of their size or because they were permanently installed, could not easily be transported to the Salon for exhibition.

This new emphasis on such works, "pictures to see," was intended to offset the prestige that the Salon offered to artists who produced the smaller commodity art usually exhibited there. The following year the Academy published a report stating that annual Salons encouraged artists to produce too quickly and thus resulted in lowered standards. Biennial or even triennial exhibitions would be preferable.[75] As a result of this Academic jury's policies during the liberal empire of the 1860s, complaints and petitions multiplied, and there were numerous pamphlets outlining some variant of the double exhibition system (Figure 5).

The most influential of these pamphlets were written by the portraitist Alexis-Joseph Pérignon, friend of Delacroix and director of the Dijon Museum.[76] The annual Salon cannot satisfy everyone, he wrote, because it has two contradictory purposes: "to be an exposition of choice works" and "to serve the artists' material interests by providing them with the means of making their talent known: showing their works and selling them." This is why there have always been two camps, he explained; one wants the jury to be more severe and the other wants to suppress it altogether. The only solution would be to have two exhibitions. One would be permanent with no jury; all artists who wanted to exhibit could bring their work and pay a fee. The public would not pay an admission fee because the works would be for sale, and one cannot charge admission to a marketplace. The other, which he called the "Imperial Exposition," would take place less often, perhaps every five years. It would have a discriminating jury that would choose only distinguished works. As nothing would be for sale, the public would pay an admission fee. Pérignon did not articulate what seems self-evident, that the contradictory

purposes of the Salon were in fact a function of the different constituencies of artists and their markets. The Academy identified throne and altar as the proper patrons for an art that ideally would be commissioned in advance and shown to the public at the Salon only as a gesture of *noblesse oblige* and as a means of elevating the level of public taste. Independent artists turned out small easel pictures for the new bourgeoisie who wanted to see in advance, preferably at the Salon, what was available for purchase.

The critic and government administrator Charles Blanc was in the aesthetically conservative camp and thus pointed out about exhibitions in general, "The more frequent they are, the weaker they are."[77] He took an extreme position, stating that:

> The sovereign, whoever he might be, ought to exhibit in the Louvre only cartoons of mural paintings, models of grand sculpture, projects of monuments that have won public competitions or that he commissioned from architects; in a word, what he himself has commissioned and paid for, what is not for sale.[78]

Blanc coopted Pérignon's liberal defense of "liberty" in order to argue for suppressing the annual Salon: Only liberty, he

5 Gustave Doré, *The Salon of 1868. Palais de l'Industrie,* Bibliothèque nationale, Paris.

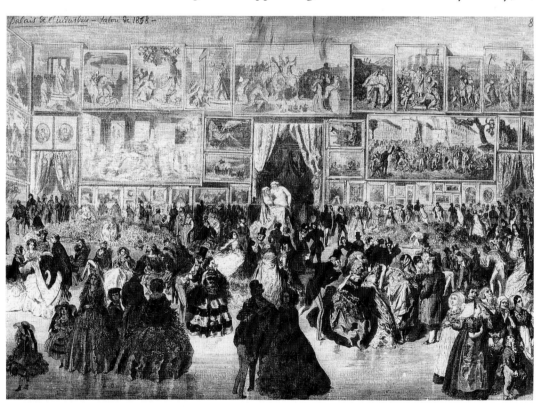

wrote, could resolve the contradictions in exhibition policy. Artists must have the liberty to organize their own exhibitions, either small group shows based on shared aesthetic principles or a general exhibition with paid admission. The state, on the other hand, must also have the liberty to organize, at longer intervals, a noncommercial Salon without admission fees for which everything would be done for the greater glory of French art. The first he called an *exhibition* of "pictures to sell," and the second he called an *exposition* of "pictures to see," a terminology reflecting a long-standing tradition in France. As early as the 1830s, a critic had written: "*Expositions* are of French origin; *exhibitions* were invented in England. The former imply something free, general, official; the latter necessarily have as their aim a special interest, a private speculation."[79]

For Blanc, artists' exhibitions were a form of low entertainment and thus should charge admission, as did theaters and other amusements. Government expositions, on the other hand, were a form of education and therefore must be free, as were churches, libraries, and universities. The suggestion that independent artists had the "liberty" to exhibit outside official circles and should, therefore, leave the state exhibitions to aesthetic conservatives was made repeatedly from the midcentury onward and shows the conservative equation of independent artists with commerce versus Academicians with education and the state.

Blanc had rearranged Pérignon's ideas to conform to a conservative agenda. Within months of publishing his proposal, he, and not Pérignon, was elected to the Academy.[80] It should also be noted that by the 1860s the community of independent artists was strong enough that although aesthetic conservatives like Blanc continued to criticize the Salon as a bazaar, they had been obliged to abandon their earlier attempts to suppress it completely. Accepting it as a necessary evil, they instead began to suggest that the state turn over the Salon to the artists themselves and abandon all responsibility for its organization and control.

In the last months of the Second Empire, the art administration was reorganized, and the fate of the Salon became a subject for debate in the government and the press.[81] A ministerial subcommittee in June 1870 proposed the familiar two-tiered exhibition system, "one open to all artists, the other directed by a jury from the administration."[82] The decision was postponed for more study – and then, on September 4,

Table 2. *Political Regimes, 1789–1870*

1774 to August 10, 1792 King Louis XVI Constituant Assembly: May 5, 1789, to Sept. 20, 1791 Legislative Assembly: Oct. 1, 1791, to Aug. 10, 1792	Bourbon Monarchy
August 10, 1792, to 4 brumaire an IV (Oct. 26, 1795) National Convention Republican calendar begins: Sept. 22, 1792	Republic
8 brumaire an IV to 18 brumaire an VIII (Oct. 30, 1795, to Nov. 9, 1799) Rotating Committee of Five Directors	Directory (Republic)
19 brumaire an VIII to 28 floréal an XII (Nov. 10, 1799, to May 18, 1804) Napoleon Bonaparte (First Consul), E. J. Sieyès, Roger Ducos	Consulate
28 floréal an XII (May 18, 1804) to April 2, 1814 Emperor Napoleon I (Napoleon Bonaparte) Republican calendar ends: Dec. 31, 1805	Empire
April 6, 1814, to March 1, 1815 King Louis XVIII	First Restoration Bourbon Monarchy
March 20 to June 22, 1815 Emperor Napoleon I	Hundred Days (Empire)
July 8, 1815, to July 29, 1830 King Louis XVIII: July 8, 1815, to Sept. 16, 1824 King Charles X: Sept. 16, 1824, to July 29, 1830	Restoration Bourbon Monarchy
August 9, 1830, to February 24, 1848 King Louis-Philippe	July Monarchy Orleanist Constitutional Monarchy
February 25, 1848, to December 2, 1852 Provisional Government: Feb. 25 to May 4, 1848 Constituant Assembly: May 4 to Dec. 20, 1848 President Louis-Napoleon Bonaparte: Dec. 20, 1848, to Dec. 2, 1852	Second Republic
December 2, 1852, to September 4, 1870 Emperor Napoleon III (Louis-Napoleon Bonaparte)	Second Empire

1870, the Second Empire fell, defeated at Sedan by the Prussian army.

The focus of this study will be the government's attempt in the early Third Republic to carry out this last directive of the Second Empire, to turn over the Salon to the control of artists and, in compensation, to mount a long-interval conservative and elite exhibition. The proposal first made in 1791 was finally carried out in the 1880s. But by the time political circumstances permitted the necessary alliance of Academic and government forces that could bring about these changes, it was already too late; the effort could not be sustained, and the entire official Salon system collapsed.

6 *Order*. From Charles Blanc, *Grammaire des arts décoratifs*, 1882.

MORAL ORDER IN
THE FINE ARTS

The French school . . . knows well that for it, as for us all, the time has come to return to serious thoughts, to a moral reform in proportion to our responsibilities and our sufferings. It knows that in continuing to reduce its mission to the practice of this frivolous – and at times worse than frivolous – art, to which we have wrongly accommodated ourselves recently, not only our foreign influence but our dignity at home will be compromised. In a word, under the penalty of no longer representing anything other than sterile fantasy or godless egotism, talent should be patriotically employed to lift up our hearts, to stimulate or fortify our faith, to reconcile us with all that is truly beautiful, truly noble, truly good.

Henri Delaborde, 1872[1]

T HE early Third Republic was a period characterized by the desire for *l'ordre moral,* the return to order, which would wash away the decadence associated with the *fête impériale* of the Second Empire, the defeats of the Franco-Prussian War, and the bitterness of the Commune.[2] Following the disastrous French defeat at Sedan and the abdication of Napoleon III, monarchists were seen as representatives of peace and moral order, for they had wanted to end that war quickly, at almost any price, whereas Gambetta and the Republicans who formed the Government of National Defense preferred to hold out as long as possible. As a result, the divisions between radical and conservative Republicans faded momentarily into insignificance, and to the rest of the country, to the monarchists and Bonapartists, they all appeared as "red Republicans." The nobles and notables, the traditional rulers, promised peace and order.

The first elections of the Third Republic, held in February 1871, returned a majority of monarchists to the Assembly, 400 out of 645; the Assembly then chose Adolphe Thiers as the "chief of the executive power of the French Republic."

Thiers was certainly a man of order; a prominent Orleanist and prime minister under Louis-Philippe in the 1830s, he later in 1871 would ruthlessly crush the Paris Commune. His was a provisional title for a provisional office, intended to govern the nation only until the moment when the monarchy could be reestablished.

For the first five years of its existence, the Third Republic had no constitution, so reluctant was the monarchist Assembly to institutionalize a Republic. This first decade, then, was one of conservative reaction, when as Halévy pointed out, all of France's Old Regimes reemerged, hoping to resume their traditional role in French life. Although the "Republic of the Dukes," to use Halévy's term, openly conspired for a return to the monarchy and traditional values, the three monarchist parties – the legitimists, the Orleanists, and the Bonapartists – proved unable to carry out that monarchist restoration. Nonetheless, the possibility remained very much alive and much discussed throughout the first decade. The Republicans gradually gained strength in the Assembly during those years, but it was not until 1879 that they could gain enough of a majority in both the Senate and the Chamber of Deputies to end the period of moral order governments and initiate the "Republic of the Republicans" that would ultimately reshape French society, secularizing education, legalizing trade unions and divorce, and guaranteeing freedom of the press.

In the 1870s, the world of art was subject to the same yearnings for stability and a return to past verities that characterized the rest of French life (Figure 6). If France's commitment to a Republican form of government hung by a thread in these first years, the future of French art institutions hung equally in the balance, suspended between the laissez-faire cultural policies of the Second Empire and the widespread desire for a restoration of these institutions' (notably the Academy's) traditional role in maintaining a hierarchically directed, classically inspired official culture, redolent of past glories. The classicism propounded by the Academy offered the provenance of antiquity through an identification with both the greatest cultural civilization (the Greeks) and the greatest imperial one (the Romans).[3] Classicism could be invoked not just in its antique manifestations and Renaissance heroes but even in its more recent representatives, David and Ingres. A classically inspired historicism, then, could serve a political purpose, uniting the country in support of its glorious cultural and national traditions.[4] Classical revivals, in fact, have proved especially valuable in times of crisis in France,

not only in the years following the humiliating defeats of 1870–
71, but also later, in the periods surrounding World Wars I
and II.[5]

The Second Empire's abdication from the traditional state
role in maintaining high culture – and especially its repudia-
tion of the Academy – had resulted in genre painting's so
completely eclipsing the Grand Tradition that upon the fall
of Napoleon III in 1870, the reaction against his regime in-
cluded a critical backlash against this painting, which seemed
to conservatives to typify everything superficial and frivo-
lous about the preceding decades. As a result, the return to
order in art meant a return to the traditional didactic values
of the Academy. This was signaled immediately by the inte-
gration of the arts administration, which for almost twenty
years had been part of the emperor's household [*Ministère de
la maison de l'Empereur*], into the more austere and high-minded
Ministry of Public Instruction.[6] For those who did not im-
mediately grasp the significance of this shift, Edouard Char-
ton, in an influential report on the fine arts administration
presented to the Chamber of Deputies in 1875, explained:

> When they [the fine arts] were attached to the Household of the
> Chief of State, the fine arts appeared less like a public service than
> an attribute of royal or imperial luxury, an element of magnifi-
> cence, a radiance from the throne, or, as was often said, the stage
> setting for sovereign power. They have only taken on the character
> of public service since 1870, the day when they were annexed to
> the Ministry of Public Instruction.[7]

The result of this shift was that – and here the Republican
view of art had hardly changed in a century – "the fine arts
have become again what they could be from the state's point
of view, a powerful means of elevating the public spirit and
enobling popular imagination through the instructive quali-
ties of expressive images."[8] Fine sentiments, to be sure, but
how was this goal to be accomplished? The reality was that
there was only one powerful art institution in France, and so
like every preceding regime, the Third Republic attempted
to cultivate the Academy of Fine Arts.

In August 1871, Jules Simon, Thiers's minister of public
instruction, wrote to the Academy asking it "without bring-
ing up old quarrels to study the questions that divided the
government and the Institute."[9] In response, the Academy
prepared a "wish list" asking for the return of its jurisdiction
over the Prix de Rome, the French Academy at Rome, the
Ecole des beaux-arts, and the reestablishment of the history
landscape competition [*grand prix de paysage historique*].[10] All

of these prerogatives had been lost in the decrees of 1863 when the government of the Second Empire had definitively broken with the Academy. On November 13, 1871, on the eighth anniversary of the odious decrees, Academic jurisdiction over the Prix de Rome was returned.[11] The Academy was jubilant over what its president, Ambroise Thomas, appropriately called "this return to the past." "I am happy to be able to congratulate the government, in the name of the Academy, for having officially reestablished the ties that have never been broken and that have never ceased to exist," Thomas stated at its 1872 annual meeting.[12] The following year, its secrétaire perpétuel, the legitimist Charles Beulé, was appointed minister of interior in the duc de Broglie's government.[13] By 1874, the Academy was so satisfied with its regained power and prestige that at its annual meeting, Beulé's replacement, Henri Delaborde, openly thanked Charles Blanc and Jules Simon, frankly attributing the Academy's restored status to the fact that both were Academicians – "our colleagues" as he called them.[14]

For Charles Blanc, then, the first fine arts director of the Third Republic, an Academic restitution presented no problem. Appointed by Gambetta's Government of National Defense, he was an obvious choice for the position, for as the brother of the socialist Louis Blanc, he had filled the same office in 1848 under the Second Republic. An influential voice in the French art world, Blanc had produced numerous art historical and critical studies and had founded the *Gazette des beaux-arts* in 1859. His own politics had become a good deal more conservative since 1848, however. The legitimist marquis de Chennevières, his successor, described Blanc in 1870 as "more a supporter of Ingres and the Academy than of Courbet and the Commune."[15]

Blanc's Republicanism called for an authoritarian centralized state apparatus to govern art, artists, and public taste, and like many such Republicans, Blanc had long championed the Grand Tradition as a tool for accomplishing the educational purposes he demanded of art.[16] "He deeply loved the Academies and the Academies loved him," Chennevières wrote of him.[17] Blanc's program had always been that "the state should construct and decorate monuments; it should open to the people vast and beautiful gardens; it should arrange, when appropriate, ceremonies or solemn festivals; it should ensure that masterpieces in danger of perishing will be preserved by the engravers' art."[18] Specifically, the state should encourage only "monumental architecture, decorative

painting, grand sculpture, classic engraving." This had been the traditional program of public art and public works put forward by the Academy, which could then expect that the commissions for such projects would be awarded to its members. The proposed return to the Grand Tradition meant that history painting, always synonymous with the French school and thus with national identity, would be reinstated as the highest category of art. The Old Regime that had miraculously emerged in the world of art in the 1870s, the aesthetic branch of the moral order governments was, then, synonymous with a restitution of Academic values.

Blanc's program seemed to promise both national regeneration and, just as important, aesthetic stability, or at least unity, in the face of the multiplicity of styles ratified by the Second Empire. The art world he inherited, however, was fragmented and pluralistic, of minimal utility for the didactic purposes that Republicans demanded of art. The unity that had characterized – or had been thought to characterize – the French school had disappeared, and in its place were Academicians, official and *pompier* artists, Naturalists, Realists, and the as-yet-unnamed Impressionists, even aging Romantics and Barbizon artists. Above all there were genre painters, whose popular, salable works formed the majority at every Salon exhibition. Actually, a variety of styles had long existed in French art, although perhaps not to so extreme a degree, but the recognition of this reality had traditionally been held in check by the hierarchical system in which history painting held unchallenged sway in commissions, honors, and prizes, and the lesser categories of genre, landscape, and still life were officially considered inferior and unworthy of government patronage.[19] The Second Empire had gradually let this system deteriorate, as it had little appeal to either the majority of artists or a wider public.[20]

So little did the government of the Second Empire care about maintaining the Grand Tradition that its fine arts admissions jury for the 1867 Universal Exposition had no statutory representation of the Academy. The exposition's international jury then sent shock waves through the French art world by awarding a majority of prizes to genre painters. The following year's Salon jury, for the first time, did the same thing. This 1868 Salon jury, elected by universal suffrage among artists who had exhibited in previous Salons, finally revealed its real constituency and the real market for art by giving its medal of honor to the genre painter Gustave Brion for his *Bible Reading: Protestant Interior in Alsace*. The

reverberations of these decisions were such that it was widely acknowledged in France that the great age of history painting was over.[21] It was against this reality that Academic forces were attempting to stage a comeback in the 1870s and 1880s.

Like most aesthetic conservatives, Blanc blamed the Second Empire for encouraging a taste in the lower categories of art.[22] He lost no time in putting into effect an aesthetic return to order based on the traditional Academic anti-Salon program. In his 1871 report to the minister of public instruction, Blanc wrote that "the state exhibits works and not products; it sponsors a Salon and not a bazaar."[23] The 1870 Salon, the last of the Second Empire, had over 5,400 entries, whereas Blanc reduced the 1872 Salon, the first of the Third Republic, to approximately 2,000 works.[24] Castagnary observed that Blanc's ideal Salon would have "a hundred pictures and two statues."[25] In 1868 the artists had, after decades of protests, finally won universal suffrage in the election of two-thirds of the jury, the remaining members being appointed by the government. In 1870 the artists elected the entire jury. But for the Salon of 1872 Blanc again restricted the jury electorate to Academicians and artists who had received official honors, reserving for himself the right to appoint approximately one-fourth of jury members.[26]

The enemy that the forces of order saw in the aesthetic sphere was not so much the avant-garde as the army of genre and landscape painters who symbolized the commodification of art and its assimilation into the capitalist system of auction houses and galleries.[27] Blanc's 1871 report, attacking "familiar, anecdotal, intimate art addressing itself to individuals," provoked an immediate response in the form of a petition from over a hundred artists representing all shades of the aesthetic spectrum save history painting. Among the signatures were those of modernists such as Daubigny, Daumier, Corot, and Manet but also names such as Petitgrand, Coffetier, Saunier, and Daumas, who have left few traces in art history. The artists informed Blanc:

French art today is composed not only of a few competent and learned pensioners that the state can employ for the decoration of monuments and gardens. It consists also, and most particularly, of a brilliant and enormous legion of landscape and genre painters, more numerous each day, whose original works are sought after by the entire world and whom our neighboring countries envy.[28]

Despite such protests, the Salon jury of 1872 proved so "severe" that more petitions followed. Shortly after the Salon opened, Blanc received another signed by over forty

artists, including not only Manet and his friends – Renoir, Pissarro, and Cézanne – but also many unknowns such as Trimolet, Authie, and Beliard. They demanded a new Salon des refusés; the following year, the government was forced to grant their request, and exhibitions of *refusés* soon became an inevitable feature of every Salon season.[29] Although the Third Republic vigorously condemned the Second Empire and all its works, the experience of the 1870s art administrations repeated that of the earlier regime in that it could not and would not deny the wishes of the majority of artists.

The return to order signaled by the reaffirmation of the Grand Tradition was intended to indicate not just an aesthetic renaissance but also a political rebirth. Although Blanc was a Republican, albeit a conservative one, much of his program was carried out by his successors, monarchists and clericals. These political groups all had experienced the humiliation of defeat, and all felt the necessity for French art to regain its public and didactic character and return to the mainstream of tradition.[30] The year-by-year chronology given in the catalogue of the 1878 Universal Exposition amply demonstrates this confluence of aesthetics and politics:

For several years, we have witnessed a marked return to serious studies, to monumental history painting, which the international jury in 1867 was forced to acknowledge had declined in France as well as in the rest of Europe. Up to 1870 it is true that genre painting continued to enjoy public favor practically exclusively. The Salon of 1868 as a whole, following the great effort of 1867, seemed just as mediocre, as if the entire school remained exhausted and uncertain. That of 1869 seemed to announce some attempts of a more elevated order. That of 1870 put forward strongly some brilliant personalities, and the Prix d'honneur could be given to a grand historic composition. Nonetheless it was only after the events of 1870–71 that the movement little by little became widespread and assumed a more visible course. The Salons of 1872 and 1873 had already witnessed some new activity in this sense. At the awards ceremonies of 1874 and 1875, the minister of public instruction officially announced a general return to serious studies, and then, in 1876, he was able to confirm the exceptional impact of an exhibition at which there was "an excellent movement toward a renaissance."[31]

In 1876 the legislature virtually doubled the Salon's budget for purchases, although this largesse was not extended to the lower categories of art. Waddington, the minister of public instruction, explained at the Salon awards ceremony that the funding was intended to encourage only "the highest art, which sets the level for all others, art momentarily abandoned in

public favor that only the state can maintain."[32] He meant, of course, history painting and sculpture.

Thus were the sides drawn during the 1870s with, on the one side, the government and Academic forces of order and tradition and, on the other, the majority of artists whose allegiance was to categories of art that traditionalists considered inferior. This relentless government assault during the 1870s on the lower categories of art – landscape, genre, and still life – must provide for us a new context within which to examine the series of eight Impressionist exhibitions from 1874 to 1886. The artists now considered canonical in this movement were actually, as scholars have repeatedly pointed out, a minority of those who exhibited in their shows and an even smaller minority of those rejected by the Salons (see Figure 1). Although modernism has privileged their plight, we must understand that their situation was merely symptomatic of the stresses, ultimately political and economic, operating on the exhibition system in its entirety.

Similarly, the "crisis of Impressionism" that affected all its painters in the late 1870s and early 1880s, during which many of its key members either returned to the Salons or lost faith in their shared enterprise, must be understood as at least partially precipitated by this resolute government campaign against the art to which they had been so firmly committed.[33] Renoir's statement at the close of this period – "I finally came to the conclusion that I knew neither how to paint nor draw" – and his trip to Italy where he studied the work of Raphael, the hero of the Academicians, take on new significance in this context.[34] This is not to deny the other factors in this crisis, among which Joel Isaacson listed personal and professional growth and differing responses to family and economic situations. It is important to emphasize, however, that modernist art history's tendency to focus only on the personal, to the complete exclusion of the political, as well as its tendency to privilege the careers of canonical artists as though they were unrelated to the conditions under which all artists of the period were operating, has left us a skewed picture of the historical circumstances under which art was – and still is – produced.

A major aspect of Blanc's program, the one that most vividly affected artists' livelihoods and the one with which we will be concerned here, was his grand plan to reorganize the state's exhibition system. The principal vehicle for Blanc's effort to elevate French art was a government-sponsored triennial exhibition, the project he had been promoting for

years. In language similar to that of his 1860s proposal, he presented his plan in the guise of Republicanism, organized around the principle of liberty: "liberty for artists to form groups with whomever they please, with or without the support of the government, to manage their affairs through a professional union and to organize, either periodically or permanently, Salons whose regulations they set themselves." In return for this concession to the artists, Blanc specified "liberty for the administration to open to the public, less often as the case may be, a strictly chosen Salon at which what should be exhibited, before all else, are the commissions and acquisitions that it has made and for which it would frankly accept responsibility before public opinion."[35] Blanc was proposing, in effect, the disenfranchisement of the majority of artists and the return of the Salon to an official function similar to its position in the Old Regime, at which only Academicians could exhibit. As his subsequent writings made clear, he never really intended that the government support the artists' Salon; rather, his goal was its replacement with an official Salon that was small, infrequent, elevated, and very "severe."[36]

Although such a program had been proposed many times, the unusual political circumstances of the 1870s resulted in its only success since 1810. For the moment, all political parties from Republicans to monarchists could agree on the importance of establishing a national identity through art and of restoring the traditional values put forth by the Academy as the standard bearer of French high culture. At the awards ceremony of the 1873 Salon, A. P. Batbie, the minister of public instruction, warned artists against the all-too-apparent tendency toward genre: "You are giving in to anecdotal painting and abandoning grand painting," he warned. "You must react against it. You must aspire to great works."[37] Similar sentiments had been expressed before, even during the Second Empire, but what made this event different was the political necessity that Batbie attached to aesthetic choices: "Yes, gentlemen, unhappy France has had the misfortune of hearing her enemies challenge the great virtues that have made her so powerful, but no one has yet refused to admire our art."[38] Grand Art would provide the means for national regeneration.

Blanc was not able to achieve this part of his program, largely because of an even more conservative project to which he was devoting enormous amounts of his own energy and government revenue, his Musée des copies where replicas of

the great works of the Italian Renaissance would be displayed for the purpose of "reviving the cult of the highest national tradition," namely, Academic classicism.[39] This museum was opened to the public in April 1873 but, even earlier, it had occupied a wing of the Palais de l'Industrie, one reason that the Salons of 1872 and 1873 had been much reduced. Blanc had personally arranged the locale:

> In order for the contrast to have all its force, all its eloquence, it was necessary that the Musée des copies be located precisely there where the fine arts administration installed it. In this way, the visitors on the one hand and the artists on the other, in passing from a temple to a bazaar, would notice the difference.[40]

When it became known that Blanc was using funds specified for *encouragements aux arts,* that is, for the support of living artists, to commission copies of works by dead ones, he was strongly criticized in the National Assembly on the grounds that the idea was fifty years behind contemporary art and several years behind photographic reproduction.[41] Continued protests from artists and critics eventually resulted in Blanc's being forced out of office in 1873, shortly after Thiers himself was obliged to resign by a coalition of monarchist and clerical forces who thought even him too liberal. Blanc's Musée des copies was unceremoniously closed by his successor,[42] and Blanc was put out to pasture at the Collège de France, eventually being appointed to its first chair of art history and aesthetics in 1878. During these years, he continued to expound the classical ideal and the necessity for abandoning the Salon and replacing it with an elite long-interval exhibition.[43]

Thiers's successor was Maréchal MacMahon, a war hero and monarchist. In his 1873 inaugural address MacMahon spoke of the necessity of "reestablishing moral order in our land."[44] He named as his new fine arts director the marquis de Chennevières, a legitimist. Despite the differing politics of Blanc and Chennevières, these two Academicians shared similar aesthetic convictions. Nonetheless, neither Chennevières nor his successor under MacMahon, the clerical Eugène Guillaume, could restrain the size of the Salon, which again began to expand (Table 3).[45] Despite the administration's continued desire to reduce its size, a growing number of artists united in demanding from the government a showcase for their work. Their economic reality was far different from that of Academicians of an earlier period who were assured pensions and commissions and thus had no need to appeal to the public to sell their art.

Table 3. *The Salon, 1870–89*

Year	Entries	Opening date
Official salons		
1870	5434	May 1
1872	2067	May 1
1873	2142	May 5
1874	3657	May 1
1875	3862	May 1
1876	4033	May 1
1877	4616	May 1
1878	4985	May 25
1879	5895	May 12
1880	7289	May 1
Salons of the Société des artistes français		
1881	4942	May 2
1882	5612	May 1
1883	4943	May 1
1884	4665	May 1
1885	5034	May 1
1886	5416	May 1
1887	5318	May 1
1888	5523	May 1
1889	5810	May 1

In the 1870s, therefore, we find two seemingly contradictory currents, the official rhetoric and the statistical reality. The Salon grew larger each year, swelled not by history painting but precisely by those landscape and genre subjects officially considered so insignificant. Despite the conservative disdain for majority opinion, the preface to the fine arts catalogue of the 1878 Universal Exposition could not resist demonstrating the vitality of French art and, by extension, the vitality of France itself – the Prussian defeat still hurt – by announcing that each Salon of the Third Republic exhibited approximately two thousand paintings and that over half a million citizens had visited the 1876 exhibition.[46] Nonetheless, conservative critics continued to condemn a trend toward what they saw as rampant commercialism invading the ideal universe of art. As one put it, and this was not meant as a compliment: "The Salon today already holds a place in the commercial and economic statistics of our country."[47]

Although the previous period had probably spawned just as much (or as little) history painting, the issue here was one of official support. History painters of the Second Empire felt neglected and abandoned by a government that had limited

the rights and privileges of Academicians and had allowed the Salon to be taken over by genre and landscape painters.[48] The art administration of the early Third Republic, on the other hand, placed the weight and prestige of the French government squarely behind this category of art.

The moral order fine arts directors – Blanc, Chennevières, and Guillaume – all were Academicians, the last in the long tradition of collaboration between the Academy and the state and the last to be appointed by monarchist regimes. The stresses within the system were already showing up in the contradictory program that the art administration was being forced to adopt, steering between electoral politics' attraction to popular policies and economic successes and the conservative elitist disdain for them. In addition, the administration had to mediate the imperatives of an institution, the Academy of Fine Arts, that despite its identification with the French school in art – that is, with nationalism – nonetheless also stood for privilege, elitism, and an aristocratic ideology that repeated revolutions in France had left unchanged. It is on these shoals that the official Salon system was ultimately wrecked.

One of Chennevières's first official acts on assuming the position of director of fine arts was to attempt to buttress up the Grand Tradition by creating a twelve-member Fine Arts Commission as an advisory body to the art administration. With a majority of its members being Academicians, its real purpose was to use its prestige to promote a revival of history and religious painting.[49] The discussion in the National Assembly that preceded its founding signaled its intentions. The speech by Dufaur de Gavardie, whose particule signaled his aristocratic rank, was thus transcribed in the official minutes of the Chamber of Deputies:

Some very competent intellectuals were wondering, not so long ago, at an elite meeting presided over by one of our honorable colleagues, M. Chesnelong, I believe, if we could not create a Conseil supérieur des beaux-arts, which would be composed of members taken from certain categories, for example, some members of the Academy of Fine Arts, some church architects [architects diocésains], some rich and distinguished amateurs such as still exist in France, and some bishops (from the Left, "Ah! Ah!") to represent the interests of religious art which is in such a state of decadence.[50]

As Chesnelong was a notorious legitimist and clerical, the commission's purpose was self-evident. The following year Chennevières established a Prix du Salon to encourage young artists in "serious studies," stating that "the public is stunned

by the abandonment of history painting over the last few years; this situation has been remarked everywhere."[51] The prize to be offered to a painter younger than thirty-two years old was a three-year fellowship in Rome, the funds to be taken out of the Salon's budget. The largely Academic jury refused to award the prize the first year, however, for it duplicated and competed with the Academy's own Prix de Rome. As a result, Chennevières awarded it himself, to Pierre-Adrien-Pascal Lehoux, for his *St. Laurent, Martyr* (Figure 7).[52]

Despite Chennevières's efforts, the year 1874 is somewhat better remembered for the first exhibition organized by a group of artists, of whom fewer than half would soon be called Impressionists. If we cite Monet's *Impression, Sunrise* (Figure 8), which gave the group its name, as symbolic of the modernist effort during these years, and Lehoux as representing the opposite polarity, the aesthetic return to order, we must also signal the ambivalence within the Salon system itself. The 1874 medal of honor at that year's Salon, voted by its jury of bemedaled, decorated, and Academic artists, went not to Bouguereau, whose *Homer and His Guide* (Figure 9) would surely have been the choice of the traditionalists, but to Gérôme for *L'Eminence grise* (Figure 10), an anecdotal genre painting that carried a moralizing legend: "And when the courtiers greeted him, he pretended he was reading his breviary and did not notice them." The painting soon became one of Gérôme's best-known works, but the award of a medal of honor for a genre painting was just as scandalous in 1874 as it had been in 1868. Stung by the ensuing criticism, Gérôme refused his medal, and when the jury would not take it back, he donated it to the student fund at the Ecole des beaux-arts.[53] Modernist artists' problems with the Salon are legendary, but examples such as this demonstrate what so provoked the aesthetic conservatives' deep-seated enmity toward that exhibition.

The following year, 1875, the liberal Republican Henri Wallon, recently appointed minister of public instruction, appropriated Chennevières's commission, then renamed it the Conseil supérieur des beaux-arts and made it directly responsible to himself.[54] He enlarged and strengthened the conseil and turned over to it many of what had been Chennevières's own functions. The new group began meeting monthly to decide on exhibitions, competitions, national manufactures, and educational policy in the fine arts, and it even established the regulations for each Salon, something that had always been the prerogative of the fine arts director.

49

7 Pierre-Adrien-Pascal Lehoux, *St. Laurent, Martyr,* 1874. Destroyed, formerly at Musée de Nîmes. Salon of 1874.

Over the next several years, the conseil was transformed into a large bureaucratic committee in which artists and even Academicians were vastly outnumbered by government functionaries.

Although originating in the Academy, the conseil gradually usurped its role as a state agency of the fine arts. There is a striking parallel here to the history of monarchism during the same years, for the fatal fragmentation of the royalists and the impossibility of a restoration was provoked by the refusal of the legitimist pretender to the throne, the comte de Chambord, to compromise on the question of the French flag by accepting the *tricolore* as the price of his accession to the throne. In art, the intransigence of both the legitimist Chennevières and the no-less conservative Academicians provoked a crisis from which emerged a vastly strengthened bureaucratic government body, the Conseil supérieur des beaux-arts. The conseil, proving itself more adaptive, survived the period of moral order, just as the Opportunist Republicans did on the national stage.[55]

8 Claude Monet, *Impression, Sunrise*, 1872–73, 0.48×0.63 m. Musée Marmottan, Paris. First Impressionist Exhibition, 1874.

9 William-Adolphe Bouguereau, *Homer and His Guide*, 1874, 2.09 × 1.43 m. Milwaukee Art Museum, Layton Art Collection. Salon of 1874.

It was from the Conseil supérieur des beaux-arts that the first official proposal for a bicameral exhibition system emerged in 1875 when, charged with setting the regulations for the 1876 Salon, it abruptly voted instead to suppress the Salon permanently and replace it with a triennale exhibition "to elevate the level of art," according to Henriquel-Dupont, the Academician who had instigated the move. A furor in the press resulted in the maintenance of the Salon, but at least in principle, an elite quinquennial exhibition was established.[56] The decision was left unimplemented for several years, but an 1883 government memorandum stated:

Since its creation in 1874, the Conseil des beaux-arts has not ceased to propose at every opportunity that the fine arts exhibitions organized by the state take place only at fixed intervals several years apart and that they include only choice works completed during a determined period, without limits on the number for each artist and without another purpose than that of establishing the highest level of national production and of offering an instructive example of public taste.[57]

In 1878, at the close of that year's Universal Exposition, the conseil again took up the question of the Salon. The participants in this discussion were identified as Guillaume,

10 Jean-Léon Gérôme, *L'Eminence grise,* 1873, 0.685 × 1.01 m. Bequest of Susan Cornelia Warren, Museum of Fine Arts, Boston. Salon of 1874, Universal Exposition, 1878. "And when the courtiers greeted him, he pretended he was reading his breviary and did not notice them."

Delaborde, Cabanel, Lehmann, Henriquel-Dupont, and Cavelier, all Academicians.[58] The proposal was actually the work of Eugène Guillaume, director of fine arts, president of the conseil, Academician, and director of the Ecole des beaux-arts. Chennevières later claimed that setting up a two-tiered exhibition system had been Guillaume's *idée fixe* for years.[59] Jules Castagnary, who himself was director of fine arts in the Republican 1880s, described Guillaume in *Le Siècle,* a leading Republican journal: "An aristocrat in the bosom of a democracy, a clerical in a Republican ministry, he was above all the protégé of the Institute, the detractor of free art, the apostle of academic mediocrity."[60]

The minister of public instruction, Agénor Bardoux, summarized Guillaume's proposal in his subsequent *Rapport au Président de la République française:*

The Conseil supérieur . . . feels that it has found the solution [to the problem of the Salon] in the organization of two series of expositions: (1) annual expositions or Salons and (2) triennial or recapitulative expositions. The former would be, as it were, expositions of artists, and the latter, expositions of art. In the first, access would be from now on openly granted to all talents by a jury freely and entirely elected, and the state would gradually turn over its administration to the participants. There we would witness each year the free expansion of national art in the countless varieties of its most recent productions. In the second, for which the administrative operations would be confined to a jury composed of predetermined elements, we would find at regular intervals a select assemblage of works, most of which already had been submitted to public judgment. The ensemble would show the highest level of contemporary production and at the same time the progress made over a certain number of years.[61]

In response, President MacMahon decreed that henceforth there should be two types of exhibition, annual Salons and Triennales, that both should open on May 1 in the Palais de l'Industrie (always renamed the Palais des Champs-Elysées for art exhibitions), and that the first Triennale should take place in 1881. Its jury would be half elected by Academicians and decorated artists and half appointed by the government. Whereas the Salon only permitted two works per artist, at the Triennale they could show an unlimited number. And as prizes, there would be six medals of honor.[62]

MacMahon's decree represents the only successful proposal for a major reorganization of the state's exhibition system in the nineteenth century. Ironically, this proposal to increase the number of official Salons proceeded from the moral order governments of the 1870s, whose art administrators regarded

the Salon as, at best, a necessary evil, a menace to the lofty mission of art. Despite this, it is doubtful if even the Second Coming was ever as anxiously and eagerly awaited as this return to order in the fine arts, symbolized, most of all, by the projected Triennale Exposition.

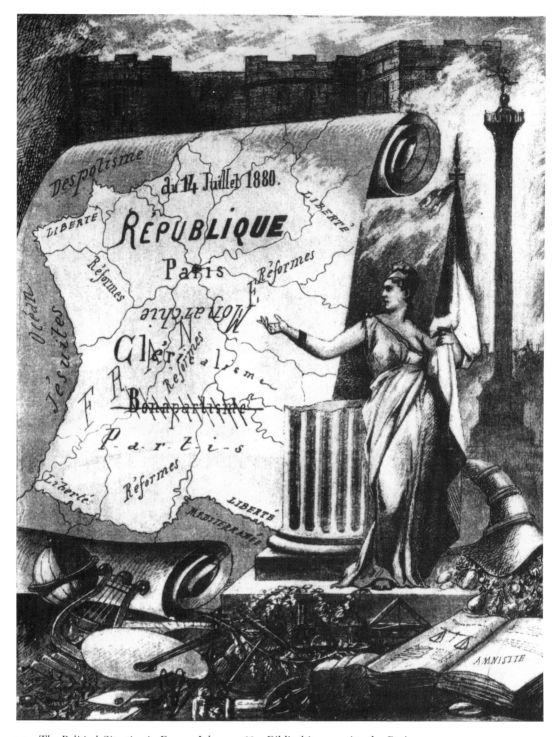

11 *The Political Situation in France, July 14, 1880.* Bibliothèque nationale, Paris.

NATIONAL EDUCATION AND INDUSTRIAL PROSPERITY

Perhaps never before has everyone talked about the fine arts in France as much as during the year 1881. The legislature, the press, even the public, everyone is preoccupied by the subject with an interest stimulated much less, it is true, by pure artistic sentiment than by political passions.

Victor Champier, 1882[1]

IN the early years of the Third Republic, the fine arts administration was evolving at the same time as was the nation as a whole, and with many of the same problems. The "dance of the ministers" that afflicted the central government during these years, with the constant attempts to form viable cabinets and the shuffling of offices and ministries, was also felt in the art administration, in which there were five ministries in the four years from 1878 to 1882, each with its own program and personnel (Figure 11).[2] Although the government as a whole moved steadily toward Republicanism in the 1870s, the fine arts administration during these same years remained closely allied with the Academy, monarchism, and clericalism. Historians usually point to the army as the last bastion of conservatism in France; we might suggest the fine arts administration as another candidate for the same honor.

After the 1876 elections, the Chamber of Deputies for the first time had a Republican majority. In 1879 when the elections for the Senate also resulted in a Republican majority, MacMahon was forced to resign as president, bringing to a close the period of moral order governments. The Republican Jules Grévy was elected in his place, and he chose the reformer Jules Ferry as his minister of public instruction. On the same day, Ferry appointed Edmond Turquet as his under secretary of state for the fine arts, a position that assumed precedence over the director of fine arts.[3] The Academician

Guillaume, with his *idée fixe* of establishing an elite Triennale to replace the Salon, departed, and the arts administration was finally in Republican hands.

During the 1870s, Republicans tried to define their art program.[4] Though it was generally accepted that art should be didactic and should educate, elevate, and refine the taste of the nation, a second Republican imperative called for rationalizing all areas of production in terms of laissez-faire economic principles. The Republicans, for example, opposed the huge state monopolies favored by the Orleanists, and if the railroads were one example of this type of monopoly and privilege,[5] the government-sponsored Salon with its jury of *privilégiés* was surely another. Nonetheless, reforming the Salon to be more Republican (i.e., democratic), however worthy a goal in principle, would effectively counteract the first part of the Republican program, the use of art as a tool to elevate and educate. An open Salon would be controlled only by the market system, and artists would exhibit there only what they could sell.

This contradiction was at least partially resolved by instituting large-scale decorative projects for public buildings that would encourage artists to produce the kind of uplifting, moral art considered worthy of a great nation. Because Blanc had been handicapped by the impoverished state of the budget following the Franco-Prussian War in addition to his own preoccupation with his Musée des copies, Chennevières was the first fine arts director to make these public works projects a priority.

In 1874 Chennevières proposed a major project for the redecoration of the Panthéon,[6] and in 1878 he proposed a vast decorating scheme for all public buildings throughout France. Departmental prefects were instructed to survey the public monuments within their jurisdiction and identify those for which government decorative commissions would be most appropriate.[7] As a result, during the early Third Republic there were major projects in Lyon, Amiens, Toulouse, and Rouen, to name just a few. Paris, with combined state and municipal patronage, had many monumental projects: at the Archives nationales, the Opera, the Sorbonne, the Petit Palais, the Hôtel de ville, and numerous *mairies*.[8]

Because a main Republican concern was to establish a secular state, the use of government funds for religious art – as in the decoration of the Panthéon, then Ste-Geneviève – was increasingly challenged, and in 1878 the Republican-controlled Budget Committee attempted unsuccessfully to reallocate

funds designated for church decoration to city halls and courthouses.[9] In 1881 the Budget Committee did reserve commissions exclusively for secular edifices, noting with satisfaction that "the majority of the subjects given to artists have been borrowed from our national history" (Figure 12).[10] So extensive was the scope of monumental decorative projects in France from 1870 to 1914 that Pierre Vaisse labeled it "the last great epoque of monumental painting in Europe"; measured quantitatively it certainly was that.[11]

But interest in such projects was not limited to partisans of the Grand Tradition. In 1879 Manet proposed to the prefect of the Seine that he be commissioned to execute a series of subjects for Paris's Hôtel de ville. His projected decorative cycle, *Le Ventre de Paris,* included allegorical figures of the wines of France and outdoor scenes of markets, ports, railroads, and gardens, a spectrum of subjects representing contemporary life.[12] Manet's project was strikingly similar to that of the painter Claude Lantier in Zola's 1886 novel *L'Oeuvre,* who conceived, but could not finish, an immense allegorical picture of Paris. Like many artists, Claude ended up painting "little flower pictures for export to England to earn enough for daily bread."[13] Although in his memoirs Chennevières claimed to have considered commissioning Manet for one of his decorative projects, in fact such work went mostly to official painters such as Henri Lévy (Figure 12) or to Academicians like Paul Baudry (Figure 13).[14]

Despite the attention given to such projects, few of the thousands of artists exhibiting at the Salon could be expected to benefit from these commissions; instead, most needed to sell their work to survive. Consequently, most of what was exhibited in the Salon fell into the lower categories of

12 Henri Lévy, *The Coronation of Charlemagne,* 4.60 × 2.785 m; 4.60 × 3.415 m; 4.60 × 2.785 m, Panthéon, Paris. Expositon national triennale, 1883.

13 Paul Baudry, *The Glorification of the Law*, 6.10 × 4.70 m, ceiling for the Cour de cassation, Palais de Justice, Paris. Salon of 1881, Exposition nationale triennale, 1883.

art – landscape, genre, and still life – small works like the little flower paintings of Claude Lantier that flooded the commodity market. The works so scorned by conservatives for "holding a place in the commercial and economic statistics of our country"[15] were precisely these small works of painting and sculpture, not the large machines that could scarcely exist without government subsidy.

Economically, the Salon represented a sizable French industry of small independent producers, typical of the strata which supported the Third Republic. From this point of view the government owed these artists some economic support, whatever the didactic import (or lack thereof) of their productions. This, of course, was exactly the dilemma that had bedeviled the Salon system since 1791, the contradiction between art as merchandise, "pictures to sell," and art as education, "pictures to see." The Salon system thus presented a problem for idealistic Republicans, torn between economic rationalism and their devotion to state-sponsored public works projects.

Neither the Academy nor the monarchists cared much about the economic problems of small producers, whether artists or shopkeepers, and so their aesthetic program, though calling for government support for Academicians (another type of monopoly), did not deal with the material problems of the independent artists. The Republicans, however, were forced to consider both groups, although the demands of these privileged artists often precluded the welfare of the rest.

It was Jules Ferry, better known for his campaign to secularize French education, who disengaged the fine arts administration from this dilemma in the years from 1879 to 1881. A change of agenda was immediately apparent when shortly after assuming office, he spoke at the 1879 Salon awards ceremony. The previous minister of public instruction, Agénor Bardoux, had in 1878 extolled traditional values: "The more our democracy elevates itself and becomes enlightened, the more our Republican institutions expand, and the more, in our aspirations, the worship of the beautiful in all its forms must maintain the highest rank."[16]

In its praise for beauty, the special province of the Academy, Bardoux's message differed little from previous official proclamations. Ferry, however, immediately attacked the Academy as despotic: "The Institute conceived the plan to force all of French art to submit to its discipline and to obey its rules. To this end, the learned society set itself up as the vigilant guardian of the doors of the Salon."[17] And then he

actually listed past Academic sins, an unthinkable act for a government minister in previous regimes. Academic juries had rejected Rousseau, Delacroix, Daubigny, and Corot, he noted, and yet today they all were recognized as great artists. Accordingly, "liberty in art" would be the new Republican program. "Contemporary art is at the same time very strong and absolutely individual," he stated. "It would be difficult to find in it any traditional schools or influences like those of years past. We might say that right now individualism overflows its banks."[18]

Even the Prix de Rome, though returned to Academic jurisdiction, would now be reformed according to more liberal aesthetic principles: The winners would no longer spend three years in Rome, seat of the Academic classical tradition, but would divide their time between Spain and Flanders as well.[19] Individualism and liberty would be key concepts in Republican aesthetics, and yet the program that Ferry set out, for the decoration of public buildings, creation of local museums, obligatory drawing instruction in the schools (already begun under Bardoux), and development of industrial art training all focused on the institutions rather than the aesthetics of art. He might be criticized for "emancipating the plebians of art,"[20] as one critic put it, but his reforms were actually directed more toward changing the public art system than either improving the lot of the masses of artists or creating a Republican aesthetic.

DRAWING AND DESIGN

During these years, the fate of the official Salon, where only the fine arts were shown, was inseparably bound up with the decorative arts and the question of *dessin* – the word in French signifying both drawing and design. For Republicans, there were three levels of artistic production. Most important were the monumental decorative projects of history painting that had received such great attention since the mid-1870s. These projects demanded major government funding but promised in return national glory and public education. Below that was the level of quotidian Salon production in the lower categories of art such as landscape and genre painting. As generations of conservative critics had pointed out, this level was adequately supported by the private sector of collectors and dealers.

Although the lowest level, in terms of prestige, had tradi-

tionally been that of decorative art – "art applied to industry," as it was often called – in terms of economics this was the most important area, the one most closely linked to national prosperity. Even during the Old Regime, France's major exports had been artisanal luxury goods; the efforts of the revolutionary period and a succession of subsequent regimes to replace them with mass production and heavy industry had been largely unsuccessful. These luxury goods, fashions, objets d'art, jewelry, and domestic furnishings, to name just a few, had been unrivaled throughout the world for their elegance, fine workmanship, and design until – and here all later historians agree – the 1851 Great Exhibition of Works of Industry of All Nations, in London, revealed the growing competition from other countries.

Léon de Laborde's thousand-page report on the 1851 event, *Application des arts à l'industrie*,[21] became the standard text on the subject, and for the rest of the century he was cited as the prophet of French decline in the decorative arts. Seeing the situation as the outcome of the suppression of the Old Regime's corporations by the Revolution, which had provided no replacement system of artisanal training, Laborde proposed a far-reaching plan for teaching drawing and design in all primary schools, establishing industrial art schools and museums, and even including such training at the Academy's elite Ecole des beaux-arts. His plan was repeatedly proposed during the next decades, with a greater and greater sense of urgency as each succeeding international exposition revealed both increasing foreign competition and diminishing French superiority.[22] By 1878, this disturbing new reality was incontestable, Antonin Proust told the Chamber of Deputies:

There is not one of us who was not struck on leaving the galleries of the 1878 Universal Exposition by the fact that there, where we previously had only imitators, today we find rivals. Especially in the productions of art applied to industry, which established and have maintained, until now, the incontestable superiority of our genius, that the progress of foreign nations is considerable, especially when compared with the Exposition of 1855.[23]

Virtually every jury report commented on the decline in France's decorative arts, to the extent that this became the paramount aesthetic issue of the 1878 Exposition, to the exclusion of all others, much as the acknowledgment of the international decline in history painting had characterized the 1867 Universal Exposition (Figure 14). So irrelevant to national policy had the fine arts become by 1878 that there was no official report devoted to the painting section of

the exposition, although the decorative arts merited several volumes.[24]

Articles in the press, including even art journals, pointed out that France's exports of art products had dropped from 35 to 16 percent of the total in the years from 1847 to 1868, whereas England's had remained steady at 28 percent.[25] Elaborate inquests were organized, statistics were gathered (Table 4), and reports were written on the causes of the current state of decline, which everyone agreed was attributable to the lack of decorative art museums and professional design schools.[26] Such institutions had recently been established throughout Europe, everywhere except in France.[27] Nikolaus Pevsner has observed that France's insistence on maintaining a strict separation and rigid hierarchy between the high arts and the decorative arts was the only aspect of its art system that was not widely imitated throughout the Western world.[28]

During the 1870s there was a constant stream of articles on foreign nations' progress in establishing such schools and museums for the decorative arts, the most illustrious of which

14 French Decorative Arts Display. From 1878 Universal Exposition, *L'Album de l'Exposition 1878,* Bibliothèque nationale, Paris.

Table 4. *Decorative Art Exports from France, 1873–81.* From Marius Vachon (1882).

DESIGNATION DES MARCHANDISES	1881	1880	1879	1878	1877	1876	1875	1874	1873
	mille francs	mille francs	mille francs	mille francs	mille francs	mille francs	mille francs	mille francs	mille francs
Tissus de soie et de bourre de soie. .	233.732	234.279	226.775	252.934	259.201	295.671	375.665	414.900	477.688
Tissus de laine.	382.984	370.226	309.297	312 808	325.130	316.446	346.392	328.024	325.918
Tissus de coton	92.617	79.115	63 387	26.498	62.150	66.400	81.526	72.842	77.053
Tissus de lin ou de chanvre.	23.167	27.997	24.725	24.396	30.078	31.720	34.477	29.075	29.599
Tissus de jute	2.137	2.326	1.485	1 504	1.000	722	1.397	985	1.469
Ouvrages en peau ou en cuir.	176.399	163.855	148.251	160.301	151.295	157.491	173.314	147.200	135.916
Nattes,tresses et chap.de paille et d'écorc.	16.077	16.358	16.610	24.469	21.359	25.842	22.391	17 223	17.632
Chapeaux de feutre, de laine et de soie.	10.223	¦9.052	10.117	11.379	12.120	10.637	9.839	9.270	11.019
Orfèvrerie et bijouterie.	59.201	54.648	50.216	59 067	63.282	53.530	60.521	49.745	50.483
Horlogerie.	16.308	17 058	15.670	16.934	16.655	17.330	17.968	17.446	16.875
Coutellerie.	2.976	2 909	2.613	2.784	2.649	2.783	2.779	2.862	2.611
Armes.	5.179	8.505	6.390	4.073	4.378	5.086	13.358	11 377	5.812
Carrosserie.	3.841	3.104	2.889	2.716	3.708	5.161	4.305	6.743	8.776
Tabletterie, bimbeloterie, mercerie et boutons	144 736	148.572	135.722	143.282	141.544	153.730	159.852	159.481	153.222
Modes et fleurs artificielles . . : . . .	45.003	32.436	30.113	30.255	36.678	35 804	42.189	34.890	37.486
Meubles et autres ouvrages en bois..	32.723	33.506	30.062	27.096	26.864	28.786	28.649	30.810	34.352
Parapluies et parasols.	2.351	2.868	3.391	3.207	3.627	·4.016	4.341	3.564	3.008
Instruments de musique	10.415	11.450	9.984	10.231	12.002	11.913	13.123	12.857	11.563
Confections (lingerie et autres).	99 427	80.340	67.745	74.790	86.503	90.749	86.055	70.549	89.152
Articles de l'industrie parisienne. . . .	2.444	10.520	6.157	5.843	9 316	9.990	8.559	11.130	10.096
Objets de collection, hors de commerce.	12.555	13.964	12.346	10.430	15.595	11.670	17.548	15.915	18.098
Livres, gravures et lithographies. . . .	27.941	28.063	23.899	22.792	24.359	23.093	24.656	21.003	23.234
Papier et carton	25.230	25.119	22.142	23.848	26.326	30.585	31.727	28.973	27.996
Faïence et porcelaine	12.487	13.119	12.904	13.510	12.608	15.425	16.904	14.397	15.594
Glaces	4.160	5.003	5 527	5.377	7.782	7.209	8.540	8.945	8.158
Verres et cristaux	22.624	13.195	19.753	24.446	26.107	31.001	34.582	32 693	34.827

– to the French, anyway – was England's South Kensington Museum (now the Victoria and Albert), whose annual subsidy was rumored to be four times France's entire fine arts budget.[29] At the inauguration of the new Berlin museum of decorative arts, the German prince imperial was even quoted as declaring, "We have defeated France in 1870 on the battlefield of war; we want to defeat her today on the battlefield of commerce and industry."[30] The only European countries besides France that lacked obligatory drawing and design instruction were Italy and Spain, old southern Mediterranean countries steeped in classicism; in relation to the rapidly industrializing North, these countries seemed hopelessly backward.[31]

In Gambetta's short-lived 1881 government, the arts administration was reorganized and became a separate ministry, the Ministry of Arts, with Antonin Proust its first – and only – minister. In proposing this change, Gambetta emphasized that the 1878 Universal Exposition had incontrovertibly exposed France's decline in the decorative arts. The new ministry, he hoped, would organize drawing and design education "to develop this broad teaching of the general principles of art that our great industries are demanding."

In our modern societies, it is not enough to develop taste and knowledge of the fine arts. The assistance that art can give to industry has considerable importance from an economic and social point of view, as it transforms the conditions of work and exercises a decisive influence on the productive forces of the nation.[32]

Antonin Proust entered modernist art history as the friend, schoolmate, and biographer of Edouard Manet (Figure 15), for whom he even arranged a decoration in the Légion d'honneur. And yet Proust holds a far more influential position in the history of the decorative arts than in the fine arts, for he worked tirelessly to establish a decorative arts museum in France, assuming, from 1881 to 1889, the presidency of the Union centrale des arts décoratifs, founded to lobby for such an institution.[33]

The museum actually opened in 1879 in temporary quarters in the Louvre. Its first exhibition was of sketches for monumental decorative paintings in public buildings, thus symbolically bringing together the two levels of art production stressed in the Republican program, monumental decoration and decorative arts.[34] The following year Rodin received his first government commission, for the doors of the new museum, the never-completed *Gates of Hell* (Figure 16).[35] The same year that Rodin began this project, 1880, also saw the establishment of the elegant *Revue des arts décoratifs* and the inclusion of decorative art "by popular demand" in Charles Blanc's course on aesthetics and art history at the Collège de France, where it joined the more traditional subject of Italian Renaissance art.[36]

Nonetheless, despite the importance of the decorative arts during this period, the odyssey of the attempts by the Musée des arts décoratifs to find permanent quarters and government support, successful only in 1905, amply illustrates the tenacity of the hierarchical ranking of French art. Even today, the Musée des arts décoratifs has an equivocal status; unlike other national decorative arts museums and unlike French fine arts museums, it is administered not by the state government but by a private agency, the Union centrale des arts décoratifs.[37]

In 1878, when drawing and design were made compulsory in primary and secondary schools in France, the state hoped through this measure to stimulate the economy by improving the quality of its export trade.[38] Academicians and aesthetic conservatives in general supported it for another reason: They hoped it would restore Academic values, thereby reducing the pool of artists in the lower categories of art by

15 Edouard Manet, *Portrait of Antonin Proust,* 1880, 1.295 × 0.959 m. Salon of 1880. Toledo Museum of Art, Ohio.

16 August Rodin, *The Gates of Hell,* 1880–1917, 6.80×4.00×0.85m, Rodin Museum, Philadelphia, gift of Jules E. Mastbaum.

funneling them into the decorative arts instead. Although the Academy feared that mixing art and industry would lead to a lowering of standards, it had no objection to a program of decorative art training, provided that it was kept separate from the high art instruction it wanted maintained in its purity, "without venal preoccupation, without ulterior motives."[39]

Partisans of the Grand Tradition saw a connection between the deterioration of French standards in the decorative arts and the dilution of the classical ideal by the majority of Salon exhibitors, "a mob of young people throwing themselves passionately into a career which has become lucrative and producing, year in, year out, pictures and statues by the thousand," as Léon de Laborde described them.[40] "An experienced administration would probably have been able to turn this general disposition of the public and this influx of talent to the profit of the applied arts," he felt.[41]

His point was taken up repeatedly. In 1870 Charles Blanc even suggested that if the Salon were dropped, the resulting savings could be used for drawing and design instruction. This in turn, he believed, would eventually improve France's export trade in industrial products.[42] The same year, Charles Clément wrote, "We are encouraging, for better or worse, a legion of mediocre painters and sculptors who should, rather, be discouraged and who would find in the industrial arts a useful employment for their artistic impulses."[43] In 1877, when France's only school for the applied arts, the Ecole de dessin et de mathématiques, was renamed the Ecole des arts décoratifs, its director Louvrier de Lajolais wrote to the minister of public instruction that the previous state of contempt for the decorative arts had resulted:

in a real depreciation of my school which is only the "petite école des beaux-arts," a nursery for young people who have no other intention but to prepare themselves with us for their eventual success in the rue Bonaparte [i.e., the Ecole des beaux-arts] and who, apart from some extraordinary individuals, form a battalion of mediocre artists, living off the charity of your administration, when they could be the skillful and well-paid servants of industry.[44]

Finally, on the occasion of the 1889 Universal Exposition, an account of the effort to establish drawing and design in the curriculum noted:

The preoccupation, very noble in principle, of encouraging higher aspirations on the part of the masses who are unaware of their real abilities has, on the contrary, if it is exaggerated to the detriment of studies necessary to all, the very great drawback of provoking a deplorable displacement by directing toward an artistic career many

mediocrities stricken with the "malady of the Salon" who are becoming a social problem because they are not productive.[45]

The program of drawing and design instruction for the lower classes was social engineering that had originated during the revolutionary period. Later Republicans invariably cited Talleyrand as the first to suggest such a program in 1791, but he was very clear about wanting this instruction at the primary level because for most children this would be the extent of their formal education. Such instruction would be necessary, he wrote, "to give them an accurate eye, a sure hand, and good habits, for these are the elements of all the trades."[46] Eugène Guillaume, Academician and director of the Ecole des beaux-arts, as well as the prime mover behind the Third Republic drawing program, described the aim of the training he envisioned as "preparing children to be intelligent and skillful workers, useful to society and to themselves."[47]

Drawing was the backbone of classical art instruction, and through Guillaume's influence the basic drawing method taught in French schools became line drawing, always the traditional Academic training. Lecoq de Boisbaudran's system, taught at the "petite école" and based on memory and expression, was rejected, and geometric drawing (Figure 17) became the basis of what was known as the Guillaume method.[48] According to its creator – and this had long been Academic dogma: "Geometry, in teaching us that surfaces and solids are defined by lines, gives us the clearest and most complete idea of drawing, which resides in contours."[49]

Geometric and linear drawing for the working classes, however, in no way challenged the hegemony of figure drawing for the "higher sphere" of art production.[50] Although geometry was the basis for the introductory drawing curricula, more advanced students were rapidly inducted into the traditional Academic vocabulary of antique and Renaissance models.[51] The upper classes, Guillaume felt, did not even need drawing instruction: "It is through the level of their ideas and not through the vain talents of *amateurs* that the kind of superiority suitable to the upper classes in society ought to be established."[52] Presumably they were to attain their level of ideas through courses such as Charles Blanc's in art history and aesthetics at the Collège de France. Guillaume was Blanc's successor there.[53]

Whatever economic basis for support the Third Republic's program of drawing and design instruction enjoyed among Republicans, it was supported and directed by Academicians

for two completely different reasons: First, it would be a means of narrowing access to the overcrowded field of high art production through social engineering, which would be to the advantage of the Academicians, and second, it would provide a means of restoring Academic aesthetic hegemony through the imposition of its preferred drawing style based on line and contour.

By 1880, then, various coalitions and special interest groups

17 *Triangle. Application and Borders.* From V. Darchez, *Nouveaux Exercices de dessin à main levée d'après les derniers programmes officiels. Cours elémentaire, troisième cahier,* Paris, 1883. Bibliothèque nationale, Paris.

across the aesthetic and political spectrum had succeeded in establishing, in uneasy equilibrium, the major programs of the "Republic of the arts." Maurice Agulhon defined the two guiding concepts of the Third Republic as *la patrie,* nationalism, and *le peuple,* the working classes.[54] We might see the extension of these concerns into the "Republic of the arts," whose two major programs included, as nationalism, the monumental decoration of public buildings throughout France, and, for the working classes, a program of obligatory drawing and design instruction to improve industrial art production. Could there be, in this program, a place for the Salon? The program inherited from the moral order governments of the 1870s for its bicameral reorganization along the same lines of education and commerce would probably have been carried out as scheduled, with the Triennale and the annual Salon on view at the same time in 1881, had not all the long-simmering Salon conflicts erupted in the intervening period.

The opening battle was fought over the installation of electric lights in the Salon. Electricity was still new in France. Although it was not installed in department stores until 1880, from 1877 on there had been experiments with electric lighting at the Salons.[55] In addition to its advantages in both safety and cleanliness, electricity symbolized modernity, particularly as it had recently been installed in the British Museum.[56]

In 1879, the year of the Republican accession to power, Turquet decided to have the Salon electrically lit so that workers could attend in the evenings (Figure 18). Posters advertising the Salon of 1880 announced in big red letters that it would be open every night, illuminated with electric light.[57] The innovation was a popular success, and attendance rose 155,000 over the previous Salon, to 683,000.[58] Not everyone was pleased, however. Jules Claretie wrote sarcastically that when the charms of music were added to those of electric light, an evening's entertainment at an exhibition might even replace a night out at the Folies Bergère. He described the elegant crowd emerging from an evening at the Salon cooing with pleasure over the innovation, and the negative reaction of an old painter watching them.[59]

The issue of electric lighting immediately became politicized and was even discussed in the Chamber of Deputies. The Right was against this and any other innovation that threatened the "aristocratic" tone of the exhibition, and a deputy on the Left reminded them that "everybody comes to the Salon at night!"[60] Artificial lighting was not exactly revolutionary in art exhibitions by this time. The Impressionist

18 Léon Du Paty, *At the Salon, Evening,* 1879, Bibliothèque nationale, Paris.

exhibitions beginning in 1874 always remained open in the evenings, and by 1880 the new Musée des arts décoratifs had installed electric lighting.[61] *Le Charivari* even claimed that the 1880 Salon had actually been improved by the innovation.[62] Nonetheless, what was standard practice in the new and more entrepreneurial arenas of the art world was still shockingly controversial in more traditional ones such as the Salon, and so the artificial lighting became a *cause célèbre*.[63]

Turquet's Salon reforms were not limited to the lighting, however; he also expanded the electorate for the jury. Since 1872 one-fourth of the members had been named by the administration, and three-fourths had been elected by the "exempt" artists (Academicians, Prix de Rome winners, those holding medals or decorations). With Turquet's reforms, beginning in 1879 the electorate would include all artists who had been in three Salons. The result was that instead of 711 electors for the painting jury, there immediately were 2,219.[64] The next year, 1880, Turquet instituted two separate painting juries, one for history and figure painting and the other for the lower categories, genre, landscape, and still life. He also did away with the alphabetical installation that had been standard since the 1860s, instituting instead several innovative exhibition sections in an attempt to give some coherence to an exhibition that all agreed was chaotic. There would be sections for foreigners, for those hors concours for prizes, for those exempt from jurying, and, the biggest section of all, for French artists who were not Academicians and had never received medals. Since the 1857 restoration of the Academic jury, government commissions to decorate public edifices had been listed in the Salon catalogues; Turquet arranged for the sketches and models for these projects actually to be exhibited in a special section. Conservatives had been criticizing the Salon for decades as encouraging only small salable works; Turquet's gesture toward the Grand Tradition now signaled the confluence of Republican and Academic aesthetic goals. Drawings, watercolors, pastels, lithographs, and engravings, as well as architectural studies would each have separate galleries instead of being installed in the corridors, where they were customarily crowded together. Within each section Turquet planned to create what he called "sympathetic groupings," namely, artists who seemed to work in a similar style.[65]

Even though most of the 1880 juries and critics liked his reforms, the painting jury did not, even trying to cancel the contract for electric lighting. From then on, the situation

deteriorated.[66] First Bouguereau and then Baudry, successive presidents of the painting jury, resigned;[67] then the jury accepted over seven thousand works, making it the largest Salon ever held in France (Tables 1 and 3). There were more works than could possibly be accommodated in the space available. Additional galleries had to be constructed at the last minute, and some of the works even had to be put in an exterior portico surrounding the garden of the Palais de l'Industrie.[68] When the show opened, the works of the privileged artists were hung at eye level in a single row, and the thousands of works by nonprivileged artists were crowded into floor-to-ceiling installations, which made "sympathetic groupings" all but impossible (Figure 19).[69] Zola claimed that the best thing about Turquet's installation was that it had become impossible to ignore the numerous dreadful works among the exempts that were usually lost in the confusion but were now so splendidly installed that in the future – and he proved to be right – the system of exemption would have to be suppressed.[70] Cartoonists had a field day, particularly on the subject of "sympathetic groupings" (Figures 20 and 21).

Despite the levity, however, Turquet had taken a major step in recognizing that the world of contemporary art had become so complex that any large exhibition had to be broken down into subcategories in order to be visually coherent. Renoir and his friend Murer, for example, published a revision of Turquet's schema into four categories: Academics and bemedaled artists, foreigners, Idealists, and finally Naturalists and Impressionists.[71] Although Turquet's categories were debatable, his principle proved sound. The sensation caused by "sympathetic groupings" can be understood only in the context of a world that was just beginning to recognize the validity of stylistic diversity in art. An earlier age had referred simply to the "French school," with the benign assurance that it was unitary and above reproach. Turquet in 1880 was attempting nothing less than the institutionalization of style as a variable artistic category, alongside the more traditional ones of history, portraiture, genre, landscape, and still life.

In response to the furor, Turquet claimed that the attacks on his policies had begun the day he tried to apply Republican principles to the fine arts administration. The painting jury was anti-Republican, he charged, and was attempting to embarrass the government. *Le Journal illustré* agreed, publishing a full-page reproduction of Angelo Francia's sculptured bust of the Republic. Bought by the government as a model for works to be placed in city halls and public buildings, it

had been rejected by the Salon jury.[72] Turquet pointed out that all the protesting jurors were members of a committee "for the profit of Christian schools." Because the fine arts administration was part of the Ministry of Public Instruction, an attack on one, he charged, was an attack on both.[73] In defense, Baudry wrote an open letter to the press, widely published, explaining that the jurors had donated works to a sale for the benefit of Christian schools purely as an act of charity. They did not know, he protested, that their names would be used for political purposes.[74] This explanation was greeted derisively in Republican circles. Would the offending

19 Pif, *Croquis.* "At the Salon. A painter whose work is badly placed installs a telescope so that art lovers can see his picture for two sous . . . which he gives them." *Le Charivari,* May 23, 1880.

20. Pif, *Croquis.* "At the Salon. 'Mister Guardian, please, where is the gallery of naked ladies?'" *Le Charivari,* May 23, 1880.

76

jurors have been so generous if the sale had benefited the communards amnestied in 1880 instead of Christian schools? asked *Le Rappel,* which concluded that in view of the well-known reactionary politics of some of them, such a possibility would be extremely unlikely.[75] Would these jurors ever have donated their work for the benefit of secular education? asked *Le Charivari,* just as skeptically.[76] And how could the jurors, most of whom had served before, accept seven thousand works without realizing that there was simply no room to exhibit that many? "In the face of their explanations," *Le Charivari* commented, "we are forced to conclude that the gentlemen of the jury, if they did not act from malice, acted with a most extraordinary incompetence."[77]

The debate over religious education was no trivial issue: A major Republican program, which Ferry was at that time trying to implement, was to take away the nation's educational system from the Catholic church, which not only

21 Cris, *Actualités.* "Current Events. At the Salon. Corner of the garden (all the way in the back to the left), where you can always be certain of finding a sympathetic grouping." *Le Charivari,* May 13, 1880.

controlled most of the schools but also openly preached the values of monarchic over Republican forms of government.[78] At no time in the century was the issue of religious control of education so incendiary as in 1880 during the Salon jury deliberations when the two branches of the legislature, the Senate and the Chamber of Deputies, were, along with the Cabinet, locked in rancorous debate over the provisions of a new education bill (Figure 22). During the Salon itself, the Jesuits, the most influential teaching order in France, were

22 *Truly Secular Education*. "Marianne's Dictation. . . . At this moment, comma, the young officer, comma, enters the bedroom of the countess, period . . . next line." *Le Monde parisien,* August 21, 1880.

23 Philo, *The Jesuits' Lament, Le Lyon républicain,* 1880, Bibliothèque nationale, Paris.

expelled from the country, and two hundred magistrates resigned in protest (Figure 23).[79]

So acrimonious did the Salon debate become that Turquet was even summoned before the Chamber of Deputies for an *interpellation* in which he had to defend his policies. This attack was instigated by what *Le Charivari* called "the three groups in the Chamber that are not at all sympathetic group-ings," namely, the three monarchist parties, the legitimists, Orleanists, and Bonapartists.[80] The attack was led by the Bonapartist deputy, Robert Mitchell:

I understand that the under secretary [Turquet] might want to democratize the arts, that he might want to apply the principles of 1789 to the organization of the painting Salon. But may I be permitted to tell him that he has taken the wrong path; art is an aristocracy, an aristocracy so much the more legitimate as it owes nothing to birth. Merit and quality of the work alone mark the places and determine the hierarchy.[81]

The transcript adds here, "applause from the Right." Politi-cal and aesthetic sentiments were similarly conflated in Rob-ert Mitchell's comparison of independent artists at the Salon with the "new social strata" [*nouvelles couches sociales*], those new members of the middle classes hitherto excluded from power and prestige. This attack had political overtones, for the term *nouvelles couches sociales* was always identified with the radical Republican Léon Gambetta, their defender. This was the "Léon" caricatured in Figure 22, whom the benefi-ciaries of secular education worshiped instead of God.[82] The *interpellation* transcript quotes Robert Mitchell as saying (and I quote the passage in its entirety):

The Revolution has happened, and the new strata have invaded the exposition (derisive comments from the Left), and the pressure from the bottom upward is such . . . (From the Right – Very good! Say it!) that little by little the great names of painting have been pushed out of the catalogue and are staying away from a Salon that is noth-ing more than a public gathering, a club (shouts and laughter from the Left and Center).[83]

To this the Republican Edouard Lockroy, who was the min-ister of public instruction in the 1880s, shot back: "So that's your attitude toward universal suffrage," and Paul de Cas-sagnac, another notorious Bonapartist, responded, "No one will be able to paint except in red!"[84] Turquet, meanwhile, gave an interview to *Le Gaulois* in which his opening state-ment was the following: "Now that the Republic has been well established in the state, why doesn't the state establish the Republic in the arts? So, then, the issue is to transform

the organization of the Salon.''[85] Conservatives charged he did this through an *épuration,* a political purge, in which twelve out of twenty administrators were fired, retired, or forced to resign.[86] So extreme had the situation become that the awards ceremony which traditionally followed each Salon was canceled in 1880.[87] Amid the charges and countercharges, one thing was certain: There was no way the art system as it was constituted could continue to function. Could there even be a Salon in 1881?

Despite the turmoil in the art world, in the larger world of politics 1880 was a year of pacification. The amnesty extended that year to the last of the exiled communards seemed to mark both an end and a new beginning in French politics. Not just in art was liberty proclaimed a guiding Republican principle: Laws were passed guaranteeing free association, permitting labor unions, allowing public meetings to be held without advance permission, and establishing freedom of the press. All of this liberalization proved a necessary underpinning for the successful resolution of the Salon crisis, for in the months following the 1880 Salon, artists formed groups, met in caucuses, and discussed the crisis of the Salon.[88]

The Conseil supérieur des beaux-arts discussed the problem repeatedly in late 1880, entertaining two alternative propositions: either to continue making broad reforms in the Salon's organization or to abandon it altogether. The Academy again recommended suppressing the annual Salon, complaining that it tempted young Prix de Rome winners to think more about the Paris exhibition than about antique art and thus was jeopardizing the future of the French school.[89] Following a proposal by Antonin Proust (who succeeded Turquet as fine arts administrator), major changes were accepted in the regulations for the 1881 Salon. As Zola had predicted, the privilege of the exempt classes was to be abolished, and all work would have to be submitted to the jury. Accordingly, the limit of two works per category could be lifted; the limitation had been necessary only because the exempt artists had flooded the Salon with their works, leaving little space for anyone else. Proust even managed to have the regulations establish a new section for decorative art, which had rapidly become an area of major Republican concern.[90]

Proust's proposition was fiercely opposed by the Academicians led by Cabanel, Guillaume, and Henri Delaborde, the Academy's secrétaire perpétuel. As the Academy, from its beginning in the seventeenth century, had firmly set itself above artisans, it would naturally see in the inclusion of

the decorative arts in the Salon, once reserved for themselves, a further sign of the debasement of the fine arts. In any case, the regulations were never implemented because, within a few weeks of their adoption, Ferry himself – no doubt with Turquet's concurrence – decided to give up the Salon altogether and hand it over to the artists' complete control.[91]

Although it was widely understood by contemporaries that the conseil had decided to abandon the Salon because of the problems of 1880, in reality its members (other than the Academicians) seem to have been unwilling to give it up. It was the government administration itself that decided to abandon the Salon, providing an implicit answer to the question of what place commodity art production would have in the Republican program.[92] The fissure that opened up in this final debate on the Salon between the conseil and the administration grew wider as the issue of the Salon's replacement, the Triennale, took center stage.

An official arrêté convoked a meeting of all French artists who had exhibited at least once. On January 12, 1881, they were to meet to elect a ninety-member committee to decide the Salon's fate.[93] However, the government had already decided it, and so on January 17, Turquet announced to this elected committee that the Salon was being turned over to their control, leaving the state free to sponsor exhibitions of the best of several years' production.[94] The year 1880, then, marked a milestone in French cultural as well as political history, for this was the year that the state abandoned the fine arts exhibition that it had sponsored for almost two hundred years.

The second stage of the Third Republic's program of Salon reform can be related to the overarching desire in French politics at this time to compromise, if necessary, in order to have peace among the factions. We might note that 1880 is the date accepted by historians as the end of the return to order period of the Third Republic and the beginning of the reign of the Opportunists, as that group of Republicans was called who wanted peace and whatever reforms could be accomplished without civil disorder.[95] The year 1880 had brought many triumphs to the Republicans: the first successes of their program for "free, compulsory, secular education" with the expulsion of the Jesuits and the establishment of secondary education for girls; the establishment of July 14 as the national holiday; the amnesty of the communards; the passing of a press law abolishing "crimes of opinion"; and a new law allowing public meetings without official authorization. Only

in the world of art, it seemed, had the Republican program met disaster.

In art politics, the debacle of the 1880 Salon had taught a lesson to Republicans, one that the Second Empire had begun to assimilate in its last years. In 1868 Emile Zola wrote about similar problems with the Salon: "The administration will delay in vain, it will be forced, sooner or later, to reinstate the Academy or to throw the doors wide open."[96] He repeated these sentiments even more strongly in 1880: "We have to have either dogma, that is, the Institute, or complete liberty."[97] The moral order governments had tried to reinstate the Academy and establish strong centralized control; the Republicans had tried to liberalize the Salon. In both cases there had been protests, petitions, criticism, and recriminations; "You are absolutely ungovernable," Jules Ferry had told the artists in 1879.[98] In fact, each of the factions that made up the community of artists was so large, so outspoken, and so powerful – and so diametrically opposed to one another's interests – that no simple solution could be possible. "It would be an interesting history to write of the efforts the administration has made during the last twenty years to satisfy artists," Zola mused in 1880. "And the worst of it is that today there is still not a single person satisfied: We continually find, both among both those exhibiting and those refused, malcontents who demand new reforms."[99]

The Republicans did not want to risk continued turbulence in the fine arts, particularly as its ministry, public instruction, was preoccupied during these years with educational reform. After his disastrous experiences of 1880, Turquet now agreed with Zola: "Either the Salon must be completely under the control of the state, or it must be absolutely free."[100] Implementing the first possibility had proved to be both a thankless and an impossible task; now it was time to try "liberty," a solution that fit in well with the Republican program of divesting large monopolies and encouraging independent enterprises. Aesthetic conservatives could even make common cause with Republicans here, for they had wanted to disencumber the state of the Salon ever since they realized they could no longer suppress it.

The determining factor, however, had probably been economic: With the "Republic of the arts" focused on monumental decoration and decorative arts, funding for these programs had to be found somewhere, and the Salon budget was the only source available. The Agniel amendment to the 1880 budget had raised subsidies for art and design schools from

30,000 to 350,000 francs, on the grounds that foreign nations were spending even greater sums on industrial design instruction.[101] On the day following the Agniel amendment, the budget for Salon purchases from artists was reduced because of the major allocation to design.[102] Even before the abandonment of the official Salon, the fine arts budget had begun to favor the decorative over the fine arts. The teaching of drawing and design was an expensive program to administer, for teachers and inspectors had to be trained and hired, curricula and materials had to be organized, and schools had to be established. In addition, the National Manufactures – Gobelins, Sèvres, and Beauvais, which set the standard for French art industries – were undergoing major restructuring and improvements during these years, all of which entailed increased government funding.

In the first Republican arts budget, that of 1881, the shifts were revelatory: In addition to the tenfold increase for instruction in drawing and design, an extra 100,000 francs was budgeted for monumental public art, secular only, and all the National Manufactures were given larger subsidies. Only the Salon budget was cut, from approximately 500,000 to about 300,000 francs, which was designated for purchases only.[103] The suppression of the annual Salon must thus be seen in terms of a dialectic reflecting new Republican priorities in the arts.

The 1881 budget report reveals the program of the "Republic of the arts" by listing the major accomplishments of the Third Republic to date: the reorganization of the museum structure, the decoration of public buildings, the establishment of compulsory drawing and design instruction in school curricula, the strengthening of National Manufactures, but nowhere a word about the Salon and its artists.[104] "You must see by this, gentlemen, how much our fine arts budget differs from those presented by preceding governments," Lockroy, the Budget Committee chairperson, told the Chamber of Deputies:

Formerly, in separating completely the teaching of the higher arts from those called industrial, in practically completely abandoning the latter, in neglecting the teaching of drawing and design in our schools, and in not caring at all about inspiring the taste for beauty among artisans, they seem to have wanted to reserve the practice and knowledge of art for a small number of the privileged. Industrial museums did not exist; the great museums did not want to provide any services for workers. It was for the benefit of the ruling class that they encouraged official painting and sculpture. . . . An aristocracy of artists was created for an aristocracy of *amateurs*. . . .

83

If in fact, art served the pleasure of only a chosen few, one would be tempted to wonder whether the state should subsidize the expenses it involves. But the current government, like that of the first Republic, must see in art an especially powerful means of national education and industrial prosperity.[105]

Here, then, is where we must locate the Republican program in art, in institutional reform and not in any formal or stylistic characteristics. National education and industrial prosperity would be the goals of the Republic of the arts.

Whatever elevated and idealistic purposes the Triennale was intended to serve during its long history, when it was finally organized, its actual function was as a face-saving gesture. The linkage of the final abandonment of the Salon to the establishment of a long-interval exhibition of "the best of several years' production," as Turquet had announced, demonstrated that the state was not altogether forsaking art. On the contrary, it was actually planning to serve a higher ideal. The conseil had insistently linked the two shows: In December 1880, "the commission unanimously approved the principle of open expositions on the condition that the state organize triennial or quinquennial expositions that would have the character of state expositions."[106] At its next meeting, this decision was even more succinctly stated: "annual open expositions entrusted to the care of artists themselves; quinquennial or triennial expositions, organized by the state." At this latter meeting, prominent among the discussants was Charles Blanc.[107]

In 1880, after almost a century of debate, when the French state finally relinquished the annual Salon to the artists' control, it was only on condition that a second exhibition, a small and exclusive long-interval show and the first since 1810, be established in its place. The dialectic of power in the art world of the 1880s is aptly demonstrated by this attempt to compromise between its two major factions. As the *Journal des artistes* had pointed out in 1827, there had always been two separate shows within the Salon. In 1880 it looked as if that reality were finally being recognized. And so if the ideology behind the Triennale were, as the critic Joséphin Péladan would say approvingly, "essentially aristocratic" and thus "a blight on the Republican character,"[108] we should understand its acceptance in 1880 as a quid pro quo having as its goal the pacification of the world of contemporary art.

The Salon of 1881, now organized by the artists, revealed no immediate and dramatic differences from the annual Salon formerly sponsored by the state. The Conseil supérieur des

beaux-arts, still committed to the encouragement of "serious studies," now voted the Prix du Salon and continued to award its own prizes in the artist-run Salon: In 1881 it awarded prizes to Lucas for his *Sappho Expiring,* to Bertrand for his *Father-land,* and to Rosset-Granger for *Eros.*[109] Even the Salon jury was similar. Cabanel was elected president of the painting jury, Bouguereau and Bonnat were made its vice-presidents, and Dubois and Guillaume headed the sculpture jury; they all were Academicians. It would be incorrect, however, to assume from this, as does Pierre Vaisse, that the government decision had no consequences.[110]

The "crisis of Impressionism" at this time, for example, was characterized not just by a loss of confidence in its participants' aesthetic enterprise but also by defections and disarray in their exhibition strategy. Some tried to return to the Salon, and some even received a modicum of recognition there. It was in 1881 that Renoir, one of those who returned, defended his decision to return with his oft-quoted statement: "There are in Paris scarcely fifteen art lovers capable of liking a painting without the Salon's approval. There are eighty thousand who will not buy an inch of canvas if the painter is not in the Salon."[111] Manet, who repeatedly tried to exhibit in the Salon, finally received a medal in 1882, the only one of his entire career.

This first Salon under the artists' control showed a profit of 130,000 francs. Subsequent Salons were equally profitable, giving the new Société des artistes français a strong voice in dealing with the government.[112] The fact that there were no dramatic shifts in Salon policies in the years following 1881 would in itself have an effect on those artists who, for years, had assumed that things would change drastically if only they could control their own exhibitions. Now they could, but the Salon's policies remained much the same. The long-term consequences were that the withdrawal of the state from the exhibition business resulted in a loss of inherent authority for all exhibitions. The conservatives immediately understood this. Marius Vachon, for example, wrote in 1881, "Tomorrow, the Salon will have no other character and no other aim but that of an art market: The Salon will no longer exist."[113]

After 1880, the Salon was no longer the official exhibition conferring the approval and the prestige of the state. The rapid proliferation of major exhibition venues confirms this new reality, and the Salon of the Société des artistes français soon became only one among many such shows. Its establishment in 1881 was followed by the Société des artistes indépendants

in 1884, whose Salons dispensed with jury and awards altogether. In 1890 the Société nationale des beaux-arts broke away from the Société des artistes français to set up its own series of Salons, and in 1903 the first of the Salons d'automne further increased the number of large annual exhibitions.[114] Today, in the late twentieth century, there are several dozen annual Salons in Paris alone. In 1880, however, this was all in the future. Both the conservatives with their Triennale and the independents with their annual Salon each felt confident that their exhibition would become the major showcase for contemporary French art.

Amid the complicated events of 1881, the proposed triennial exposition was postponed, first to 1882 and then to 1883, but it was neither forgotten nor abandoned.[115] There was still, after all, a powerful faction of conservative and Academic artists who needed to be appeased. In early 1882 the news that the state planned to hold the Triennale the following year was announced to the artists' society that had taken over the Salon, which immediately adopted a resolution proposed by Robert-Fleury: "The Société libre des artistes declares that triennial expositions are incompatible with the interests of artists and expresses the desire that they be formally condemned."[116] Paul Mantz, the old Romantic and long-time Republican and now the fine arts director, received the artists' representatives, telling them (and this was promptly reported in *La Chronique des arts et de la curiosité,* which heartily approved) that "the administration was looking for a way of reconciling the two exhibitions but that if it could not find a way it was willing to sacrifice the Triennale."[117] Protests against the Triennale continued nonetheless, coming not from avant-garde artists, who had ignored it from the beginning, but from established artists who saw their own artist-run exhibition threatened. According to *La Chronique des arts et de la curiosité,* they feared that the government intended to retract the agreement turning the Salon over to artists' control.[118] With the two shows scheduled to open on the same date, they were certain that the Triennale, with the resources of the state behind it, would overshadow the annual Salon.

A second formal protest to Paul Mantz followed on June 17, two days after the Société des artistes français had drafted its statutes:

The Société des artistes français has been founded. This society, whose principal purpose is to organize the annual fine arts exposition, will inaugurate its first exposition next May 1.

Having learned that the state intends to hold a state exposition

in 1883, the artists are concerned that this double exhibition might compromise the beginning of this new society.

As it was at the request of the state that the artists formed a society, they should then be able to depend on the state to facilitate their task and not to seem to hinder it.

We the signatories hope, then, M. Minister, that you would be willing to consider the reasons we are setting forth to you and to postpone this state exposition to the moment when the new society will have proved itself to the public.[119]

The letter was signed by a majority of the new society's steering committee, which included Bouguereau, Français, Hébert, Henner, Chapu, Robert-Fleury, and Puvis de Chavannes. They were not artists who could be dismissed as "intransigents" but a group of established and successful artists who had to be reckoned with. Many of them were even Academicians and so found themselves opposing an exhibition that their institution had long supported. Many eventually exhibited in the Triennale even while protesting its existence. These apparent contradictions within the artistic community can be understood as reflecting the artists' – even the Academicians' – conviction that their livelihoods depended on their continued access to a variety of exhibition venues. They well understood that the real purpose of the long-interval exhibition was to suppress all others.

The Republican governments of the 1880s were placed in the uncomfortable position of having inherited the Triennale, the "blight on the Republican character," from the moral order governments of the 1870s. It now found itself caught between the proverbial rock and the hard place, with its own advisory body, the Conseil supérieur des beaux-arts, supporting the show while the great majority of artists, including the most prominent, opposed it. When the regulations for the 1883 Triennale were signed a few weeks later, its opening had been postponed to September 15; it would now follow, but not compete with, the annual Salon.[120] Gustave Ollendorff, the director of museum administration, wrote bitterly that although everyone knew the best season for exhibitions was spring, Mantz had hesitated to schedule two competing exhibitions and had refused to postpone the Salon because it was not politically expedient to do so.[121] The numerous artists' protests against the Triennale had shown that the opposition movement included the majority of French artists, from the famous and successful to the young and unknown, and in an age of electoral politics, this could scarcely be overlooked. To make matters worse, the language of the triennial enterprise – with all the talk of establishing an

aristocracy of the arts – was increasingly out of phase with political developments, which were decidedly Republican. Worse even than a return to order, it reeked of a return to the Old Regime. The solution, typical of the Opportunist governments of those years, was to continue to support the show, which did have its adherents, but only insofar as it did not conflict with the more popular artist-run Salon.

When the Triennale regulations were first decreed in 1878, they had called for a jury entirely elected by the exempt class of artists;[122] in this it most closely approached the Salons of the Old Regime, which were limited to Academicians. As the Triennale was finally constituted, however, the jury was to be appointed by the government, half from the Academy and half from government functionaries and supporters, thus giving a clear indication of the exposition's two major constituencies.

Despite the economic advantage of abandoning the annual Salon, the government was now forced to advance 100,000 francs for the show's organization, although it anticipated a profit from admission fees.[123] There was no money budgeted for purchasing works from the exhibition, however, nor were there, in the revised regulations, any prizes. Although there were repeated rumors that the state would make available additional funds for purchases, they were never appropriated.[124] This may have pleased those who thought art was becoming too commercial, but it rendered the show even less attractive to artists.

When the definitive regulations for the Triennale were published, the art community was stunned to discover that what had always been referred to simply as the Exposition Triennale was now officially titled Exposition nationale, thus usurping the official title of the annual Salon.[125] Although Georges Lafenestre, commissioner general of exhibitions, claimed that the name had been changed innocently in order not to set the periodicity of the event,[126] the negative reaction was immediate: Six hundred artists, including most of the luminaries of the official art world, signed a letter of protest against the show:

Considering that in making an exposition called national, the state seems today to regret having given artists the right to direct their exhibition;

That this exposition, at first announced as a triennial exposition, under the title of Exposition nationale today becomes an obvious competition with the association of French artists, charged by the state itself with organizing the Salon;

That national expositions duplicate annual expositions, for their new title Exposition nationale undeniably permits one to be held every year.[127]

They concluded by demanding that the state take their views into account and do nothing to jeopardize the success of their own show. There does not seem to have been much danger of that, however, for apart from the Conseil supérieur des beaux-arts, the Triennale enjoyed only lukewarm support from the government.

24 Henri Meyer, *The Triennale. The Grand Salon Carré with the Portraits of the Major Painters and Sculptors. Le Journal Illustré,* September 30, 1883, Bibliothèque nationale, Paris.

AESTHETIC PURITY

ONCE the state had turned the Salon over to the artists' control, the projected 1883 Triennale (Figure 24) remained the only official exhibition in France. Whatever it offered to the state – a face-saving gesture, a means to pacify its own agencies of Academy and conseil – it presented to conservatives the opportunity to realize the aesthetic *revanche* for which they had been yearning since 1791. Rarely does history present such an opportunity, as it seemed to do in 1883, to relive past glories. So great were the hopes for this long-awaited exhibition that the actual event should be examined in some detail, particularly because it represented an unsuccessful rearguard action against modernism in all its manifestations – institutional, economic, and aesthetic – and has, as a result, vanished from the art historical record without a trace.

As specified by the regulations of July 1882, the Exposition nationale would open on September 15, 1883, and continue through October 31; it would include works by both French and foreign artists completed since the 1878 Universal Exposition, or even earlier if previously unexhibited. Unlike the annual Salon, there would be no limit on the number of works that each artist could show. Jurying would be through a two-track system: Artists could submit a list of works they wanted to exhibit, and those works not accepted *sur notice* could be brought before the jury for a viewing.[1]

"The Institute dominates the jury," wrote one critic. "It is they who have the majority. The ministry has added to them some of its employees, who have official competence and who are connoisseurs insofar as they are bureau chiefs. . . . The administration and the Institute pushed for exclusivity."[2] This jury of half Academicians and half government appointees was expected to, and did, make a conservative choice. Such a jury had not been seen since the 1850s when Nieuwerkerke

had replaced the Salon's elected jury with a similar marriage of Academy and state. That jury, whose harshness had precipitated the 1863 Salon des refusés, had disappeared in its aftermath.[3] The Triennale jury was a nostalgic throwback to earlier, simpler days, although it should be noted that the Third Republic was unwilling to reestablish the even "purer" juries of the July Monarchy, composed exclusively of Academicians.

In the later nineteenth century, whatever the momentary exigencies, the state tacitly recognized the narrowness of its agency, the Academy, by never again allowing it, exclusively, to represent French art. By 1883 the Academic party was even less popular among artists than it had been in the 1860s: Out of forty-eight artists elected to the 1883 Salon jury, only seven were Academicians.[4] The government seems to have acknowledged this unpopularity by appointing to the Triennale jury several independents such as Jules Breton, Gustave Moreau, and Puvis de Chavannes, apparently to make at least a gesture of openness.[5] It is doubtful whether these artists had much influence, however, for the Triennale jury elected as officers only Academicians: Meissonier was named president of the painting section, Gérôme and Cabanel its vice-presidents.[6]

Even among conservative artists and Academicians, there were many abstentions from the exhibition, universally blamed on the hostility it had provoked from the beginning. According to *Gazette des beaux-arts,* there would have been even more, but the administration forced the artists to participate, by lending, without their permission, works in state collections.[7] Many prominent artists, even many jury members, abstained from submitting their work. Established artists such as Carolus-Duran, Gérôme, Moreau, Ribot, Vollon, Cabat, Delaunay, Detaille, Neuville, Robert-Fleury, and Signol did not participate, and in their absence many critics questioned just how "national" the show could really be.[8]

Despite the much publicized limit of 1,500 works for the entire show, by the first jury meeting only 676 works had been submitted. Eventually the cutoff date for submissions was extended three weeks, and even then only 1,353 works were installed.[9] The critic Joséphin Péladan (who later organized the Salons de la Rose + Croix) claimed that it was a myth that the jury had been "severe." In fact, he said, its members accepted almost everything submitted to them, so desperate were they to fill the space and so reluctant were the artists to participate in it.[10] Government purchases from the

Salons of 1878 to 1883, provincial museums, the Luxembourg collection, and even private collections all were pressed into service in order to fill the Exposition nationale.

Although many of the stars of the official art world eventually found themselves represented in the Triennale, with or without their consent, the exhibition remained unpopular. Aside from the artists' outright hostility, there was simply a lack of interest in an exhibition without prize money or medals, for during these years private gallery exhibitions had become viable, even preferable, alternatives to the crowded, badly installed official Salons.[11] In 1883, for example, Georges Petit held his second Exposition internationale, a luxurious display of the work of twelve established artists, including Cabanel, Robert-Fleury, Hébert, de Nittis, and Alfred Stevens. Their work was shown in an impressive setting of velvet, tapestries, chandeliers, fresh flowers, and liveried attendants, designed to appeal to a new class of wealthy, some would say parvenu, collectors (Figure 46).[12] At the same time, his archrival, Durand-Ruel, held a series of one-artist shows, similarly installed, for Boudin, Renoir, Monet, Pissarro, and Sisley.[13] In addition, private societies, such as the Union des femmes peintres et sculpteurs, the Cercle de l'union artistique (Figure 25), or the Société d'aquarellistes français, held annual exhibitions that offered the ambience of an elegant private collector's gallery to an elite public.[14] The huge, badly installed Salon could not compete with these smaller shows. The Triennale hoped to.

In his opening speech to the Triennale jury, Jules Ferry, at the time both prime minister and minister of public instruction, stated: "The role of the annual Salon is to be more and more inclusive; the role of a national exposition is to be systematically limited and exclusive. Two such different intentions cannot be contained in a single institution."[15] Although Ferry had attacked the Academy in his speech at the 1879 Salon, as one of the Opportunist politicians of the Third Republic, he was willing to compromise to avoid ill will. He had announced his goal in 1879 as the ability to support both Henner as an example of "grand style" and Robert-Fleury as a partisan of "modern painting."[16] Henner was not only on the Triennale jury but was also well represented in the exhibition (Figure 26), whereas Robert-Fleury, whose historical genre scenes were not quite the last word in modern painting, seems to have boycotted the Triennale in favor of the 1883 Salon.

The jury carried out Ferry's directive only too willingly,

for as Péladan remarked, "It is easily noticeable, from the first glance at the [Triennale] Salon, that the organizers wanted especially to exhibit Grand Painting."[17] Only forty women artists were represented in the Triennale, as opposed to over five hundred in the 1883 Salon. Most of the artists identified with modernism did not even bother to submit their work, for rejection was virtually guaranteed by the rhetoric that had surrounded the exhibition since its inception. The jury filled the show with its own work: Cabanel had ten paintings, Meissonier and Hébert seven each, and Bonnat six. Landscape painting was minimally acceptable, although not in its contemporary manifestations: Dupré, Harpignies, and Français showed eight, seven, and four paintings, respectively, although none were accepted *sur notice*. Despite their age and reputation, all had to suffer the humiliation of bringing their work before the jury. Younger landscapists were not represented at all. In contrast, Lhermitte's *Harvesters' Pay* (Figure 27), a monument of the *juste milieu,* was accepted without a viewing, and Cormon's immense *Cain* (Figure 28) was, according to Péladan, accepted simply because of its size.[18] Of those favored by modernists, Puvis de Chavannes showed

25 *Le Cercle de l'union artistique,* 1869, Bibliothèque nationale, Paris.

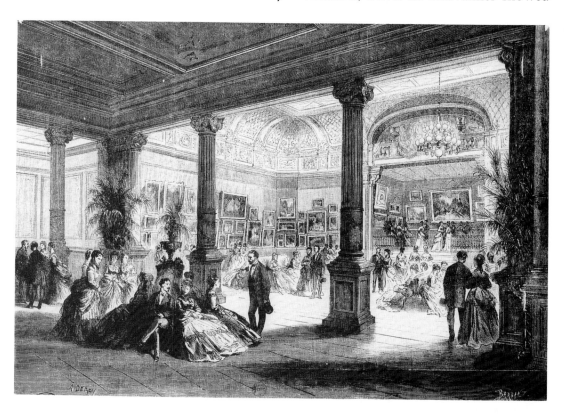

four works, among them his *Poor Fisherman* (Figure 29); Max Liebermann and Fantin-Latour displayed one each; and Rodin showed his *Age of Bronze* and *St. John Preaching*.

The only member of the Impressionist group who even attempted to exhibit was Manet who, ever desirous of state recognition, sent notice of five works, including *In the Conservatory [La Serre], Chez le père Lathuille,* and *A Bar at the Folies Bergère* (Figure 30). Despite his intervening death, all were rejected, even his portrait of *Antonin Proust* (Figure 15), a refusal all the more shocking as Proust was an influential Republican, a former minister of arts, and a major force in the world of art.[19] *Moniteur des arts* commented: "The only thing spoken of everywhere in the art world right now is the rumor that the pictures of Manet, the recently deceased artist, have been rejected by the members of the jury of the Triennale Salon."[20] The jury did accept his *Jeanne,* asked for a revision of *A Bar at the Folies Bergère* and *Chez le père Lathuille* – and then rejected them again.[21] *Moniteur des arts* reported: "One of the examiners, although he is considered a great artist, never liked either Manet or his painting and forgot himself enough to say: 'Enough of that kind of filth!' "[22] Manet's enemy was, no doubt, Gérôme, who several months later wrote to Jules Ferry protesting the decision to hold Manet's posthumous show at the Ecole des beaux-arts.[23] In any case,

26 Jean-Jacques Henner, *Bara,* 1882, 0.85 × 1.45 m, Musée du Petit Palais, Paris. Salon of 1882, Exposition nationale triennale, 1883.

no works by Manet were in the exhibition, not even *Jeanne;* Péladan claimed that Antonin Proust had personally withdrawn Manet's paintings.[24]

Bouguereau's *Birth of Venus* (Figure 31) was included, possibly without his approval. As a staunch supporter of the Société des artistes français and president of the 1883 Salon jury, Bouguereau had signed several protest letters. But the picture belonged to the state, and it was his only representation in the show.

The jury also accepted without a viewing "eight or ten paintings" by Meissonier.[25] Meissonier was, in fact, widely recognized as the driving force behind the exhibition; alluding to the classical character of the show, Albert Wolff remarked, "The Exposition nationale, *Meissonier fecit.*"[26] Although Meissonier had shown at the Salon only once since 1865, he had accepted the presidency of the jury and was widely credited with the installation design.[27] In fact, it was rumored that he had fervently espoused the Triennale only out of spite for the Société des artistes français, which had never elected

27 Léon-Augustin Lhermitte, *Harvesters' Pay*, 1882, 2.15 × 2.72 m, Musée d'Orsay. Salon of 1882, Exposition nationale triennale, 1883.

him to any of its juries.[28] In the first convocation of French artists in January 1880, at which a committee of fifty painters had been elected to organize the annual Salon, Meissonier, probably the most honored among French artists, had not placed at all. In 1883 he was quoted as stating repeatedly, in what was clearly a jibe at the artists' Salons, "We have to show foreigners that we too know how to mount exhibitions that are not just marketplaces."[29]

The intention of the exhibition's supporters was clearly to mount a "pure" show devoid of the tendencies of the preceding decades, and in this respect it almost succeeded. Gustave Ollendorff, the secretary of the jury as well as the director of museum administration, was pleased and wrote: "The elite that alone should represent art in France and that alone is worthy of representing it is found virtually all reunited at the Triennale Salon."[30] Although monumental works in the Grand Tradition of history painting, such as Lévy's *Coronation of Charlemagne* (Figure 12) or Baudry's *Glorification of the Law* (Figure 13), were obviously given priority, there were numerous reflections and reverberations of those very movements that had been excluded from the show. Impressionism as such was absent, but Bastien-Lepage's *Haymaking* (Figure 32) showed a certain familiarity with its tenets. In this *juste milieu* context, Léon Bonnat, who sent *Job* (Figure 33), could even be called "the master of the contemporary school of realism."[31]

28 Cormon [Fernand-Anne Piestre], *Cain,* 1880, 3.84 × 7.00 m, Musée d'Orsay. Salon of 1880, Exposition nationale triennale 1883.

Georges Rochegrosse, a twenty-three-year-old Salon neophyte, sent his enormous melodramatic *Andromache* (Figure 34), and was universally hailed as the most promising young artist in the show: Indeed, his painting was originally shown at the 1883 Salon where it was awarded the Prix du Salon; when that show closed it was carried in triumph to the Triennale. Critics compared him with Shakespeare, with the antique masters, and with the young Delacroix, although his facture was more in the classical tradition of Ingres.[32] His was a *juste milieu* production of blood and lust that would have been flatly rejected as vulgar fifty years earlier. A comparison of *Andromache* with *A Bar at the Folies Bergère* (Figure 30), the two best-known paintings accepted and rejected by the Triennale, reveals the distance between conservative and modernist taste in both subject matter and facture but also reveals surprising affinities, as, for example, the inclusion of the cut-off legs at the upper left of both paintings, a feature

29 Puvis de Chavannes, *Poor Fisherman*, 1881, 1.55 × 1.925 m, Musée d'Orsay. Salon of 1881, Exposition nationale triennale, 1883.

98

usually identified with the advent of photography but completely unacceptable in classical history painting.

Cabanel's *Phèdre* (Figure 35) occupied the same ambiguous position as did Rochegrosse's *Andromache,* between melodrama and the heroic tradition. With his name conspicuously missing from the petitions protesting the show, Cabanel seemed the compleat Academician, representing the entire enterprise.

The most prominent painting by the most prominent supporter of the Triennale was Meissonier's *Ruins of the Tuileries, May 1871* (Figure 36). Meissonier had never before exhibited this picture, and the demolition of the remains of the Tuileries in 1883 might have influenced his decision to do so in the Triennale. Despite its subject's being from contemporary history, it is clearly in the Realist tradition.[33] Its legend, "The glory of our ancestors surviving always through the flames, May 1871," referred to the end of the Commune, but we might interpret this vision of past glory seen through ruins as emblematic of the entire return-to-order period. Visible on

30 Edouard Manet, *A Bar at the Folies Bergère,* 1881–82, 0.96 × 1.30 m, The Home House Trustees, Courtauld Institute Galleries. Salon of 1882.

31 William-Adolphe Bouguereau, *Birth of Venus*, 1879, 3.00 × 2.18 m, Musée d'Orsay. Salon of 1879, Exposition nationale triennale, 1883.

either side of the far doorway in the painting are two deco-
rative shields that survived the fire that destroyed the Tuil-
eries; they commemorate the great Napoleonic victories of
Marengo and Austerlitz. Through the doorway we see in the
distance the Arc de triomphe du Carrousel, erected by Na-
poleon to commemorate his military victories, surmounted
by a sculptural group representing peace and victory. On one
level Meissonier's painting openly declares its Bonapartist
sympathies and criticizes the Republic, which had brought
peace but only with defeat; on another, more generalized,
plane Meissonier's picture offered contemporaries an image
evocative of both their sufferings and their aspirations. It
offers us today an entry into the *mentalité* of the period and

32 Jules Bastien-Lepage,
Haymaking, 1877,
1.8 × 1.95 m, Musée
d'Orsay. Salon of 1878,
Exposition nationale
triennale, 1883.

33 Léon Bonnat, *Job*, 1880, 1.6×1.3 m, Louvre/Musée Bonnat, Bayonne. Salon of 1880, Exposition
nationale triennale, 1883.

34 Georges Rochegrosse, *Andromache,* 1883, 4.7 × 3.35 m, Musée des beaux-arts, Rouen. Salon of 1883, Exposition nationale triennale, 1883. Legend: "After the seizure of the city, the royal prince Astyanax is, on the orders of Odysseus, torn from the arms of his mother Andromache and thrown down from the ramparts."

helps us understand the appeal of the return to order to a nation battered by war, invasion, defeat, and domestic insurrection.

The 1883 Triennale was intended to be, and was, a showcase for late nineteenth-century classicism. Nonetheless the academic historicism that was displayed there as the *crème de la crème* of Grand Painting, despite its claims to "aesthetic purity," showed a remarkable ability to coopt and assimilate the characteristics of the various modernist traditions, from Romanticism through Impressionism, mixing them freely with the sentimental traditions of popular culture and even, on occasion, with the theater of melodrama.

35 Alexandre Cabanel, *Phèdre,* 1880, 1.96 × 2.83 m, Musée Fabre, Montpellier. Salon of 1880, Exposition nationale triennale, 1883. Legend: "Exhausted, on a bed of pain, Phaedra shuts herself up in her palace; a light veil covers her blond hair. This is the third day that her body has had no nourishment; struck down by a secret malady, she wants to put an end to her sad destiny (Euripides)".

THE INSTALLATION

Most critics spent more time commenting on the politics of the show's inception and on its installation than on the art. The art had, after all, been exhibited before, in the Salons of the previous five years, and neither the critics nor the public had yet formed the habit of savoring a retrospective show.[34] What was new and seemed to merit attention was not the individual works, most of which were familiar, but the

104

36 Jean-Louis-Ernest Meissonier, *Ruins of the Tuileries, May 1871,* 1.36×0.96 m, Musée d'Orsay. Exposition nationale triennale, 1883. Inscribed "Gloria Maiorum Per Flammas Usque Superstes/Maius MDCCCLXXI."

phenomenon of a "pure" (or almost pure) exhibition purged of the modernist styles of the last fifty years. The installation (Figures 24 and 37) garnered the most enthusiasm, for it had achieved "a magnificence of decoration heretofore unknown."[35] In contrast, the annual Salons were hardly distinguished for their decor (Figure 38). The critic Marius Vachon described the Salon of 1881:

It is really a stunning antithesis to dare give this vast hangar the name Salon. No tapestries, some raggedy hangings and dusty cloths of a nondescript color suspended over the doors like curtains and nailed miserably to the ceiling for a border; here and there some broken-down sofas of filthy leather, scarcely able to offer a bare hospitality to a hundred people; the floor gray with dust, mud, and filth, outrageously reflecting the light onto the pictures; not rugs or flowers or greenery; not a single oasis in this long and arid Sahara, which we leave exhausted, broken, blind, and dying of thirst.[36]

Unattractive as this image is, the Salon had scarcely changed in a century. What was new was the abundance of visual spectacles with which it now had to compete, in particular private gallery shows and the elegant new department stores. At the 1873 Vienna International Exposition, Du Sommerard,

37 Installation, 1883 Exposition nationale triennale. From France, *Ouvrages commandés ou acquis par l'administration des beaux-arts: Salon de 1883 et Exposition nationale,* Bibliothèque nationale, Paris.

the French commissioner general, had called on commercial interests to decorate the French exposition hall for the fine arts, the result being that it overflowed with curtains and tapestries, furnishings, and bronzes.[37] Although the French art displays at the 1878 Universal Exposition were less elegant, the regular Salons, by contrast, seemed outright tacky.

Private dealers and private exhibition societies, of which the Impressionists were only one example, were already sponsoring elegant displays to attract a new public that saw art as a luxury, as a commodity and investment, as a spectacle.[38] The very definition of art distribution, like commodity distribution in general, was undergoing a massive transformation during these last decades of the nineteenth century, a transformation of expectation and actuality that could not but affect the fine arts.

But here in 1883, all would be reclaimed:

The garden of the Palais de l'Industrie has been transformed. . . . Tapestries are exhibited everywhere. The government warehouse has been literally pillaged. In the garden rooms statues are arranged to stand out against neutral-toned wall coverings; against these walls, tapestries are mounted. Masses of flowers and foliage cover the

38 Installation, 1883 Salon. From France, *Ouvrages commandés ou acquis par l'administration des beaux-arts: Salon de 1883 et Exposition nationale,* Bibliothèque nationale, Paris.

entire surface of the garden. All the facilities of the state have been pressed into service: Versailles, Compiègne, Saint-Cloud, as well as the city of Paris are sending their marvelous floral displays. Forty thousand feet of flowers are anticipated. It will be dazzling.[39]

Another art critic wrote: "The garden walls themselves, the exterior galleries of the first floor, and the grand entrance vestibule are covered by some six hundred marvels coming from the former collection of royal tapestries dating from the Renaissance to the seventeenth and eighteenth centuries."[40]

The installation of such tapestries at an elite high art exhibition (they are prominently displayed in Figure 37) was not fortuitous; such a decor had graced the first Salon held in the Louvre, in 1699, when it was the king's palace and the exhibition was open only to Academicians. In 1883 such a combination also symbolized the Third Republic's alliance between the arts and industry by showcasing the two major areas meriting state protection, Grand Art and decorative art.[41] So ambitious was the decorating scheme that the show was humorously labeled "the National Exposition of Tapestries."[42] Critics pointed out that it was, in fact, an official show about "decorations,"[43] and caricaturists enjoyed the pun (Figure 39). Nonetheless, everyone was impressed with the spaciousness of the installation, never before seen in an official exhibition. Roger Marx described it as follows:

The Palais de l'Industrie usually gives the effect of a vast bazaar where the works are piled up in confusion; now it has the appearance of a museum or a private collection composed only of choice works. Instead of being crammed in, one on top of another in an infinite number of rows, the pictures are placed at eye level [*sur la cimaise*] far enough apart so that they have nothing to fear or hope from their surroundings. Furthermore, the works of a single artist are no longer spread out from one end to the other but are virtually always united in such a way that the Salon seems at first glance to be a series of individual exhibitions.[44]

As such installations were still unusual, there was widespread anxiety that a public accustomed to the traditional floor-to-ceiling frame-to-frame Salon installations would find these galleries "naked" and "sad."[45] As a compromise, the names of exhibitors were inscribed in gold letters framed by laurel leaves on shields and cartouches installed high up on the walls of each gallery. This not only relieved the barrenness of the upper stretches of wall but also had the advantage of immediately identifying for visitors the works displayed there.

The crowded floor-to-ceiling installations of the annual Salon had been traditional for centuries, used to display art

equally in private galleries and public exhibitions, in picture shops, and even in museums (Figure 40). Now these same installations seemed unbearably commercial, like so much merchandise chaotically thrown together. A spacious, spare installation, permitting contemplation, emphasizing rarity and preciosity, now seemed more worthy of the dignity of art. These new "noncommercial" settings were, in fact, adopted from the selling techniques of the new department stores where commodities were presented for sale in the ambience of an elegant private Salon designed to appeal to a new class of wealthy buyer.[46] Art dealers, most notably Georges Petit, were trying to appeal to this same new class by adapting these display techniques for art, and the supporters of the Triennale were attempting to consecrate the traditional French school by presenting it in this same "noncommercial" setting.

Though it is always difficult to attribute any shift in taste to concrete conditions, to explain, for example, why art

39 Henriot, *Actualités.* "Current Events. To complete the decoration of the Triennale Salon they should have added to the artists' works the medals and decorations that they have already received." *Le Charivari,* September 17, 1883.

installations diverged from time-honored precedents to adopt as a model those of the department store (which were in turn based on aristocratic interiors), we might mention here two factors, first the rise of interior decoration as an art form, with individual creativity and self-expression replacing historicism, and second the attempt to maintain art as a refuge from the commercialism and materialism of daily life.

The shift to what Debora Silverman called "interiority,"[47] with its emphasis on individual inner states and private realities, was typical of the last decades of the nineteenth century, heralding what Marx condemned as bourgeois individualism and what Jules Ferry praised as the highest value in art. Interior decor, which had been an exercise in historicism (i.e., period rooms) was transformed in the later nineteenth century into a species of self-expression, with each object, work of art, and choice of color or fabric being a reflection of the individual. As individuals found themselves increasingly forced to operate in a public sphere whose values were more and more antipathetic, they could, at least, create their own interior spaces, either psychologically or physically. Commercial interests were quick to merchandise this trend by offering a

40 *The Louis La Caze Collection in the Louvre,* 1870, Bibliothèque nationale, Paris.

rich variety of home furnishings in the new department stores. On the other hand, as René Saisselin pointed out, the analogue to the growing commercialism and materialism of life in the late nineteenth century was that an insupportable burden was now placed on works of art, which were required to serve as entry points into an ideal realm of aesthetic experience, a finer, purer world than the quotidian.[48]

The enthusiasm that greeted the installation of this show, even from those critics most resolutely opposed to its intentions, reveals that it had struck a responsive chord. The 1883 Triennale was the first time that an official French exhibition adopted the spacious installation that has since come to characterize modern exhibitions and that was already, by the 1880s, characterizing the private ones. It is ironic that this should have taken place in the context of what was in essence a conservative and reactionary gesture and also ironic that at the same time as official rhetoric was calling for a new public art, the most prestigious space in which this new art could be displayed was one acknowledging the preeminence of the private realm. How else to explain the obvious satisfaction of even the most conservative critics in repeatedly comparing the installation of the 1883 Triennale with that of a private gallery?[49]

Even the catalogue was praised as more dignified and worthy of the lofty position that art should occupy, in that it contained none of the advertising that was seen as demeaning the annual Salon catalogues (Figure 41).[50] Medals and cash prizes, always features of the Salon, were absent from the

41 *Eau des Brahmes,* advertisement from the catalogue of the Salon of 1881.

Triennale, for true artists were supposed to live for and not by art – and here aesthetic conservatives found themselves in unexpected accord with the Republican Budget Committee, which had refused to vote any additional funds. Never before had art been placed in such an idealistic and resolutely non-commercial atmosphere, whose very terms were being set by the new market system.[51]

The luxurious installation of the 1883 exhibition later reappeared in 1890 at the Salon of the newly founded Société nationale des beaux-arts, which broke away from the Société des artistes français in that year to set up a rival exhibition under Meissonier's leadership.[52] The issues that caused that split can be seen in embryo here in 1883 when Meissonier, the chief architect of the Triennale, opposed Bouguereau, the president of that year's Salon. In 1883, as in 1890, Meissonier preferred a Salon that was "aristocratic" and didactic, while Bouguereau wanted a "democratic" and commercially viable Salon. In this conflict can be seen the two competing economic systems of the period, state-sponsored and protected monopolies versus smaller liberal, free-enterprise production.[53] The institutional dialectics of this aesthetic split were subsequently resolved by the division into noncommercial museum exhibitions, the heirs of Meissonier, and commercial galleries, the heirs of Bouguereau.

In this context the secessionist exhibitions of the various modernist movements of late nineteenth-century France emerge as a *juste-milieu* between the polarities represented in the larger art community: The secessionists, from the Impressionists on, wanted to come before the public both to sell their work and to make a unified aesthetic statement.

The chaotic and immense annual Salon was not conducive to any group's ability to make a coherent aesthetic statement. As the varieties of aesthetic practice became more diverse, this situation became ever more strident. "Imagine the most absolute cacophony," Zola wrote, "an orchestra in which each instrumentalist is trying to play a solo in a different key. That is what our Salons are like."[54] Turquet's attempt to resolve this in 1880 with his "sympathetic groupings" at the last official Salon pointed the direction of the future. The 1883 Triennale was an attempt to present one such "sympathetic grouping," just as were the Impressionist exhibitions.

Aside from the striking innovations carried out in the installation of the Triennale, the public was little impressed: *Le Charivari* carried a short poem that read:

Certainly not triumphant, the Triennale Salon.
At certain hours you would think you are in the
 Beaumarchais theater, so vast is the emptiness.
I admit that I'm not at all unhappy about this.
It will humble the pretentiousness of certain big-shot
 painters who thought they had the right to say:
Only us and us alone![55]

Most critics acknowledged, in either sorrow or satisfaction, the paucity of visitors, but the Triennale's supporters blamed the season, "between the departure of Parisians for the country and their return after the hunting season."[56] Nonetheless, the unpopularity of the show with the public as well as with artists was a serious blow to partisans of the Grand Tradition, for although they constantly proclaimed their scorn for the mob, *la foule,* the absence of their audience was an embarrassing comment on their intention of educating the nation. "It is with profound regret that we are obliged to acknowledge the lack of enthusiasm that the public has for visiting it," was one comment.[57]

Although the number of visitors almost equaled that at the annual Salon, this feat was accomplished only by extending the Triennale for an extra month.[58] Of the 150,000 francs anticipated in admission fees, only 89,516 were collected, well below the 300,000 francs that the 1883 annual Salon had earned.[59] The show's supporters claimed that it had returned a profit, but it was later revealed that in fact the Triennale had shown a loss.[60] In contrast, once the annual Salons were turned over to artists in 1881, they consistently showed a solid profit.[61] This was not something that government officials could easily ignore.

CRITICAL RESPONSE

Although critics had little to say about individual works and much to say about the installation, they commented at even greater length on the novelty of the viewing experience. For some the spacious installation seemed to call forth a new and contemplative attitude toward the works:

In entering the rooms of the Triennale Salon, so intelligently arranged, the public has the impression of a museum. You go through them with pleasure, and you leave without fatigue; the pleasures that you experience are the most elevated and the most delicate. Works that you scarcely glimpsed in the confusion of the annual

exhibitions reveal beauties you never suspected, and those that had passed unnoticed now strike you, stop you, and hold you with their exceptional qualities.[62]

Tempering the enthusiasm of even the most conservative was the recognition that it had not been completely possible to roll back the decades to a (largely imaginary) golden age of artistic hegemony. Georges Goepp wrote:

Even here, in this exposition prepared with so much care, where absolutely bad works are not numerous, where the intransigents of art have been for the most part excluded, where Manet has not been permitted to appear, but where people are nonetheless prostrate with respect before the strange productions of Puvis de Chavannes – even here the most contradictory systems confront one another; the most irreconcilable contradictions combat and hurl themselves at one another without our yet being able to comprehend the harvest that these difficult sowings will reap for posterity.[63]

A slightly more optimistic note was sounded by *Moniteur des arts:*

If the eye does not always find itself perfectly satisfied and complete there, it nonetheless is not shocked by the excess of banality, incoherence, and confusion pushed to its extreme limit. We find there, grouped together in a relatively small space, all those who in these last years have affirmed their personality without falling into eccentricity or insurrectional obstinacy.[64]

This might seem like lukewarm praise, but to conservative eyes the difference between the Triennale and the annual Salon – virtually imperceptible today – constituted a major victory. These critics accurately defined the endeavor: to stay within the mainstream of tradition, modernizing it slightly by inflecting it with the *frisson* of forbidden styles from Romanticism to Impressionism, all the while firmly rejecting the "intransigents" who had created those styles. During the Triennale itself, Charles Gounod, president of the Academy, attacked Realism, Impressionism, and all of *l'art moderne,* but we should not conclude from this that the enemy here was only modernism, for what had been equally barred from the show were the thousands of commercially produced easel pictures so offensive to both conservatives and modernists alike – Zola called them *articles de Paris* after the small decorative art objects that provided much of the city's prosperity.[65] These small pictures customarily crowded every annual exhibition, their creators completely unknown to us today.

In the praise that the 1883 Triennale evoked from its partisans, the issues of unity and purity stand out. "Despite the diversity of means of expression and the divergence of their

chosen paths, what an impression of unity in the pursuit of the same goals arises from this ensemble,'' wrote Paul Lefort in *Gazette des beaux-arts*.[66] These same qualities were in short supply in the early years of the Third Republic, marked as they were by major rifts and compromises in and among political parties, regions, and classes. In such circumstances, any group's being able to come to some agreement on a statement, aesthetic or political, was an achievement, and the desire to speak with one voice during what the contemporary historian Daniel Halévy called "our confusing times"[67] was not limited to either conservatives or modernists. If critics praising the 1883 Triennale seemed obsessed with purity, considering the beleaguered state of aesthetic conservatives, that would be understandable. But the Impressionists, at the other pole of the aesthetic spectrum, seemed equally devoted to the concept, for the idea of a "pure" Impressionism was a vital issue in the early 1880s.[68]

During these years the Impressionists proved to be just as exclusive as the conservatives were, for their ranks were split between colorists and landscapists in one camp who were at odds with Degas and his followers in the other. This was one of the key issues in the "crisis of Impressionism," which resulted in the fragmented representation of the Impressionist movement in its shows from 1878 to 1882.[69] "It is totally necessary that we be just among ourselves, that no stain be allowed to compromise our success," wrote Monet to Durand-Ruel concerning the 1882 Impressionist show. The "stain" that Monet was trying to avoid was the inclusion of Degas's followers with their more anecdotal subject matter and academically acceptable style of drawing.[70] Pissarro, writing to his friend de Bellio of the same show, echoed Monet's sentiments: "This is the first time that we do not have any too strong stains to deplore."[71] It was during these same years that agitation for economic protectionism grew, and it materialized in 1892 when the Méline tariff brought to an end the period of free trade begun under Napoleon III.[72] Shall we call this phenomenon *aesthetic protectionism,* the seemingly universal desire to pull inward, to exhibit only among friends, among like-minded colleagues, to seek aesthetic unity and purity?

The aesthetic unity that the Impressionists were seeking in 1882 is familiar to us today, but what species of aesthetic unity were the conservative artists of the 1883 Triennale striving to achieve? Writing in *Gazette des beaux-arts,* Paul Lefort identified it: "There exists among us a school that is vibrant, that

makes progress, and that, gaining in number and value each day, will flourish and assert its authority. This school, very naturalist in its principles, nonetheless has an ideal!"[73] In other words, the unity found at the Triennale consisted of a measure of adherence to traditional Academic values but was inflected – one might say "modernized" – by Naturalism. This was the "school" that could include productions as seemingly diverse as those of Bastien-Lepage and Rochegrosse, but this unity could become apparent only when divested of the more extreme manifestations of modernist painting and the overwhelming numbers of commodity art productions at the annual Salons. That was the achievement of the 1883 Triennale.

Nonetheless, at the same time that conservative critics were pleased with the Triennale's ability to escape the aesthetic incoherence of the annual Salons, others were admitting that it was precisely those "intransigents" with their extreme styles of painting who, though controversial, added life to the shows. The critic for *L'Art,* for example, complained:

Despite these efforts, despite the intelligent arrangement of the decor, despite the luxury, despite the exceptional resources employed, despite everything, in fact, this exposition is depressing, it lacks interest: You can't take ten steps into the half-empty galleries before boredom overtakes you and an invincible force pushes you out the door.[74]

Le Charivari commented: "The unexpected, now that is what is lacking at the Triennale and what the most majestic solemnities can never replace."[75] The "majestic solemnities" of the Grand Tradition were even the target of satire in a concurrent exhibition by a group calling itself "The Incoherents" (Figure 42). These artists published their own regulations, stating that "all works will be admitted except those that are obscene or serious."[76] They exhibited parodies of "serious studies," prompting one critic to note maliciously: "They would never want to make fun of the Institute."[77] "The exhibition of Incoherent Art is to the Triennial Salon what *Le Tintamarre* is to *Revue des deux-mondes,*" explained *L'Illustration,* comparing a radical satirical broadsheet with the staid and serious journal.[78]

Among the works satirizing the Grand Tradition were a *Hercules* picking up a dumbbell, and a fashionably dressed *Leda* riding a crane.[79] Bonapartism and history painting were sent up by the caricaturist Caran d'Ache, who exhibited a triptych showing some smoke, a little red, some flashes, and a flag; the pictures were entitled *Austerlitz, Wagram,* and *Iéna,*

after Napoleon's great victories.[80] "I don't at all like incoherence applied to these glorious names," complained one art critic. The Opportunist Republicans fared no better; Raoul Colonna de Cesari (many of the names were fictitious) showed an *Incoherent National Flag:* The flag was red (for the radical Republicans) surmounted by an eagle with outstretched wings (for the Bonapartists) and decorated with gold fleurs-de-lis (for the legitimists).[81] Toulouse-Lautrec was one of these punsters, and the following year he produced what has become the most famous nineteenth-century parody of Grand Painting, a satire of Puvis de Chavannes's *Sacred Wood Dear to the Arts and the Muses* (Figure 43).

If we ignore for the moment this nineteenth-century version of the battle of the ancients and the moderns and focus instead on areas of concord rather than discord, we will find

42 Henri Gray, *The Incoherents,* poster advertising the first exhibition, 1883.

that whether directly observed or honored in the breach, aesthetic purity was clearly a critical issue operating across the entire spectrum of art production during the early 1880s. Individuals and "sympathetic groupings" from Academicians to the avant-garde attempted to define and showcase their work in relation to all available aesthetic choices – or art products, to use a different discursive model.

Although this effort has been subsumed into the definition of modernism – in the Greenbergian sense of the genres' attempt to limit and focus on their own means – we might also consider a parallel in economic theory: market differentiation as a recognized stage in the development of capitalism. The factors important to the proper distribution of any product, including art, are visibility, knowledge of the market, and homogeneity of the product, but the annual Salon could no longer offer artists any of these conditions. The precondition for any kind of marketing – that different kinds of people know where to look for certain kinds of goods – had broken down in the democratic Salon. We have only to remember, in Zola's *L'Oeuvre,* Claude Lantier's inability to find even his own painting in the Salon. Other efforts were needed to bring these goods to their proper audiences, and the new concern for aesthetic purity as the guiding principle in the organization of exhibitions was the result.

43 Henri de Toulouse-Lautrec, *Parody of Puvis de Chavannes's "The Sacred Wood Dear to the Arts and the Muses,"* 1884, 1.72 × 3.80 m, Henry and Rose Pearlman Foundation, on loan to the Art Museum, Princeton University.

INDEPENDENTS AND
INDEPENDENCE

"ᴄᴇʀᴛᴀɪɴʟʏ not triumphant," was *Le Charivari*'s verdict on the 1883 Triennale; "a nonsuccess," Albert Wolff called it.[1] The public and all but the most conservative critics seemed to agree. And yet even before the show was over, the Conseil supérieur des beaux-arts had moved to schedule the next one. In mid-November, Georges Lafenestre, the commissioner general of exhibitions and, not incidentally, a member of the Academy, wrote a long report insisting on the necessity of immediately and definitively establishing the Triennale as a regular event. Unlike the artists and the public, Lafenestre found the experiment satisfactory in every way save one, that of scheduling:

It is difficult to understand why the state does not reinstate the possibility of installing the official Salon [i.e., the Triennale] in its own palace at the most suitable season, as the palace is lent, without any burdensome conditions, to all the private societies that ask for it. The date of May 1, the traditional date, coinciding with the greatest activity of Parisian society, is the appropriate date. This is the only one that allows the National Exposition, if it takes place, to be held during the best season of the year.[2]

He also mentioned the necessity of instituting "several very important prizes destined to reward the forms of art that are the most crucial to the maintenance of national traditions"; he meant, of course, history painting.[3]

At the same time, Gustave Ollendorff, director of museum administration as well as secretary of the Triennale, published an article in *Revue des deux-mondes* calling on the state to evict the artists from the Palais de l'Industrie in order to use it for the next Triennale.[4] It was as artists had feared; aesthetic conservatives were using the Triennale as a wedge for introducing their entire program. Having already accomplished what had been for almost a century their primary objective, namely, getting rid of the government-sponsored

annual Salon, they were now moving to consolidate their gains by institutionalizing, in its place, the elite and exclusive show that they had long maintained was the only worthy representative of French art.

This initial campaign of reports and articles apparently did accomplish its purpose, for the current fine arts administrator, Albert Kaempfen, was a political appointee, a former editor of the *Journal officiel,* who had little background in art. This was one of the drawbacks of Republican rule, that the connoisseurs and *amateurs* who had formerly run the institutions of high culture were being replaced with the "new men" whose political loyalties, it was hoped, would compensate for their lack of expertise. On December 10, Kaempfen sent a report to Armand Fallières, the minister of public instruction, urging him to decree the 1886 Triennale. Admitting, for the first time, that the 1883 show had lost money, Kaempfen nonetheless promised that the 1886 show would return at least 150,000 francs.[5]

Fallières, minister of public instruction and therefore *ex officio* president of the Conseil supèrieur des beaux-arts, pronounced the show "very brilliant but not very lucrative."[6] For the moment, "brilliant" took precedence, and on December 13 the 1886 Triennale was decreed, again as the "Exposition nationale."[7] It would be similar in structure to the 1883 show except that the number of paintings would be reduced even further, to only six hundred, and the jury would be greatly enlarged by the addition of numerous government functionaries, who would now outnumber both independent artists and Academicians combined. In addition, the show would appropriate the traditional Salon dates of May 1 to June 15.[8]

The officers of the Société des artistes français visited Fallières on the very day of the decree to protest the show formally, and a second arts organization, the Société libre des artistes under the presidency of the sculptor Jules Dalou, joined the protest with a letter of solidarity.[9] Fallières reassured them that the administration would not interfere with the artists' Salon, but they nonetheless drew up a petition stating their objections, principally to the preemption of their May 1 opening date, a date repeatedly promised to them as permanent.[10] The artists' Salon had shown a profit and increasing attendance in each of its three years, and the Société des artistes français was dependent on the revenues of this annual event for its continued existence, which made all their objections that much more urgent.

These events and protests in 1884 occupied the attention of the majority of French artists, to the extent that one critic claimed that the future of the Triennale was "the sole artistic question of today."[11] Modernists, however, are more likely to associate this date with the establishment of the Salon des Indépendants, at which Redon, Signac, and the other Neoimpressionists exhibited and at which Seurat made his debut with *Une Baignade* (Figure 44).[12] The hundreds of artists who founded the Société des artistes indépendants left the Société des artistes français because they were finding its Salon jury just as oppressive as the state's. Although in modernist art history the Salon des Indépendants is virtually synonymous with the Neoimpressionist group, over a thousand works of virtually every school and style were exhibited there: "All the schools are present," wrote one critic, "academicism, realism, modernism, impressionism, pointillism, and eclecticism."[13]

The new Salon that these artists established in 1884 had neither prizes nor jury; it sufficed to be a member of the society to have the right to exhibit. Fifty years earlier, David d'Angers had proposed a system in which "to exhibit would no longer be a privilege but a right"; the Indépendants were

44 Georges Seurat, *Une Baignade,* 1883–84, 2.00 × 3.00 m, National Gallery, London.

merely putting his theory into practice.[14] And if the state lent the Palais de l'Industrie to the Société des artistes français, giving that organization a quasi-official stature, so also did the city of Paris lend its buildings, in the Tuileries, to the Indépendants.[15]

The contrast between the two exhibitions was striking, with the state still supporting an institution identified with conservative and traditional high art, whereas the city of Paris, always more politically radical, demonstrated its support for equality, independence, and modernity. Nonetheless, President Jules Grévy visited the Indépendants on opening day, in the company of the director of fine arts, the prefect of the Department of the Seine, and the president of the Paris Municipal Council.[16] The state was intent on preserving its neutrality in aesthetic issues, and in subsequent years official contingents visited all the major Salons on opening day and purchased work from all of them. As conservatives had predicted, the state's divestiture of the Salon resulted in the loss of the inherent authority of any exhibition. The statutes of the Société des artistes français were not even a year old before the first members had defected; the artists' Salon was already dividing and propagating.

In the following months, the Société des artistes français continued to pressure the government, which responded with protestations of its intention to have both the artists' Salon and the 1886 Triennale on exhibit in the Palais de l'Industrie at the same time.[17] In April 1885 Edmond Turquet returned to power as part of the new ministry of René Goblet. Turquet immediately moved against the Triennale, aided by the Budget Committee for the Fine Arts whose chairperson was the very Antonin Proust whose portrait by Manet (Figure 15) had been so unceremoniously, and so unwisely, rejected by the 1883 Triennale jury. On the Budget Committee's unanimous recommendation, Turquet proposed the cancellation of the 1886 show.[18] In his report to Goblet recommending this decision, Turquet cleverly manipulated the conservative position, paraphrasing Charles Blanc's often reiterated statement that the more frequently expositions were held, the weaker they would become. Turquet concluded that a triennial exhibition would be simply "a useless repetition of previous Salons," that five or six years should be the absolute minimum interval between such *expositions de choix*. As the 1889 Universal Exposition had already been decreed and would take place six years after the first Triennale, the problem was thus neatly resolved.

The cancellation of the 1886 Triennale aroused a storm of commentary in the press. Journals sympathetic to artists, such as *Le Temps,* applauded: "Well, here we are with artists in full and definitive possession of the National Salon. The 'Triennale,' which was suspended over their heads as a perpetual threat of revision and which could have led someday to the suppression of their privileges, has been deconstitutionalized."[19] In the ensuing discussion of the Triennale's virtues and vices, the financial losses suffered by the 1883 show were, for the first time, freely acknowledged. As an anonymous article in *Le Temps* noted, "The deficit that it showed in its receipts has been the sword's point of its adversaries."[20] Nonetheless, even its opponents accepted as accomplishments the show's elegant decor and spacious installation as well as the quality of the catalogue free of all commercial advertisements. These qualities, which had first appeared in the commercial sphere, were rapidly becoming the norm for all art exhibitions.[21]

Why, after all this time, had the show been canceled? The conservatives blamed Edmond Turquet for his long-standing support of the Société des artistes français.[22] The Republican Antonin Proust was also held responsible, for it was the Budget Committee he headed that, based on his report, had unanimously proposed its cancellation.[23] Proust probably was responsible for the decision, for on assuming the short-lived post of minister of arts in 1881, he had immediately reminded the Conseil supérieur des beaux-arts that he was one of the early supporters of the concept of an open Salon as well as a supporter of the decorative arts. He was much less enthusiastic about the conseil's pet project, the elite long-interval high art exhibition.[24] In 1885, besides chairing the Budget Committee, Proust was president of both the Union centrale des arts décoratifs and the planning commission for the 1889 Universal Exposition. At the same time as the 1886 Triennale was canceled, the Budget Committee voted major appropriations to both the National Manufacture of Gobelins and the Ecole des arts et métiers in Lille. We can see this as again demonstrating the dialectic that functioned in the Third Republic between the fine and decorative arts, to the increasing advantage of the latter.[25] Despite the *ad hominem* attacks on Turquet and Proust, we should not overlook the Third Republic policy of supporting small businesses.[26] In this light, the Société des artistes français with its entrepreneurial stance seemed like the wave of the future: It had removed itself from the government dole and was doing well financially. The

Triennale, on the other hand, having lost money in 1883, was demonstrably unpopular with both the public and the artists. It could continue to survive only with constant infusions of government money and, like the now-defunct official Salon, would be a steady drain on the government budget. Not surprisingly, the Budget Committee took a dim view of an exhibition that was "brilliant, though not very lucrative." It seemed to belong to an earlier era, and as the Third Republic solidified its base of support, conciliatory gestures such as this, offered to a steadily diminishing constituency, seemed unnecessary.

There does, however, seem to have been something of a constituency for the Triennale, one identified in the press as the government art administration. This explanation was put forward most succinctly by the critic Albert Wolff, who explained it in terms that seem quintessentially modern: "Men are replaced, but the bureaucracy remains." "One of their most pleasant tasks has been taken away from them," he wrote. "They no longer supervise the arts, omnipotent and majestic. What! The artists are taking care of their affairs themselves – and very well, no less – and this without the protection of the bureaucracy?"[27]

Emile Hervet, writing in *La Patrie,* offered the same explanation, pointing out that the special section of the fine arts administration in charge of exhibitions (he meant Lafenestre) was fervently committed to the Triennale: "The administration preempts a large part of the fine arts budget, and if it is paid for doing nothing or very little, eventually it will be noted that this is an abuse and that its personnel and its costs should be considerably reduced."[28] In Hervet's explanation, each department of government had its own agenda, and the branches of government were seen as operating at cross-purposes, the Budget Committee opposed to the schemes of the fine arts administration and the Conseil supérieur des beaux-arts sometimes at odds with both of them. The sociologist Michel Crozier identified this phenomenon of bureaucratic fiefdoms, with each administrative pyramid closed back upon itself in isolation from the others, as typical of the functioning (or not) of modern France.[29]

The transformation of the art administration during this period intensified the problem, for its personnel – no longer the cultivated, often aristocratic *amateurs* who dabbled in government service, such as the comte de Nieuwerkerke or the marquis de Chennevières – were now a professional class of political appointees such as Albert Kaempfen.[30] From the

moment when Maréchal MacMahon attempted to seize power by dissolving the Assembly in 1877 and was, in consequence, forced to resign, the French president had become a figurehead, and the real power resided with the deputies. Soon, however, the power began to gravitate toward the career functionaries, who usually outlasted them.

The sizable increase in the number of government functionaries who were scheduled to make up the jury of the 1886 Triennale (and who already made up the majority of the Conseil supérieur des beaux-arts) was, no doubt, a major factor determining the artists' new fear of a bureaucracy that was not even particularly well qualified for its job. The Conseil supérieur des beaux-arts had grown from a small group of twelve members in 1873 to fifty-one in 1885. During this time the Academicians, who had been so dedicated to religious painting and who gave the conseil an aura of clericalism that it never quite lost, were gradually outnumbered by members of the government bureaucracy and by political appointees.[31] Not only were Academicians in the minority; artists of all persuasions also were soon greatly outnumbered, and by 1885 they made up only about one-fourth of conseil membership.

For decades a rhetorical war had been waged that pitted "the interests of artists" (traditionally synonymous with material interests) against "the interests of art" (usually referring to high-minded, usually Academic, ideals). By the mid-1880s it seemed that this binary opposition had been replaced by "the interests of artists" versus "the interests of the bureaucracy." "The Salon of the artists" was now often contrasted with "the Salon of the administration," and administrators were labeled "the parasites of art," a quintessentially modern attack.[32] A subtle shift had taken place in which the enemy for most artists was no longer the Academy, which had become largely irrelevant, but was instead the anonymous state bureaucracy, which was just beginning to develop along professional lines. The Academy had, in many ways, outlived its usefulness as a state agency in charge of aesthetics, but the Third Republic's attempt to rule the arts by bureaucratic committee brought a whole new set of problems to the world of art.

To the majority of artists it looked as if the state was usurping its prerogatives by imposing on them the authority of functionaries, just when they had so recently freed themselves from Academic control. The view from the Right of the political spectrum was different, however. There the new

government policies were equally criticized, not as a modern reincarnation of traditional French centralization and paternalism, but as the evil fruits of democracy. Edmond About, editor of *Le XIXe siècle* and widely considered the spokesman for the conseil, chronicled the shift in the art administration to his readers:

For twenty years, a revolution has been going on relentlessly, day by day, in this very special and interesting world. The high administrators who controlled it wanted to be popular; little by little they introduced democratic customs into what is and should always be an aristocracy. They sacrificed the elite to the numerous; they enthroned the universal suffrage of artists as if artists constituted a guild, as if the first comers, without having attended the Ecole des beaux-arts and having no credentials other than faith and hope, had the right to call themselves artists. The Institute, natural adviser to the state and partner in its sovereign authority, did show itself to be, from time to time, a little bit exclusive. In addition, it was suspected of opposing the established government. The state then retaliated by tying its hands and by conferring on the majority of artists or on their elected delegates more and more unlimited power over admission to the Salon and its rewards.[33]

The critic Albert Wolff noted "a real danger for the free development of art" when the Salon jury was limited to the Academy, "a choice of men all representing one single principle."[34] Of all the exhibition juries of the period, that of the Triennale had come the closest to that Academic ideal, but the experiment had not been a success. In the legendary wars between the Salon juries and modernists, it can easily be forgotten that neither the juries nor their shows were homogenous. Despite frequent rejections, the Impressionists and members of every other camp did manage to show in the Salons of the Third Republic. Between 1859 and 1886 most members of the Impressionist circle actually had a majority of acceptances.[35] Degas and Morisot were never refused, and Manet was shut out only three times in twenty-seven years. Although they may not have had all their pictures accepted and although their work was often badly displayed, they nonetheless did manage to exhibit, whereas in the Triennale they, and a majority of French artists, were completely locked out.

When Edmond Turquet announced the demise of the Triennale at the awards ceremony of the 1885 annual Salon, he was greeted with thunderous applause by the assembled artists, and thus the issue of the Triennale was closed.[36] By 1885, the "Republic of the arts" had been founded with all the same virtues and drawbacks of the Republic itself. The

abandonment of the annual Salon coupled with the repudiation of the Triennale meant an end to the whole tradition of officially privileged artists in the exhibition system. The change came just as the Third Republic achieved another of its cherished goals, the elimination of lifetime tenure for senators. From 1884 on, they also would be obliged to "go before the jury," that is, to get themselves reelected.[37] And so France in the mid-1880s, in both art and politics, underwent a major reevaluation and rejection of the concept of privilege.

From 1885 on, there were no longer any regularly scheduled state-sponsored exhibitions in France. Artists had been freed from government tutelage and were now irrevocably part of the free-enterprise system. Did this mean that either the self-proclaimed Indépendants, who organized their own exhibitions, or the unaligned independent artists, who still wanted to show in the now-unofficial Salon, were finally "free"? When Charles Gounod, president of the Academy, had told that assembly in 1883, "Although it is commonly accepted that what is called individuality means independence and that independence means liberty, this is a profound error," he actually understood the chasm between the rhetoric

45 Pif, *Croquis*. "The truly independent artist will remain next to his work, ready to change it drastically as soon as the public reveals its preferences." *Le Charivari*, May 18, 1884.

127

and the reality far better than did many of the proponents of modernism.[38] Zola, for example, recounted all the drawbacks of state control of the art education and exhibition system, concluding: "This is what makes the most independent talented artists remain servile, bowing and scraping before functionaries."[39] He, Duranty, Castagnary, and other partisans of the avant-garde continuously juxtaposed state tutelage with "liberty," blithely confident that the termination of state control would inevitably lead to the advent of artistic freedom. The elusiveness of "independence" only gradually became apparent when market forces stepped in to assume the regulatory role vacated by the state (Figure 45).

THE REPUBLIC OF THE ARTS

THE period from 1880 to 1885 saw the termination and collapse of the official French Salon system. Although most studies of this period explore the forces of innovation and the rise of modernist art and aesthetics, here we have followed instead the forces of resistance and the persistence of the old order. The abandonment of the state Salon in 1880 followed by the establishment and subsequent collapse of its replacement, the elite Triennale of 1883, mark a watershed in the history of late nineteenth-century French art. After this, the dealer–critic system remained unchallenged as the determinant of artists' success. This system was not new, of course. It had been growing steadily for several decades, but after 1885 it became the unchallenged arbiter of French artistic life, replacing official salons, honors, commissions, and medals.[1]

As an example of this change, we might cite the experience of the dealer Louis Martinet who in the 1860s established a "Société nationale des beaux-arts" whose exhibitions, he hoped, would rival the Salon.[2] But despite exhibitions featuring the work of the most prominent artists, from Ingres and Bonnat to Manet and Carpeaux, and despite laudatory critical reviews, the enterprise failed even to meet its expenses because during this earlier period, private initiatives could not compete with the prestige of state-sponsored shows. By 1880 there were still, according to Renoir, eighty thousand Parisian collectors who would not buy an inch of canvas unless the painter was in the Salon.[3]

By 1890 the official Salon no longer existed but had been replaced by three major annual exhibitions, each with a somewhat different aesthetic stance. Although there was a good deal of overlapping participation (most artists showed wherever and whenever they could), the popular Salons of the Société des artistes français, the largest, were dominated

by *juste milieu* artists, whereas the greatest stylistic variety could always be found at the unjuried Salons of the Indépendants, where many of the Postimpressionists showed. The Salons of the Société nationale des beaux-arts, founded in 1890 under Meissonier's leadership, were the most exclusive, showing established artists in an elegant setting and including, for the first time, the decorative arts.[4] The 1880s were clearly, then, a time of major transformation of the practices and institutions of art.

Although I have identified the immediate factors that resulted in the end of the Salon as issuing out of the moral order governments of the 1870s, history should not be trivialized by the assumption that such momentous events can be precipitated by short-term circumstances. Rather, the contradictions that eventually resulted in the collapse of the Salon were created with its reorganization in 1791. Nonetheless, although Academic and other aesthetically conservative forces were on the defensive for most of the nineteenth century, steadily losing ground in both institutional prerogatives and aesthetic influence, they still were sufficiently powerful to resist, and from time to time to reverse, the gradual erosion of their position. The history of the Salon amply demonstrates this, for although it increased in size and democratization, this process was interrupted several times by successful rearguard skirmishes, such as Nieuwerkerke's reinstatement of the Academic jury in 1857. Such victories could not be sustained, however, and from the 1863 Salon des refusés to the end of the Second Empire in 1870, the Salon's rapid liberalization seemed destined to end in an institution completely run by artists.

This process was dramatically interrupted, for the second time, by the Franco-Prussian War. In the aftermath, as Daniel Halévy noted, all the Old Regimes returned in force, and old battles previously won had to be refought – but with unforeseen results. For if restorations are usually characterized by a return to the past and also a hardening of position, as witnessed by the return to order of the 1870s, then their subsequent defeat often results not in a reinstatement of the status quo but in what the French call *une fuite en avant,* a rush into the future. The attempt by Academicians and other moral order conservatives to suppress the annual Salon and reinstate their own elite long-interval exhibition led to the collapse of the entire state-run exhibition system and its replacement by a variety of free-market alternatives, ranging from salons large and small sponsored by private societies to the commercial

galleries characteristic of the modern system of art distribution.

Although modernist art history has taken little notice of the events studied here, the "persistence of the Old Regime," as Arno Mayer termed this phenomenon,[5] must be acknowledged and examined in depth, for in numerous revivals, it has demonstrated its continued vitality. Never has a French institution been pronounced dead more often than has the Academy with its ideology of classicizing historicism, and yet even in the twentieth century, it has been able to maintain its continued grip on French high culture.[6] Is it any wonder, then, that as the heir to centuries-old traditions the Academy seemed to offer in the 1870s and 1880s, as did monarchism itself, not just order and stability but also nationalism and glory?

The classically inspired historicism that was the goal of the return to order served a political purpose in attempting to unite France in troubled times through support of its past cultural and national traditions. Insofar as modernist artists rejected the classical basis of high art, as either subject matter or formal idealism, they were setting themselves against not just an entrenched ideology of aesthetics but a nationalist one that permeated the entire French educational system. As an example, during Jules Ferry's first term as minister of public instruction in 1879, his attempt to reduce the emphasis on Greek and Latin in the French school system in favor of living languages almost led to his losing office.[7] As late as 1900 more than half the curriculum of French lycées was still devoted to classical languages, to grammar, and rhetoric, whereas despite Republican reforms, only one-eighth of the students' time was spent on science.[8]

The resilience of the classical tradition in France came from its ability to adapt and to compromise just enough to present the look of modernity while maintaining its superiority as official high culture; this was apparent at the 1883 Triennale. Classically inspired institutions such as the Academy and the Ecole des beaux-arts benefited from this entrenched institutional power and could thus maintain a residual influence even among Republicans who were in principle opposed to the ideology and the system of privilege that these institutions professed. Only when we have understood this Republican ambivalence toward the institutions of high culture does the government's ambivalence toward the concept of the Triennale make sense.[9]

The establishment and demise of the Triennale is important

because even given the short-term ability of the Academic party to marshal the resources of government to its support, aesthetic conservatives could not sustain the effort necessary to redefine the major institution of art distribution, namely, the Salon. The Academy's isolation was thus delineated all the more keenly. Art historical investigations have tended to follow shifts in art production by focusing on individual artists' careers. It is often remarked, for example, that Degas did history paintings in his youth and then later switched to the genre subjects from contemporary life that characterized early modernism. An investigation of art institutions, however, shows a concurrent process in which these systems were no longer able or willing to sustain the values of the art enterprise as defined by Academic practitioners. Although the collapse of the Triennale and everything it stood for in no way indicates a shift in government allegiance to modernist aesthetics, nonetheless by the mid-1880s not the critics, or the public, or the government administration, or the masses of artists supported a restitution of Academic values. The social, political, and economic structures reinforcing Academic hegemony had, over the century, slowly crumbled, causing the systemic collapse apparent in the debacle of the 1883 Exposition nationale triennale, attacked by artists, unvisited by the public, ignored by the critics, and, eventually, abandoned by the state. Seen in this context, the Salons of the new Société des artistes français, whatever their failings, were a major success. If the collapse of the official Salon system proved anything, it was that in the end, each "sympathetic grouping" of artists needed to establish its own exhibition venues. And from the 1870s onward that is exactly what they did.

The Universal Expositions, taking place in 1855, 1867, 1878, 1889, and 1900, came closest to the Academic ideal of the regularly scheduled long-interval exhibition, but in an international context and subject to the political exigencies of the moment, the governments of neither the Second Empire nor the Third Republic ever fully backed the conservative aesthetic program and proved unwilling to entrust these events wholly to an Academic jury. In 1867, the low point of Academic influence, the Second Empire provided no statutory representation of the Academy, but in 1878, the high point of moral order in art, the Universal Exposition admissions jury was one-third each named by the Academy, appointed by the government, and elected by the artists. In this context we can see the conservatism of the 1883 Triennale, whose

jury was completely appointed by the government, with Academicians making up half its members.

The Academy's dominance then waned, and the juries for the Universal Expositions of 1889 and 1900 were half elected by the artists' societies and one-fourth each appointed by the government and the Academy. These juries thus ended up representing virtually all constituencies in the art world (albeit with an emphasis on the *juste milieu*), and the shows themselves were mixtures of the elevated and the popular, to the disappointment of true conservatives. In this context, these Décennales failed to achieve the principal aim envisioned by aesthetic conservatives, namely, Academic restitution and the elimination of marketplace art as the dominant vehicle of French culture.

What is at issue here, above the clash of the different constituencies of artists, is the very purpose of government-sponsored exhibitions. The language used to attack the annual Salon emphasized its commercial character: The Salon, it was charged, had become a marketplace, a store, a bazaar. The language that accompanied pleas for its replacement by the Triennale stressed the importance of reserving a leading and active educational role for art. In the rhetoric of nineteenth-century aesthetic conservatism, the Triennale was an elite exhibition [*exposition de choix*], but in the language of Republicanism, it was an educational one [*exposition d'enseignement*].[10] For Republicans – and this ideology was established in the 1790s and continued through the Third Republic – exhibitions should be "major schools of visual education" demonstrating "the most serious influence on public taste and on the development of a national art."[11] Education and nationalism were irresistible concepts to Republican statesmen, and help to explain why they supported the Triennale, a show that seemed so quintessentially aristocratic.

If the fine arts, along with the army, had remained the last bastion of conservatism – and with the Boulanger crisis of 1889 the army attempted its own Restoration[12] – then within the fine arts, the museum administration represented the last enclave of resistance. Gustave Ollendorff, director of museum administration, could still write in 1883: "Art is a religion that does not need many priests; it is aristocratic in nature. In order to remain pure and elevated, it should remain the patrimony of a small elite."[13] But after the advent of Republican rule, such sentiments, evocation of both religion and monarchy, seemed hopelessly anachronistic, redolent of the Old Regime. Outside the hallowed walls of the Louvre, art

was rapidly being absorbed into the new economic order of free enterprise.

THE REPUBLIC OF THE ARTS

Official French high culture was traditionally historicist and classical, and at no time was this more important than in the 1870s following France's humiliating defeat in the Franco-Prussian War. The influence that the institutions of high culture could still muster, and the sudden urgency that this endeavor assumed in the aftermath of the disastrous events of the war, accounted for the establishment of the Triennale after almost a century of debate.

The abandonment of the Salon, though linked to the Triennale, is a more elusive event, and for an explanation we might look to Republican unease on the question of easel painting in general. When we survey the artistic achievements of the "Republic of the arts," we quickly notice the absence of any real government effort in support of easel painting; indeed, the major Republican contribution in this area was the abandonment of the Salon. In view of Republican ambivalence in dealing with institutions of high culture, it is no surprise, then, that the major governmental artistic achievements seem to have been concentrated outside Academic jurisdiction, either in the areas of architectural engineering and technology, such as the Eiffel Tower and the 1889 Galerie des machines, or in support of the decorative arts. Miriam Levin showed that architecture and decorative arts were utilitarian areas in which the Republican interest in technology could be combined with economic and aesthetic issues, whereas the Republican efforts to encourage artisanal production for the export trade resulted, as Debora Silverman demonstrated, in official support and encouragement for Art Nouveau.[14] These concerns were completely extraneous to easel painting. The best the Republic could do – and this does represent an achievement – was to institute a massive campaign of "decorative" painting for monumental architectural spaces such as the Panthéon. But as we have noted, this program could not ensure a livelihood for very many French artists.

Although scholars have attempted to identify a Republican style in painting, with few exceptions most prominent Republicans either had little interest in painting or preferred the prevailing *juste-milieu* styles, a slightly modernized classicism

or a slightly classicized modernism.[15] Although small-scale sculpture could be subsumed into the category of decorative arts that Republicans supported, easel painting had no place whatsoever in their program. This is why Republican efforts in the fine arts tended toward the institutional, such as the public works projects, or the introduction of drawing instruction in French schools. Despite all the praise of individuality, individual creativity was bypassed as an issue in favor of encouraging institutions, such as the Société des artistes français or the Union centrale des arts décoratifs, which could promote artists' livelihoods as small producers.

The "Republic of the arts" resulted in the transformation of artists into the small businessmen and entrepreneurs of Gambetta's "new social strata." And though the statutes of the Impressionists' Société anonyme are often cited as having been modeled on a bakers' union, as though this combination of art and commerce was somehow incongruous,[16] in fact all the newly founded artists' societies were drawing up statutes during this period as the artists struggled to redefine themselves from subjects of an Empire to citizens of a Republic. Jean-Paul Bouillon labeled these decades "the time of societies," a transitional moment coming "between the epoch when Academies reigned and our contemporary period ruled by the laws of the marketplace."[17]

The attempt to hold an exhibition united by some aesthetic principle is one we attribute to the various avant-garde secession movements that sprang up in the later nineteenth century, but during this period it was rapidly becoming apparent to all parties that new types of exhibition would be necessary. The variety of styles had become so extreme and the Salon exhibitions so huge that the viewing public was finding them incoherent, a word that appeared often in the critical discourse of the period. Since the July Monarchy, conservatives had been referring to the Salon derisively as a market or a bazaar, a thinly disguised reference to the rampant capitalism they saw infecting modern life. By the Third Republic, a new term of insult had come into use. To conservatives, the Salon was now *la Babel officielle,* a polyglot assemblage which they contrasted unfavorably with the one true aesthetic language consecrated by tradition and the Academy and displayed in history painting.[18]

This "official Tower of Babel" worked to the detriment of all artists. Although many continued to exhibit there, just because it was visited by hundreds of thousands of Parisians each spring, artists and collectors increasingly preferred smaller

exhibitions where they and their works could be seen to better advantage.

These smaller exhibitions fell into three major groupings: private gallery shows, such as those of Georges Petit or Durand-Ruel; exhibitions of artists' societies, such as the Société des aquarellistes français; and exhibitions held by *cercles,* the private clubs that Maurice Agulhon described as the typical form of bourgeois sociability in nineteenth-century France.[19] Whereas the Salon was a public site open to visitors from all social strata, the smaller exhibitions intentionally limited their audience to the affluent classes. The societies and *cercles* were open only to members and their guests, although free passes were readily available to the desired public; *La Chronique des arts et de la curiosité* often carried notices to its readers that they could obtain entry passes for such shows at its offices.[20]

The journal *La Paix* described these new types of art exhibitions:

The custom of having these small exhibitions is fairly recent in Paris and results especially from the prodigious expansion that has taken place at the Salon, which, in the last few years has turned into a real market hall. The quantity of works shown there is such that the majority of them pass unnoticed. The public here, it is true, is less numerous, but it is also more select, in the sense that everybody goes to the Salon, but the small expositions are attended only by those particularly interested in the arts.[21]

The best people, it seemed, now loathed the Salon, as this description from the fashionable journal *La Vie parisienne* makes clear:

Quite definitely, the central marketplace of painting has had its day. Nothing could be more unfashionable, more vulgar, more sickening than this immense bazaar on the Champs-Elysées, where exhibits of vehicles, cheeses, and pictures follow one after another. . . . Do you know anything more odious than the banal exhibitions at the Palais de l'Industrie where scrap-iron arcades, rags of green fabric, and the smells of excrement debase everything that has the misfortune of being shown there?[22]

In contrast, art galleries such as Georges Petit's (Figure 46) provided the elegance that the reviewer for *La Vie parisienne* obviously missed:

Imagine that a few feet from the boulevard de la Madeleine a contemplative temple, a luxurious gallery announces itself by great staircases and high vestibules, with antique busts, rare flowers, soft carpets. On marble floors carpeted with velvet, the comings and goings of fashionable Parisians complete the decor, the most

Bien décidément les Halles centrales de la Peinture ont fait leur temps. Rien de plus démodé, de plus commun, de plus nauséabond que cet immense bazar des Champs-Élysées, où se succèdent les voitures, les fromages et les tableaux. Les aquarellistes, en se mettant dans leurs meubles les premiers, avaient donné timidement l'exemple. Voici un résultat hors ligne de leur essai encouragé.

Figurez-vous, à deux pas du boulevard de la Madeleine, un temple recueilli, une galerie luxueuse, s'annonçant par de grands escaliers et de hauts vestibules, avec bustes antiques, fleurs rares, tapis moelleux. Sur les dalles recouvertes de pourpre, un va-et-vient de toilettes parisiennes complètent ce décor, à la fois le plus parisien et le plus artistique qu'on puisse voir. Avant d'entrer, on se sent pris d'indulgence, presque de respect pour ce qu'on va voir. Toute idée vulgaire ou hostile disparaît rien qu'à soulever ce grand rideau de velours sur cette vaste galerie tapissée d'étoffe rouge, où les cadres scintillent, où les couleurs éclatent harmonieuses et chaudes sur ce fond calculé si à point. Savez-vous rien de plus odieux, aux expositions banales du Palais de l'Industrie, que ces arcatures de ferrailles, ces lambeaux de lustrine verte et ces odeurs de crotin qui ravalent tout ce qui a le malheur d'y être exposé! Ici, au contraire, sous la lumière bien dirigée, par l'opposition du ton riche et chaud des étoffes de fond, le moindre coloriage prend les proportions d'un tableau. Donc, amateurs, préparez votre or; toute œuvre qui s'exposera et se vendra ici désormais, sera déjà cotée au plus haut par le seul fait d'une exposition dans un pareil milieu.

46 *The New Exhibition Space at the Rue de Sèze* [Galerie Georges Petit], *La Vie parisienne,* February 25, 1882, Bibliothèque nationale, Paris.

Parisian and at the same time the most artistic that one could see. Before entering, one is suffused with goodwill, almost respect for what one is about to see. All vulgar or hostile ideas disappear as soon as the great velvet curtain is opened onto this vast gallery upholstered in red fabric where picture frames glisten and where warm and harmonious colors stand out against this perfectly designed background.[23]

The article closes with the prediction that "every work exhibited and sold here from now on is already highly valued just by having been seen in such a place."[24] Works at the Salon, in contrast, would be debased, would lose their value to fashionable collectors simply by having been seen there. No wonder, then, that the fashionable artist Fagerolles in Zola's *L'Oeuvre* refused to send work to the Salon, saying, "I didn't want to exhibit there, it lowers the value," and it is even less surprising that his astute dealer Naudet also opposed his participation.[25]

The Salon with its thousands of artists functioned like a port of entry for younger unknowns, but the *cercles,* societies, and galleries dealt in more established reputations. Most of the artists who showed there regularly were fashionable Salon artists, even Academicians, whose work appealed to the even more fashionable affluent classes that patronized these establishments; the works of artists such as Eugène Lami, James Tissot, Gustave Doré, Eugène Isabey, Carolus-Duran, de Nittis, and Jules Lefebvre could be found there. "Exhibition rooms are transforming themselves into aristocratic salons," wrote Zola, "where the pictures are expected to be as smooth and fine as the skin of a pretty woman."[26]

If we were to place the series of Impressionist exhibitions from 1874 to 1886 in the context of the period discussed here, we would find that in fact their Société anonyme was typical of artists' societies; their shows actually received far more critical attention than did most such exhibitions.[27] These Impressionist exhibitions differed from the gallery and *cercle* shows, however, in that the Impressionists asked an entrance fee but were open to all visitors. They were, in fact, seeking an audience that had not yet declared itself, whereas the other private exhibition societies already knew their audience and catered to it. As Martha Ward pointed out, the fact that the Impressionists had no permanent exhibition venue, as did the galleries, *cercles,* and societies, was a major determinant in the perception of their group as marginalized.[28]

The question arises as to why, beginning in the 1870s, it should have been imperative to exclude the populace from

exhibitions. For over two centuries the Salon had been the preeminent site for the intermingling of the classes in France, until the definitive establishment of the Third Republic succeeded in blurring once-clear class distinctions. Culture rapidly became a class attribute in an increasingly fluid society in which such marks of "distinction," to use Pierre Bourdieu's term, had to substitute for the older criteria of birth and breeding. But we do not have to look for arcane explanations for the attractiveness of exclusive social experiences. I suggested in Chapter 3 the term *aesthetic protectionism* for the desire of artists in the early 1880s to turn inward and exhibit only with like-minded colleagues, as a way of defending themselves against the competition, the incoherence, and the complexity of the full range of aesthetic possibilities available in the outside world. Accordingly, the phenomenon of these smaller exclusive exhibitions might be termed *social protectionism* in that in the face of the social disorders of the century, culminating in the Paris Commune, it was increasingly problematic for members of the affluent class to mingle easily and unprotected with representatives of the lower orders.

A lithograph (Figure 47) shows well this new anxiety toward "the Sunday crowd," which came on the only free day. All the individuals shown here are caricatured members of social classes, from the working man and woman in the foreground, to the well-dressed bourgeois couple, even to the few top-hatted gentlemen in the rear, ominously buried by the lower orders. The military presence is overwhelming in this image, witnessing the necessity of keeping order in public places, of controlling the lower classes. This is an uncomfortable image, almost a menacing one, especially if we compare this version of the viewing experience with the reassurance provided by the fashionable gallery of Denman Tripp (Figure 48), from which the lower classes are simply absent. On entering Georges Petit's gallery, the critic from *La Vie parisienne* promised, "all hostile and vulgar ideas disappear,"[29] but what had really disappeared were the hostile and vulgar classes. It was no longer desirable or even possible to imagine the peaceful intermingling of social classes on the common ground of art, a common enough trope in earlier depictions of the Salon, such as Figure 5.

The new importance accorded to interior design and decoration in these decades – and the new viewing spaces show that well – must also be understood in relation to what is tacitly resisted. In his highly influential *Grammaire des arts*

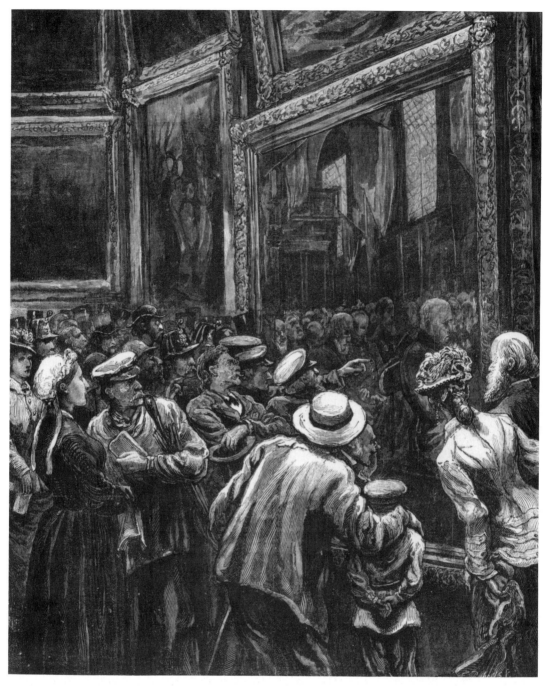

47 *The Sunday Public Visiting the Fine Arts Gallery on the Champ-de-Mars,* 1878, Bibliothèque nationale, Paris.

décoratifs, Charles Blanc wrote: "Everything merges in a pri-
mordial cause, generator of the movements of the universe,
ORDER." He even presented a schematic diagram showing
its importance (Figure 6).[30] Blanc's emphasis on ordered
interiors is only the obverse of disorderly exteriors. "Whoever
has just experienced the tumult and noise of the street should
expect to find some calm in the interior of the house he en-
ters," wrote Blanc; "This impression depends first of all on
the tranquillity that results, in a softly lit space, from furni-
ture arranged in good order, each piece in the place that the
division of walls and beams assigns to it."[31]

Disorder in the streets was almost the constant condition
of life in nineteenth-century France, particularly in Paris.
Although every generation experienced its own revolution,
nonetheless, the Paris Commune of 1870–71, with hand-to-
hand fighting in the streets and over twenty thousand deaths,
seems to have terminally poisoned class relations. A right-
wing authoritarian government might have reassured the
affluent classes, as the moral order governments of the 1870s
tried to do, but a Republican government, even an Oppor-
tunist one, raised the specter of encouraging such segments
of the populace as we see in Figure 47. And so the explicit

48 *New Galleries of
Denman Tripp, Rue de
Provence,* 1883,
Bibliothèque nationale,
Paris.

call for order in the 1870s became, in the 1880s, an example of what Frederic Jameson called "the political unconscious." During these years, the menace of disorder in the streets was countered by the ideal order of new interior spaces from which, as *La Vie parisienne* noted, hostility and vulgarity were eliminated. Blanc's soothing vision of each piece of furniture in its assigned place is the aesthetic counterpart of the nostalgic vision of the Old Regime, in which individuals knew and accepted their place in the social hierarchy. As the outdoor views of urban life favored by the Impressionists were gradually displaced by the interior visions of the Post-impressionists, this desire for order found its formal analogue in the works of Cézanne, Seurat, and their followers.

In the small elegant gallery and society shows, aesthetic and social protectionism often operated together. Georges Lafenestre, commissioner general of exhibitions, commented on the advantages of this new type of exhibition:

We have recognized the value of these rare assemblies of methodically grouped works that permit the profitable study of an artist or a group of artists in their intimate manifestations. We have savored there this delicate pleasure of easy comparison and prolonged delectation that is absolutely forbidden to the bewildered explorers of the official Babel.[32]

This is what Turquet had attempted, albeit unsuccessfully, in the last government-sponsored Salon of 1880 with his "sympathetic groupings" of separate categories within the exhibition.[33] Whereas artists whose work was salable and appealed to a wide audience could easily shift their professional focus from the huge government Salon to private exhibitions in galleries or *cercles,* and whereas artists of the avant-garde had begun to organize their own secessionist exhibitions, those artists whose audience was often limited to the Academy and to the government art administration were forced to appeal to the government to organize for them this same type of stylistically unified show. Hence the Triennale. Not surprisingly, it was the sculptors who proved least likely to boycott the Triennale, for as Jules Ferry had pointed out in 1879, "Here is an art whose principal client is the government."[34]

The conservative desire to mount a stylistically unified exhibition becomes more understandable when we examine the art milieu within which all artists were forced to operate. In August 1883, Maurice Du Seigneur surveyed all the major Parisian exhibitions of the preceding year for *L'Artiste*.[35] A brief summary reveals the competition that the artists' annual Salon, formerly a monopoly, now faced.

By 1882–83, the Salon of the Société des artistes français already had an active competitor in the Musée des arts décoratifs, which had begun to hold its own regular exhibitions of decorative art. In addition, there was a show of major examples from the state furniture collection that year and, also at the Musée des arts décoratifs, an exhibition of Japanese painted objects organized by Siegfried Bing, who would become the driving force behind Art Nouveau. The Ecole des beaux-arts traditionally held exhibitions of recently deceased major artists: Courbet and the Academician Henri Lehmann were so honored during this period. There had also been two major historical shows, *Portraits from This Century,* with work from all the major artists, at the Ecole des beaux-arts, and a show of works relating to the philosopher Jean-Jacques Rousseau at the Pavilion of the city of Paris. Then there were the annual exhibitions of all the *cercles* and private societies (Figure 49): the Société d'aquarellistes français, the Cercle de

49 Draner, *Actualités.* "If only there were enough scrapings from all that to nourish someone who is hungry." *Le Charivari,* February 22, 1884.

l'union artistique (called Les Mirlitons), the Cercle artistique et littéraire de la rue Volney, the Union des femmes peintres et sculpteurs, the Impressionists (Du Seigneur called them "the Indépendants"), and the Cercle Franc-comtois, about which he commented, "The intimacy of this little Salon contrasted nicely with the *demi-mondaine* ambience of the other *cercles.*" Paul Baudry showed his work at the Orangerie; Tissot and Lepic, at the Musée des arts décoratifs.

In addition to all this, Georges Petit, in the inaugural year of his splendidly appointed gallery, mounted show after show: Alfred Stevens, Japanese art, and – twice – his Société internationale de peintres et sculpteurs. This latter group, informally called *Les Jeunes,* included Bastien-Lepage, Boldini, Cazin, Liebermann, and Sargent. Although their art could hardly be called radical, Du Seigneur wrote that their 1882 show at Petit's was a protest against that year's artist-run Salon – in only the second year of its organization! Georges Petit's *pièce de résistance,* however, was his show *A Hundred Masterpieces,* with a handsomely illustrated catalogue written by the prominent art critic Albert Wolff. Compared with this, it is no wonder that the catalogues of the annual Salon, forced to include advertisements to subsidize the printing costs, seemed tawdry and commercial. Petit's luxurious catalogue did not need to include any extraneous advertisement because it was in its entirety an advertisement.[36]

THE EXHIBITION AS STORE

Let us look more closely at the dynamics of commercial transformation in the late nineteenth century as manifested in systems of art distribution. The concept of market differentiation as a recognized stage in the development of capitalism, in which specific kinds of goods are brought to their proper audiences, was introduced to this discussion in Chapter 4, with the observation that this process broke down in the increasingly democratic Salon in which consumers of all varieties were frustrated in their attempts even to locate the art they liked. The solution was to be found in smaller shows, Turquet's "sympathetic groupings" or Lafenestre's "rare assemblies of methodically grouped works," which recognized that visibility and homogeneity of the product were necessary for market coherence. The rise of the department store (Figure 50) is, of course, the major retailing innovation in the second half of the nineteenth century, challenging the

hegemony of the small shopkeepers. Just as the new *grands magasins* established separate departments for various kinds of goods, so did Turquet in 1880 try to subdivide the Salon into homogenous groups, "departments," we might call them. Artists and dealers, the small shopkeepers of the art world, found a simpler solution by mounting smaller unified shows.

Among the small shopkeepers of late nineteenth-century France there were two major factions. One was traditional minded, backward looking, and fearful of competition; they represented reaction in the name of tradition against the encroachment of modernity. More entrepreneurial shopkeepers, however, took advantage of their ability to introduce new products, to specialize, to offer a variety and a range of styles in a single item. Whereas impersonal mass marketing characterized large department stores (and the Salon), small shops (like the dealers or *cercles*) could offer personal attention and exclusivity.[37] We can see this difference by comparing the photograph of the 1883 Salon (Figure 38) with the lithograph of Denman Tripp's gallery (Figure 48).

In order to survive, the small shops had to adapt their selling techniques to the new market conditions. One of the most successful ways was to cloak in elegance the commercial intent of the display. Genteel shop owners – and among art

50 *Le Printemps Department Store,* Paris, 1883, Bibliothèque nationale, Paris.

145

dealers Georges Petit stands out – did their best to disguise the fact that their shops were places of business.[38] The ambience of their establishments was intended to convey that they were offering not commodities but elegance and distinction in an industrializing world of too much being the same.

Even the department stores tried to do this; the Bon Marché, for example, established its own art gallery (Figure 51), modeled on the Galerie d'Apollon in the Louvre and decorated with ceiling paintings by Henri Lévy – the same Henri Lévy who did *The Coronation of Charlemagne* for the Panthéon (Figure 12). His theme for the Bon Marché, *Industry and Commerce Vying to Adorn Beauty*,[39] was clearly intended to raise the prestige of the department store through its association with high culture. This attempt was largely unsuccessful, however, for department stores as well as Salons were criticized by conservatives as "bazaars" or "towers of Babel" where shoddy mass-produced goods triumphed over quality and art.[40] Both the Salon and the department store, conservatives charged, specialized in cheaper merchandise that attracted a more popular and democratic clientele.[41]

51 *Au Bon Marché*, advertisement, 1875, Bibliothèque nationale, Paris.

The two major groups of artists were the nonexempt independents and those with entrenched privilege, namely, the Academicians and official artists. We might see a parallel here between the Republican government's supporting the "nation of small shopkeepers" that had set itself against the big Orleanist commercial and industrial interests and the same government's ultimately siding with the independent artists against the privileged artists of the Triennale. If the department store was seen as the enemy by both the backward looking conservative shopkeepers and the more modern elite boutique owners, so too was the annual Salon seen as the enemy by both the aesthetically conservative artists who wanted a return to the old order and the modernist artists who were often excluded from it.

Philip Nord argued that both the lavish boutiques and the department stores were a new cultural phenomenon catering to *arrivistes, nouveaux-riches,* and *parvenus* (the French language is particularly rich in words of scorn for this unfortunate class). We might see the developments in art distribution in the same light, with the enormous commercial Salon and the smaller *cercle,* society, and gallery shows all resulting from the same pressures. In its attempt to return to an earlier noncommercial tradition, the Triennale was just as much a product of these forces. When Nord writes, "The commercial struggle for life took a fresh turn under the Second Empire, obliging small shops to abandon established, familiar ways of conducting business in favor of new methods better suited to attract and process an expanding clientele,"[42] we can substitute "artists" for "small shops" and thus arrive at an accurate depiction of changes in art institutions witnessed by the Third Republic.

LIBERTY

With the demise of the Triennale, the government was rapidly abandoning its traditional role of directing art and would substitute liberty as the guiding Republican aesthetic as well as economic principle. The Republican aesthetic ideal was to include all parties, in order to create in art, as had been done in politics, the system that was the least divisive. Turquet described his ideal Salon as "all groups, all categories, all cliques, the studies of every school should find a place there, one next to another, a Bouguereau next to a Ribot, a Baudry alongside a Manet."[43] The principle underlying this was an

extension into aesthetics of what had worked well for the Opportunist Republicans in politics.

But as we have seen, the first Republican attempts to reform the annual Salon met with such disaster in 1880 that it was abandoned altogether. The Republican strategy of giving the annual Salon to the artists while providing a Triennale to appease the traditional elite was also a failure. The end result was that Republican art policy with regard to easel painting ultimately represented – no less than did that of its much despised predecessor, the Second Empire – a general retreat from the traditional state role of directing art to the more passive position of purchasing individual works.

By the late 1880s, Gustave Larroumet, director of fine arts, accepted the pluralism that had now come to characterize French art: "Ten years is now sufficient to see a school be born and die. The smaller they are, the more they multiply. Instead of mutually replacing each other, they coexist."[44] This "coexistence" was in fact just what French political parties were learning to do during these years, for the period of *ralliement* – when conservative Catholics and monarchists ended their bitter opposition to the Republic – is usually dated by historians to 1885, the year of the collapse of the Triennale.[45] Just as the official policy of the Second Empire had been to support all the various styles of art, so by 1890 the earlier directive role of the Third Republic art administrations was abolished as reeking of the past:

But just as it [the state] no longer favors one literary or scholarly school in preference to others, it no longer attempts to have this or that theory of art dominate. . . . This conception is essentially modern and democratic; it is opposed at every point to the authoritarian conception of the Old Regime.[46]

After the interlude of the return to order period, government policy was eventually forced to pick up where the Second Empire had left off, by acknowledging the realities of the contemporary art world. According to Larroumet, the state was now on the side of both individual liberty and free enterprise, a position anticipated by Jules Ferry, who had announced his program of liberty and individuality in 1879, the year of the Republicans' accession to power.[47] Larroumet defended this new government philosophy:

In our time, the state no longer has any exclusive doctrine, and no more than it teaches an official aesthetic does it form its museums in order to serve a cause, to support what strengthens it or to cast aside what combats it. It should be the impartial spectator of the

struggles of opinion that are set forth around it, to be sensitive only to talent, to affirm it, and to aid it everywhere it is encountered.[48]

The government's newfound determination to remain neutral while supporting only "quality" was strengthened by the economic realization that if the state waited to correct its mistakes until after an artist's death, it would be very expensive indeed:

For fifty years, the state systematically shunted aside in its purchases all artists who worked outside the official formula. As a result, the masterpieces of Dupré and Millet, of Corot and Rousseau, of Courbet and Manet, did not enter our museums. It was then necessary to buy them back at great expense when they came up for sale or to renounce their acquisition when they were too expensive: As a result, the history of French art is incomplete at the Louvre and at the Luxembourg.[49]

By 1895 the fine arts director is no longer using the traditional term "the French school" [*l'école française*], always synonymous with history painting, but has substituted for it "French art" [*l'art français*], which is defined simply as the total of all the various styles and movements.[50] Nonetheless, at the same time as Larroumet was pledging government support for "quality," he admitted that the committee of twenty-one government functionaries that now decided on art purchases bought mostly landscapes. This represented a major shift from the earlier decades of the century when Grand Art alone, as Viel-Castel explained in the 1830s, was considered worthy of state support. Larroumet's explanation: "In landscapes and portraits, the qualities of execution are sufficient: These are even the only ones that might be judged. In the other categories it is necessary that we take sides on systems and theories, that is to say, on ideas."[51] With the advent of Republicanism, consensus and rule by committee had become important principles, and – a liability of democracy that is still with us – to achieve majority support, art had to offend none of the participating constituencies.

By 1890, the year that the Société nationale des beaux-arts broke away from the Société des artistes français to set up still another rival Salon, government art policy had come full circle, and "individualism," synonymous with selfishness in the earlier nineteenth century, had become the highest goal for art.[52] As Léon Bourgeois, minister of public instruction, stated in 1890,

For me, just as there is no longer either a state religion or a state truth, there is not and should not be any state art or state taste. I think that art is something essentially individual and that there can

never be a work of art where there is not initiative and individual will.[53]

In the course of twenty years, the Tower of Babel had become the Mansion of State. The official state eclecticism preached by the Second Empire had been reinstalled as Republican devotion to liberty.[54] But this did not represent the demise of either Academicism or classicism, nor was it the last return to order that France would experience. In similar circumstances after World War I, a new return to order gripped France's art world, and classicism again presented itself wrapped in nationalism and old glory.[55]

*

What has this book shown? That what happens in the world of art must always be seen as part of the larger political order and that the larger political struggle is reiterated there; that art institutions cannot escape the forces – economic, political, social – that operate elsewhere in the society, nor can artists operate above or outside history. In this study we have examined a brief but crucial moment in France, when it seemed almost possible that the past could be restored. But this aesthetic restoration did not work out either as its proponents vad hoped or as its opponents had feared, simply because institutions, in this case the Salon, are themselves products, just as much as individuals are, of the contemporary world in which they exist.

In the process of exploring the complex conditions under which the official Salon came to an end in France, after almost two hundred years of hegemony, I hope to have shed some light on how inextricably intertwined political and cultural history are, and if this study has in any way helped situate those manifestations of modernism, which are so often viewed in isolation from the circumstances in which they arose, that would indeed be a worthy accomplishment. An institutional analysis of the history of art always opens, inevitably, onto politics and, at the same time, onto works of art.

THE THIRD REPUBLIC FINE ARTS ADMINISTRATION

THE French political system in the Third Republic called for a president elected by the National Assembly. The president then appointed a prime minister, who held the title of vice-président (later président) du Conseil des ministres d'état; sometimes he also held a ministerial post. The prime minister formed a cabinet by appointing the other ministers, each of whom appointed the officials who held administrative posts under him.[1]

In consequence the ministre de l'instruction publique, who had fine arts and often religion under his jurisdiction and whose background was usually in education, not the arts, appointed the directeur des beaux-arts. Although technically subordinate to the sous-secrétaire d'état des beaux-arts (appointed by the minister of public instruction to oversee the different directors of art, music, theater, etc.), the director of fine arts was usually the highest authority in the fine arts and (in principle) had specific expertise in his field.

During this period, the under secretaries appear to have left the administration of the fine arts to the directors of fine arts. The major exception was Turquet, who served his first term without a director; Kaempfen, who was the director during Turquet's second term, was a political appointee and seems to have stayed in the background during Turquet's tenure. So unusual was it for the under secretary to intrude in fine arts affairs that Paul Mantz actually resigned because Logerotte was interfering in his administration.[2] The only radical shift during this period was the short-lived experiment of creating a cabinet-level Ministry of Arts; Antonin Proust held this post in the Gambetta government, responsible only to the prime minister.

In general, fine arts policies can be safely attributed to the director of fine arts, although on occasion, usually when his policies were either very unpopular or when they departed

Table 5. *The Third Republic Fine Arts Administration, 1870–90*

Président	Vice-président du Conseil des ministres	Ministre de l'instruction publique, des cultes et des beaux-arts	Ministre des beaux-arts	Directeur des beaux-arts	Sous-secrétaire d'état des beaux-arts
Government of National Defense (Sept. 4, 1870– Feb. 17, 1871)	General Louis Trochu Sept. 4, 1870	Jules Simon Sept. 4, 1870	—	Charles Blanc Nov. 15, 1870	—
Adolphe Thiers (February 19, 1871– May 23, 1873)	Jules Dufaure Feb. 19, 1871	Jules Simon Feb. 19, 1871	—	(Charles Blanc)	—
	Jules Dufaure May 18, 1873	William Waddington May 18, 1873	—	(Charles Blanc)	—
Maréchal MacMahon (May 25, 1873– Jan. 30, 1879)	Duc Albert de Broglie May 25, 1873	Anselme Polycarpe Batbie May 25, 1873	—	(Charles Blanc)	—
	Duc Albert de Broglie Nov. 26, 1873	Oscar de Fourtou Nov. 26, 1873	—	Marquis Philippe de Chennevières Dec. 23, 1873	Albert Desjardins Nov. 27, 1873
	General Ernest de Cissey May 22, 1874	Vte Arthur de Cumont May 22, 1874	—	(Chennevières)	—
	Louis-Joseph Buffet March 10, 1875	Henri Wallon March 10, 1875	—	(Chennevières)	—
	Président du Conseil des ministres				
	Jules Dufaure March 9, 1876	William Waddington[a] March 9, 1876	—	(Chennevières)	—
	Jules Simon Dec. 12, 1876	William Waddington[a] Dec. 12, 1876	—	(Chennevières)	—
	Duc Albert de Broglie May 17, 1877	Joseph Brunet May 17, 1877	—	(Chennevières)	—
	General Vte de Gaëtan Grimaudet de Rochebouët Nov. 23, 1877	Hervé Faye Nov. 23, 1877	—	(Chennevières)	—
	Jules Dufaure Dec. 13, 1877	Agénor Bardoux Dec. 13, 1877	—	Eugène Guillaume[b] May 27, 1878	Jean Casimir-Périer Dec. 20, 1877

President	Ministre de l'instruction publique	Ministre de l'instruction publique et des beaux-arts	Ministre des arts	Directeur des beaux-arts	Sous-secrétaire des beaux-arts
Jules Grévy (Jan. 30, 1879– Dec. 2, 1887)	William Waddington Feb. 4, 1879	Jules Ferry[a] Feb. 4, 1879	—	—	Edmond Turquet Feb. 5, 1879
	Charles de Freycinet Dec. 28, 1879	Jules Ferry[a] Dec. 28, 1879	—	—	(Turquet)
	Jules Ferry Sept. 23, 1880	Jules Ferry[a] Sept 23, 1880	—	—	(Turquet)
	Léon Gambetta Nov. 14, 1881	—	Antonin Proust Nov. 14, 1881	—	—
	Charles de Freycinet Jan. 30, 1882	Jules Ferry[a] Jan. 30, 1882	—	Paul Mantz[b] Feb. 2, 1882	Jules Duvaux Feb. 2, 1882
	Eugène Duclerc Aug. 7, 1882	Jules Duvaux[a] Aug. 7, 1882	—	Albert Kaempfen[c] Nov. 30, 1882 to Sept. 26, 1887	Jules Logerotte[d] August 10, 1882 (Logerotte)
	Armand Fallières Jan. 29, 1883	Jules Duvaux[a] Jan. 29, 1883	—	(Kaempfen)	Eugène Durand[d] Feb. 27, 1883 (Durand)
	Jules Ferry Feb. 21, 1883	Jules Ferry[a] Feb. 21, 1883	—	(Kaempfen)	—
		Armand Fallières[a] Nov. 20, 1883	—		
	Henri Brisson Apr. 6, 1885	René Goblet Apr. 6, 1885	—	(Kaempfen)	Edmond Turquet Apr. 11, 1885 to June 4, 1887
	Charles de Freycinet Jan. 7, 1886	René Goblet Jan. 7, 1886	—		
	René Goblet Dec. 11, 1886	Marcellin Berthelot[a] Dec. 11, 1886	—	(Kaempfen)	
	Maurice Rouvier May 30, 1887	Eugène Spuller May 30, 1887	—		
			—	Jules Castagnary Sept. 26, 1887	
Sadi Carnot (Dec. 3, 1887– June 25, 1894)	Pierre Tirard Dec. 12, 1887	Léopold Faye Dec. 12, 1887	—	(Castagnary)	—
	Charles Floquet Apr. 3, 1888	Edouard Lockroy[a] Apr. 3, 1888	—	Gustave Larroumet[e] June 12, 1888 (Larroumet)	—
	P. E. Tirard Feb. 22, 1889	Armand Fallières[a] Feb. 22, 1889	—		—
	Charles de Freycinet Mar. 17, 1890	Léon Bourgeois[a] Mar. 17, 1890	—	Henry Roujon Oct. 20, 1891	—

[a] These ministers had the title of ministre de l'instruction publique et des beaux-arts. Cultes (religion) was moved repeatedly to other ministries during this period.

[b] Directeur général des beaux-arts.

[c] Inspecteur des beaux-arts, délégué dans les fonctions de directeur des beaux-arts (acting director of fine arts).

[d] Sous-secrétaire d'instruction publique et beaux-arts.

[e] Délégué dans les fonctions de directeur de beaux-arts (acting director of fine arts).

too drastically from the politics of the current regime, he could be overruled by the minister of public instruction. Jules Simon, for example, overruled Charles Blanc in granting an 1873 Salon des refusés.[3] All final decisions were officially made by the minister of public instruction, usually on the basis of a report from the director of fine arts, a report that, in fact, often constituted a major policy statement.

Gustave Larroumet (director of fine arts, 1888–91) described the actual working relationship between the minister of public instruction and the director of fine arts as follows:

A minister taking office seems to say to his director of fine arts: "My dear director, I don't know anything about the fine arts, and I don't have the time to learn about them. Therefore, do whatever you think you should do. I have confidence in you, and I will sign with my eyes closed anything you put before me."[4]

NOTES

INTRODUCTION

1 Daniel Halévy, *The End of the Notables,* trans. Alain Silvera and June Guicharnaud (Middletown, CT: Wesleyan University Press, 1974), p. 7 (originally entitled *La Fin des notables,* Paris, 1930).

2 The only serious discussions of the 1883 Exposition nationale [triennale] are by contemporaries Paul Dupré and Gustave Ollendorff, *Traité de l'administration des beaux-arts,* 2 vols. (Paris: P. Dupont, 1885), vol. 2, pp. 171–81; and influenced by their reading of the events, Pierre Vaisse, "La Troisième République et ses peintres: Recherches sur les rapports des pouvoirs publics et de la peinture en France de 1870 à 1914" (thèse, doctorat d'état, Université de Paris IV, 1980), pp. 351ff. For a discussion of the entire series of double exhibition proposals, see Patricia Mainardi, "The Double Exhibition in Nineteenth Century France," *Art Journal,* Spring 1989, pp. 23–28.

3 Stanley Hoffmann, "Paradoxes of the French Political Community," in Stanley Hoffmann, ed., *In Search of France* (Cambridge, MA: Harvard University Press, 1963), pp. 1–117.

4 See Herbert Butterfield, *The Whig Interpretation of History* (New York: Norton, 1965), p. v.

5 I am using *modernism* here in the sense of Mallarmé, Fry, and Greenberg. The clearest articulation of what has been until recently the theoretical base of the historiography of nineteenth- and twentieth-century art is by Clement Greenberg, "Modernist Painting," *Source: Art and Literature,* Spring 1965, pp. 193–201.

6 Herman Lebovics, *The Alliance of Iron and Wheat in the Third French Republic 1860–1914: Origins of the New Conservatism* (Baton Rouge: Louisiana State University Press, 1988), p. 7.

7 See Walter Benjamin, "Paris – The Capital of the Nineteenth Century," in his *Charles Baudelaire: A Lyric Poet in the Era of High Capitalism,* trans. Harry Zohn (London: NLB, 1973), pp. 157–76; and Walter Benjamin, "The Work of Art in the Age of Mechanical Reproduction," in Francis Frascina and Charles Harrison, eds., *Modern Art and Modernism: A Critical Anthology* (New York: Harper & Row, 1982), pp. 217–20.

8 Thomas Kuhn's description of how old scientific paradigms break down and are replaced can be applied to the reception of recent challenges to formalist modernism in art history. See Thomas S. Kuhn,

The Structure of Scientific Revolutions, 2nd enlarged ed. (Chicago: University of Chicago Press, 1970).

9 Among the many scholars emphasizing this fact, two should be especially cited: Geneviève Lacambre, "Les Institutions du Second Empire et le Salon des refusés," in Francis Haskell, ed., *Saloni, gallerie, musei e loro influenza sullo sviluppo dell'arte dei secoli XIX e XX: Atti del XXIV Congresso internazionale di storia dell'arte* (Bologna: CLUEB, 1981), pp. 163–75; and Vaisse, "La Troisième République."

10 Vaisse, "La Troisième République."

11 Marie-Claude Genet-Delacroix, "Art et État sous la IIIe République" (thèse, doctorat d'état, Université Panthéon–Sorbonne Paris I, 1988–89).

12 Daniel J. Sherman, *Worthy Monuments: Art Museums and the Politics of Culture in Nineteenth-Century France* (Cambridge, MA: Harvard University Press, 1989).

13 Miriam R. Levin, *Republican Art and Ideology in Late Nineteenth Century France* (Ann Arbor, MI: University Microfilms International Research Press, 1986).

14 Debora L. Silverman, *Art Nouveau in Fin-de-Siècle France: Politics, Psychology, and Style* (Berkeley and Los Angeles: University of California Press, 1989).

15 See E. Müntz, "Le Salon. Essai de statistique," *La Chronique des arts et de la curiosité,* May 31, 1873, pp. 213–16, in which he compared the 1870 Salon in Paris with those in London, Berlin, and St. Petersburg.

CHAPTER I. PICTURES TO SEE AND PICTURES TO SELL

1 Edmond Duranty, "Post-scriptum au salon de peinture," *Gazette des beaux-arts,* October 1, 1877, pp. 355–67, esp. p. 362.

2 There has yet to be a major study of the nineteenth-century Salon, although every historian writing about nineteenth-century French art is obliged to refer to it, with a greater or lesser degree of accuracy. For brief accounts, see Germain Bazin, "Le Salon de 1830 à 1900," in Mario Salmi, ed., *Scritti di Storia dell'arte in onore di Lionello Venturi,* 2 vols. (Rome: De Luca 1956), vol. 2, pp. 117–23; and Jacques Lethève, "The Salon and Exhibitions," in his *Daily Life of French Artists,* trans. Hilary E. Paddon (New York: Praeger, 1972), pp. 108–28. Some partial studies include those by William Hauptman, "Juries, Protests, and Counter-Exhibitions Before 1850," *Art Bulletin,* March 1985, pp. 95–109; Jon Whiteley, "Exhibitions of Contemporary Painting in London and Paris 1760–1860," in Francis Haskell, ed., *Saloni, gallerie, musei e loro influenza sullo sviluppo dell'arte dei secoli XIX e XX: Atti del XXIV Congresso internazionale di storia dell'arte* (Bologna: CLUEB, 1981), pp. 69–87; Patricia Mainardi, "The Eviction of the Salon from the Louvre," *Gazette des beaux-arts,* July–August 1988, pp. 31–40; and Patricia Mainardi, "The Double Exhibition in Nineteenth Century France," *Art Journal,* Spring 1989, pp. 23–28.

3 For an excellent survey of these private societies, see Jean-Paul Bouillon, "Sociétés d'artistes et institutions officielles dans la seconde moitié du XIXe siècle," *Romantisme* 54 (1986): 89–113.

4 On the eighteenth-century Salon, see Thomas E. Crow, *Painters and*

Public Life in Eighteenth-Century Paris (New Haven, CT: Yale University Press, 1985).

5 This classic defense of the Salon of the Old Regime was formulated by Léon de Laborde in his *Application des arts à l'industrie,* vol. 8 of Exposition universelle de 1851, *Travaux de la commission française sur l'industrie des nations* (Paris, 1856), pp. 224–25. On the early development of French exhibitions, see Crow, *Painters and Public Life;* and Patricia Mainardi, *Art and Politics of the Second Empire: The Universal Expositions of 1855 and 1867* (New Haven, CT: Yale University Press, 1987), pp. 7–11. The terms *pictures to see* and *pictures to sell* were used by Charles Blanc in his "Salon de 1868," *Le Temps,* May 12, 1868.

6 On Greuze's attempt to be accepted as a history painter, see Crow, *Painters and Public Life,* pp. 161–74. On Ingres, see Charles Blanc, *Ingres, sa vie et ses ouvrages* (Paris: Veuve J. Renouard, 1870), p. 45.

7 See Archives nationales (hereafter AN) AF IV 1050, dossier 6, document 7: Vivant Denon's report to the emperor on the 1810 Salon, dated September 11, 1810. See also the attacks on public taste, accused of becoming too debased to appreciate sculpture, in A. L. Castellan, "Beaux-arts: Salon de 1812," *Le Moniteur universel,* December 22, 1812, pp. 1411–12; and T. [Emeric-David], "Beaux-arts: Salon," *Le Moniteur universel,* July 10, 1817, pp. 755–56.

8 Pierre-Jean-Baptiste Chaussard, "Beaux-arts: Exposition des ouvrages de peinture, sculpture, architecture, gravure, dessins, modèles, composés par les artistes vivans, et exposés dans le salon du Musée central des arts, le Ier fructidor, an VII de la République," *La Décade philosophique* 22, no. 36 (30 fructidor an VII [1799]): 542–52; esp. p. 545.

9 Edouard Charton, "Rapport fait au nom de la commission des services administratifs sur la direction des beaux-arts au ministère de l'instruction publique, des cultes et des beaux-arts," *La Chronique des arts et de la curiosité,* January 8, 1876, p. 12.

10 Jean Locquin, *La Peinture d'histoire en France de 1747 à 1785* (Paris: Laurens, 1912), pp. 1–8.

11 Ibid.

12 Ibid.

13 See Diane Kelder, *Aspects of "Official" Painting and Philosophic Art 1789–1799* (New York: Garland, 1976); and Régis Michel, "L'Art des salons," in Philippe Bordes and Régis Michel, eds., *Aux Armes & aux arts! Les Arts de la Révolution 1789–1799* (Paris: Adam Biro, 1988), pp. 9–101.

14 On the eighteenth-century decisions, see Locquin, *La Peinture d'histoire,* pp. 1–8. The various Revolutionary competitions are discussed by Brigitte Gallini, "Concours et prix d'encouragement," in Grand Palais, Paris, *La Révolution française et l'Europe 1789–1799,* 3 vols., 1989, vol. 3, pp. 830–51; and Udolpho Van de Sandt, "Institutions et concours," in Bordes and Michel, *Aux Armes & aux arts,* pp. 137–65.

15 R. L. F., "Un mot sur le concours du Salon," *Nouvelles des arts* 1, an X [1801–2], pp. 49–50.

16 AN AF IV 1050, dossier 2, 1806, document no. 18: Vivant Denon's report to the emperor, February 19, 1806.

17 AN AF IV 1050, dossier 1, document no. 5: Vivant Denon's report to the emperor, dated 23 fructidor an XII [1804].

18 In 1876 Duranty pointed out that the majority of state commissions were for 600 to 1,200 francs; see Duranty, "Post-scriptum au salon de peinture," p. 364.

19 Pierre-Jean-Baptiste Chaussard, "Beaux-arts: Exposition des ouvrages de peinture, sculpture, architecture, gravure, dans les salles du Muséum, premier thermidor an VI," *La Décade philosophique* 18, no. 32 (20 thermidor an VI [1798]), pp. 274–82.

20 Joachim Le Breton, *Beaux-arts,* ed. Udolpho van de Sandt, vol. 5 of *Rapports à l'Empereur sur le progrès des sciences, des lettres et des arts depuis 1789* (Paris: Belin, 1989; originally Paris, 1808), p. 156.

21 Charles Blanc, "Rapport au citoyen ministre de l'intérieur, sur les arts du dessin et sur leur avenir dans la République," *Le Moniteur universel,* October 13, 1848, pp. 2763–64.

22 Bardoux expressed these sentiments at the awards ceremony for the 1878 Salon. His speech was included in the 1879 Salon catalogue, pp. v–viii.

23 Comte Horace de Viel-Castel, "Beaux-arts: Des Beaux-arts," *L'Artiste* 1, no. 24 (1831): 289–91.

24 Louis Peisse, "Le Salon," *Revue des deux-mondes,* April 1, 1843, pp. 85–109, esp. pp. 104–05.

25 Jules Castagnary, "Salon de 1878, "in Castagnary, *Salons,* 2 vols. (Paris: Charpentier, 1892), vol. 2, p. 317.

26 See "Adresse, mémoire et observations présentés à l'Assemblée nationale, le 19 avril 1791, par la Commune des arts qui ont le dessin pour base," in Sigismond Lacroix, ed., *Actes de la Commune de Paris pendant la Révolution,* 2e série, vol. 4 (Paris: L. Cerf, 1905), p. 627.

27 The decree was published on p. 2 of the 1791 Salon catalogue.

28 Although we might see in the Concours de l'an VII (1798–99) the intention of mounting a solemn elite exhibition, this competition, as well as that of Year II (1794–95), was more concerned with ensuring the artists' livelihoods through the commissions given as awards than with creating a didactic exhibition. For the concours, see van de Sandt, "Institutions et concours"; and Gallini, "Concours et prix d'encouragement."

29 Bénézech's letter was reproduced in the preface to the 1796 Salon catalogue, pp. 6–8.

30 Polyscope, "Beaux-arts: Observations de Polyscope sur le Salon de peinture, sculpture, etc. de l'an V," *La Décade philosophique, littéraire et politique* 11, no. 2 (20 vendémiaire an V [1796]): 91–95. For a similar explanation, but on the side of the history painters "who did not want to compromise themselves by exhibiting their work in this bawdyhouse," see *Coup d'oeil sur le Sallon du Louvre, de l'an 5ème de la République,* Bibliothèque nationale (hereafter BN) Deloynes Collection, vol. 18, no. 486, p. 1.

31 XX, "Sur l'Exposition publique du 15 fructidor an X," *Journal des arts, des sciences et de littérature, par une société d'hommes de lettres et d'artistes,* no. 208, 20 prairial an X [1802], p. 371. For the later continuation of this debate, see Gustave Planche, "Salon de 1840," in Planche, *Etudes sur l'école française (1831–1852): Peinture et sculpture,* 2 vols. (Paris: Michel Lévy frères, 1855), vol. 2, pp. 157–88; esp. p. 158.

32 Auguste Jal, *Esquisses, croquis, pochades, ou tout ce qu'on voudra sur le Salon de 1827* (Paris: A. Dupont, 1828), p. 15.

33 See, for example, his second Salon review: E. J. D. (E.-J. Delécluze), "Beaux-arts: Ecole française: Salon de 1822," *Le Moniteur universel*, May 3, 1822, pp. 673–74; and D. (E.-J. Delécluze), "Beaux-arts: Salon de 1824," *Le Moniteur universel*, September 8, 1824, p. 1225.

34 E.-J. Delécluze, *Louis David, son école et son temps* (Paris: MACULA, 1983), pp. 324–25 (originally 1855).

35 Petrus Borel, "Exposition, Galerie Colbert: Au Bénéfice des indigens," *La Liberté: Journal des Arts*, 1832, no. 1, pp. 30–32; see also Alexandre Decamps, *Le Musée: Revue du Salon de 1834* (Paris: Everat, 1834), pp. 17–18.

36 See l'Institut de France, Archives de l'Académie des beaux-arts, registre des procès-verbaux, pièces annexes, 1831, "Considérations préliminaires," in the dossier "Pièces concernant la réforme de l'Ecole des beaux-arts et de l'Académie de France à Rome 1831." For a later proposal, see l'Institut de France, Archives de l'Académie des beaux-arts, procès-verbaux, June 11, 1870.

37 L'Institut de France, Archives de l'Académie des beaux-arts, procès-verbaux, June 11, 1870.

38 Pierre-Jean-Baptiste Chaussard, "Beaux-arts: Fin du compte-rendu de l'exposition des ouvrages composés par les artistes vivans," *La Décade philosophique* 23, no. 4 (10 brumaire an VIII [1799]): 212–28.

39 See Gonzague-Privat, "Projets de réformes pour les expositions artistiques," *L'Evénement*, April 12, 1876; and Duranty, "Post-scriptum au salon de peinture."

40 See "Rapport de Monsieur Barrère de Vieusac sur la pétition des artistes de dix août dernière, 21 août 1791," in the BN Deloynes Collection, vol. 53, no. 1515, p. 873.

41 Quatremère de Quincy, *Considérations sur les arts du dessin en France, suivies d'un plan d'Académie, ou d'école publique, et d'un système d'encouragemens* (Paris: Desenne, 1791), esp. pp. 101–6.

42 "Séance du 16 ventôse, l'an 2 de la République française," in Athanase Detournelle, *Aux armes et aux arts! Journal de la Société populaire et républicaine des arts* (Paris, 1794), p. 150.

43 For examples of the use of the term *aristocracy* as applied to the Academy, see Jules Raimbaud, "Union et liberté," *La Liberté: Journal des Arts*, 1832, no. 2, pp. 13–16; Gustave Planche, "Beaux-arts: La Quatrième Classe de l'Institut," *L'Artiste* 4, no. 11 (1832): 117–18.

44 Castagnary, "Salon de 1875," in *Salons*, vol. 2, p. 135.

45 Edmond About, "Le Deuxième Salon triennal," *Le XIXe Siècle*, December 18, 1883.

46 Institut de France, Académie des beaux-arts, *Séance publique annuelle du samedi 20 octobre 1883, présidée par M. Ch. Gounod* (Paris: Firmin-Didot, 1883), pp. 3–9. Gounod's speech was also published in "Institut de France," *Journal officiel*, October 22, 1883, pp. 5496–97.

47 On the French Right, see René Rémond, *Les Droites en France* (Paris: Aubier Montaigne, 1982).

48 These terms appear in the discussion of the double exhibition throughout the century. See Mainardi, "Double Exhibition." For Third Republic examples, see About, "Le Deuxième Salon triennal"; Gustave Ollendorff, "L'Exposition nationale de 1883," *Revue des deux-mondes*, November 15, 1883, pp. 436–53; Louis Enault, *Paris-Salon triennal 1883* (Paris: E. Bernard et Cie, 1883), pp. x–xi.

49 Individual recurrences of the double exhibition have been discussed, for example, by Ferdinand Boyer, "Napoléon et l'attribution des grands prix décennaux (1810–1811)," *Bulletin de la Société de l'histoire de l'art français,* 1947–48, pp. 66–72; Léon Rosenthal, *Du Romantisme au réalisme: La Peinture en France de 1830 à 1848* (Paris: MACULA, 1987, originally Paris, 1914), pp. 44–47; Vaisse, "La Troisième République," pp. 351ff; Vaisse, "Salons, expositions et sociétés d'artistes en France, 1871–1914," in Haskell, *Saloni,* pp. 141–55.

50 During the Restoration (1815–30), there were two chambers, the Chamber of Peers and the Chamber of Deputies; under the July Monarchy (1830–48) the peerage was no longer hereditary but appointed for life. The Second Republic (1848–52) had only one chamber in the National Assembly, all of whose members were elected. The Second Empire (1852–70) established three chambers in the National Assembly, the elected Corps législatif, the lifetime-tenured Senate, appointed from among the notables, and the small Conseil d'état, appointed by the president. The Third Republic reestablished the bicameral National Assembly of an elected Chamber of Deputies and Senate. Until 1884 some senators had lifetime appointments. For a clear presentation of the various French political systems, see Andrée Martin-Pannetier, *Manuel: Institutions et vie politique françaises de 1789 à nos jours,* 2nd ed. (Paris: Librairie générale de droit et de jurisprudence, 1989).

51 Daniel Halévy, *The End of the Notables,* trans. Alain Silvera and June Guicharnaud (Middletown, CT: Wesleyan University Press, 1974), pp. 197–98.

52 Jean-Marie Mayeur and Madeleine Rebérioux, *The Third Republic from Its Origins to the Great War 1871–1914,* trans. J. R. Foster (Cambridge: Cambridge University Press, 1987), p. 83. See Martin-Pannetier, *Manuel.*

53 This is one of the main theses of Pierre Bourdieu, *Distinction: A Social Critique of the Judgment of Taste,* trans. Richard Nice (Cambridge, MA: Harvard University Press, 1984).

54 The Prix décennaux were announced by decree on 24 fructidor an XII (September 11, 1804) and were published in *Moniteur universel,* 15 vendémiaire an XIII (October 5, 1804). The decree was revised on November 28, 1809. The competition was to be held on 18 brumaire an XVIII (November 9, 1810). All official documents are included in Institut de France, *Rapports et discussions de toutes les classes de l'Institut de France sur les ouvrages admis au concours pour les Prix décennaux* (Paris: Baudouin et Cie, 1810); see also Boyer, "Napoléon et l'attribution des grands prix." The records of the Prix décennaux are in AN AF IV 1050, dossier 11.

55 All the Academies were suppressed on August 8, 1793, and reinstated as components of the Institut national on October 25, 1795.

56 See Institut de France, *Rapports . . . Prix décennaux.* The awards lists are in AN AF IV 1050, dossier 11.

57 For the conservative opposition to even a biennial Salon, see Delécluze, "Beaux-arts," 1822.

58 "A M. le Directeur du Journal des artistes," *Journal des artistes,* October 7, 1827, pp. 633–66.

59 Artists were signing a petition requesting an annual Salon while Louis-Philippe was visiting the 1831 exhibition. See Charles Lenormant, *Les*

Artistes contemporains, 2 vols. (Paris: A. Mesnier 1833), vol. 1: *Salon de 1831,* pp. 182–84. Louis-Philippe announced at the 1831 awards ceremony that the Salon would henceforth be annual. See "Beaux-arts: Séance royale pour la clôture du Salon de 1831," *L'Artiste,* 2, no. 3 (1831): 25–26. Gustave Planche discussed the "petition covered with more than a hundred illustrious names" in his "Le Salon et le budget." *L'Artiste* 4, no. 13 (1832): 142–43.

60 See Charles Beulé, "Du Principe des expositions," in Beulé, *Causeries sur l'art* (Paris: Didier, 1867), pp. 1–39; and Léon Rosenthal, *Du Romantisme au réalisme* (Paris: MACULA, 1914), pp. 3f, 37ff, 60; another Academician who shared these sentiments was Georges Lafenestre, "Le Salon et ses vicissitudes," *Revue des deux-mondes,* May 1, 1881, pp. 104–35.

61 This is the main thesis of Koenraad Swart, amply demonstrated in his *The Sense of Decadence in Nineteenth Century France* (The Hague: Nijhoff, 1964).

62 All studies of Ingres mention his outspoken distaste for the Salons. For this statement, see Jean-Louis Fouché, "L'Opinion d'Ingres sur le Salon: Procès-verbaux de la commission permanente des beaux-arts (1848–1849)," *La Chronique des arts et de la curiosité,* March 14, 1908, pp. 98–99; see also Henri Delaborde, *Ingres, sa vie, ses travaux, sa doctrine* (Paris: H. Plon, 1870), pp. 372–73, n. 1.

63 David d'Angers, "Quelques idées sur les expositions," *Journal des artistes,* March 25, 1838, pp. 156–58. Rosenthal quotes various opinions for and against the annual Salon, in *Du Romantisme au réalisme,* pp. 37–50.

64 David d'Angers, "Le Jury," *L'Artiste,* April 11, 1847, pp. 92–94.

65 Even when the Salon began to charge admission daily, in 1857, Sunday always remained free, and that was when the largest crowds visited. See Mainardi, "The Eviction."

66 AN C981, Assemblée nationale: Procès-verbaux de la commission du budget, exercice 1850, November 24, 1849, p. 410; see also October 27, 1849, p. 291; February 25, 1850, p. 687; AN C982, Budget de 1850, September 9, 1849, dossier 213, no. 281.

67 AN C981, February 25, 1850, p. 687.

68 "Mouvement des arts," *L'Artiste,* March 15, 1850, pp. 156–57. The same idea was proposed by Fernand Boissard, "De la condition des artistes et des moyens de l'améliorer," *L'Artiste,* February 1, 1850, pp. 100–2.

69 "Mouvement des arts," *L'Artiste,* March 15, 1850, pp. 156–57; see also the same column, April 15, 1850, pp. 190–1.

70 AN C982, Budget de 1850, "Note pour le budget," chap. 14.

71 See "Mouvement des arts," *L'Artiste,* April 15, 1850, pp. 190–91.

72 Philippe de Chennevières, *Lettres sur l'art français en 1850* (Argentan: Barbier, 1851), pp. 14–16.

73 For a typical proposal from the aesthetically conservative camp, see Blanc, "Salon de 1868." For an example of one from the opposition camp, see Alexis-Joseph Pérignon, *Deux expositions des beaux-arts* (Paris: Dubuisson, 1866); and Alexis-Joseph Pérignon, *Lettre de M. Pérignon sur la nécessité de transformer l'organisation de l'exposition des beaux-arts* (Paris: Chaix, 1866). These and a number of similar proposals are contained in Archives du Louvre, Série X, Salon de 1866.

74 See Mainardi, *Art and Politics;* and Mainardi, "The Eviction."

75 Institut de France, Académie des beaux-arts, *Rapport sur l'ouvrage de M. le comte de Laborde membre de l'Institut intitulé: De l'Union des arts et de l'industrie, adressé à LL. EE. les ministres de l'état, de la maison de l'Empereur, de l'instruction publique et des cultes, de l'agriculture, du commerce et des travaux publics* (Paris: Firmin-Didot, 1858), pp. 24–25.

76 See Pérignon, *Deux expositions,* and *Lettre.* Pérignon's *Deux expositions* was republished in 1881.

77 Blanc, "Salon de 1868." Blanc's proposal for a double exhibition was set forth in this article; his ideas were first sketched out in Charles Blanc, "Société des arts-unis," *Gazette des beaux-arts,* June 1860, pp. 257–65.

78 Blanc, "Société des arts-unis," p. 252.

79 Lenormant, *Les Artistes contemporains,* vol. 1, p. 187. See also Patricia Mainardi, "Courbet's Exhibitionism," *Gazette des beaux-arts,* December 1991, pp. 253–66.

80 Blanc was elected an *académicien libre* of the Academy of Fine Arts on November 25, 1868. This category of membership was for those who were not practicing artists, for example, critics, collectors, and art administrators.

81 Maurice Richard met with artists on January 14, 1870, to discuss turning the Salon over to their jurisdiction; see Maxime DuCamp, "France: Paris, 15 janvier," in *Journal des débats,* January 16, 1870; and Charles Blanc, "Le Rôle d'un gouvernement dans les arts," *Le Temps,* April 30, 1870. The Academy, resolutely anti-Salon, debated various exhibition possibilities; see l'Institut de France, Archives de l'Académie des beaux-arts, procès-verbaux, June 11, 1870. On the progress of the reorganization, see "Nouvelles," *La Chronique des arts et de la curiosité,* May 29, 1870, p. 86.

82 See AN F21 496, Administration générale, 1815–73, no. 169–72: Commission de l'exposition, procès-verbaux, séance du 11 juin 1870 à 4 h.

CHAPTER 2. MORAL ORDER IN THE FINE ARTS

1 Henri Delaborde, "A Propos du Salon de 1872," *La Chronique des arts et de la curiosité,* May 12, 1872, pp. 257–60.

2 Some general histories of the period that I have found helpful include Daniel Halévy's classic studies, *The End of the Notables,* trans. Alain Silvera and June Guicharnaud (Middletown, CT: Wesleyan University Press, 1974), and *La République des ducs* (Paris: B. Grasset, 1937); Jean-Marie Mayeur and Madeleine Rebérioux, *The Third Republic from Its Origins to the Great War 1871–1914,* trans. J. R. Foster (Cambridge: Cambridge University Press, 1984), originally Jean-Marie Mayeur, *Les Débuts de la Troisième République 1871–1898,* (Paris, 1973); D. W. Brogan, *The Development of Modern France (1870–1939),* rev. ed. (London: H. Hamilton, 1967); Guy Chapman, *The Third Republic of France: The First Phase 1871–1894* (London: Macmillan, 1962); Sanford Elwitt, *The Making of the Third Republic: Class and Politics in France, 1868–1884* (Baton Rouge, LA: Louisiana State University Press, 1975). Some studies of conservatism that have proved valuable in developing my own ideas include René Rémond, *Les Droites en France* (Paris: Aubier Montaigne, 1982); Herman Lebovics, *The Alliance of Iron and Wheat*

in the Third French Republic 1860–1914: Origins of the New Conservatism (Baton Rouge: Louisiana State University Press, 1988); Philip G. Nord, *Paris Shopkeepers and the Politics of Resentment* (Princeton, NJ: Princeton University Press, 1986); Arno J. Mayer, *The Persistence of the Old Regime: Europe to the Great War* (New York: Pantheon, 1981). Two excellent studies by cultural historians include Miriam R. Levin, *Republican Art and Ideology in Late Nineteenth Century France* (Ann Arbor, MI: University Microfilms International Research Press, 1986) and Debora L. Silverman, *Art Nouveau in Fin-de-Siècle France: Politics, Psychology, and Style* (Berkeley and Los Angeles: University of California Press, 1989). Although there has been less interest among art historians in relating political to cultural events, two essays that give a good sense of the period are those by Paul Tucker, "The First Impressionist Exhibition in Context," in Charles S. Moffett, ed., *The New Painting: Impressionism 1874–1886* (San Francisco: Fine Arts Museums of San Francisco, 1986), pp. 93–117; and Jane Mayo Roos, "Aristocracy in the Arts: Philippe de Chennevières and the Salons of the Mid-1870s," *Art Journal,* Spring 1989, pp. 53–62. In addition, the doctoral dissertations of Pierre Vaisse and Marie–Claude Genet-Delacroix are invaluable studies of the period. See Pierre Vaisse, "La Troisième République et ses peintres: Recherches sur les rapports des pouvoirs publics et de la peinture en France de 1870 à 1914" (thèse, doctorat d'État, Université de Paris IV, 1980); and Marie-Claude Genet-Delacroix, "Art et État sous la IIIe République" (thèse, doctorat d'état, Université Panthéon-Sorbonne Paris I, 1988–89). I am especially grateful to Dr. Genet-Delacroix for giving me a copy of her thesis.

3 On the political significance of classicism in postrevolutionary France, see Patricia Mainardi, "Assuring the Empire of the Future: The 1798 Fête de la Liberté," *Art Journal,* Summer 1989, pp. 155–63.

4 Arno Mayer discusses at length the persistence of classicism in European high culture; see *The Persistence of the Old Regime,* pp. 189–273.

5 On the twentieth-century returns to order, see Kenneth E. Silver, *Esprit de Corps: The Art of the Parisian Avant-Garde and the First World War, 1914–1925* (Princeton, NJ: Princeton University Press, 1989); and the forthcoming study by the French historian Laurence Bertrand Dorléac on art under Vichy.

6 The changes actually began during the Second Empire; the Ministry of Fine Arts was created on January 2, 1870, and replaced on May 15 by the Ministry of Letters, Sciences, and Fine Arts. On August 23, less than two weeks before the collapse of the Second Empire, the fine arts were transferred to the Ministry of Public Instruction where they remained throughout the Third Republic.

7 Edouard Charton, "Rapport fait au nom de la commission des services administratifs sur la direction des beaux-arts au ministère de l'instruction publique, des cultes et des beaux-arts," *La Chronique des arts et de la curiosité,* January 8, 1876, p. 12.

8 Georges Lafenestre, "Le Salon et ses vicissitudes," *Revue des deux-mondes,* May 1, 1881, pp. 104–35.

9 L'Institut de France, Archives de l'Académie des beaux-arts, procès-verbaux, August 19, September 9, 16, 1871, annexe à la séance du 16 septembre 1871: "Rapport adressé par l'Académie des beaux-arts à M. le ministre de l'instruction publique," pp. 474–78. In 1885 Academic members of the Conseil supérieur des beaux-arts, the government's

fine arts advisory committee, again requested reestablishment of the history landscape prize and were again refused on budgetary grounds. See "Concours et expositions," *La Chronique des arts et de la curiosité,* August 22, 1885, p. 217.

10 L'Institut de France, Archives de l'Académie des beaux-arts, procès-verbaux, annexe à la séance du 16 septembre 1871: "Rapport adressé par l'Académie des beaux-arts à M. le ministre de l'instruction publique," pp. 474–78.

11 See Charles Blanc, "Rapport au ministre de l'instruction publique, des cultes et des beaux-arts, sur l'Exposition nationale de 1872," *Journal officiel,* December 19, 1871, pp. 5070–71. For the decree of November 13, giving back the Prix de Rome to the Academy, see "Partie officielle," *Journal officiel,* December 9, 1871, p. 1855. The Academy's other requests were not granted.

12 Institut de France, Académie des beaux-arts, *Séance publique annuelle du samedi 9 novembre 1872, présidée par M. Ambroise Thomas* (Paris: Firmin-Didot, 1872), p. 3.

13 Beulé served as minister of interior in the first cabinet of the duc de Broglie from May 25 to November 25, 1873.

14 Institut de France, Académie des beaux-arts, *Séance publique annuelle du samedi 24 octobre 1874, présidée par M. Cavelier* (Paris: Firmin-Didot, 1874), p. 41. Blanc was a member of the Académie des beaux-arts, and Simon was a member of the Académie des sciences morales et politiques. Beulé had died in April 1874, or he no doubt would have been thanked, too.

15 Philippe de Chennevières, "Charles Blanc," in his *Souvenirs d'un directeur des beaux-arts* (Paris: Arthena, 1979, originally 1883–89), vol. 1, pp. 86–98; esp. p. 88. On Blanc, see also Misook Song, *Art Theories of Charles Blanc, 1813–1882* (Ann Arbor, University Microfilms International Research Press, 1984); and Louis Fiaux, *Portraits politiques contemporains,* 5 vols., Paris, 1881–85, vol. 3: *Charles Blanc* (Paris: C. Marpon et E. Flammarion, 1882).

16 The critic Jules Castagnary, who himself was fine arts director in the 1880s, wrote perceptively on Blanc's aesthetic politics in his "Salon de 1872"; see Castagnary, *Salons* (Paris: Charpentier, 1892), vol. 2, pp. 4–8.

17 Chennevières, "Charles Blanc," *Souvenirs,* vol. 1, p. 86.

18 Blanc published his program in his 1871 "Rapport." He had already put forth almost the identical program in 1860 and in 1870; see Charles Blanc, "Société des arts-unis," *Gazette des beaux-arts,* June 1860, pp. 257–65; and "Le Rôle d'un gouvernement dans les arts," *Le Temps,* April 30, 1870.

19 For a general picture of government patronage, see Pierre Angrand, "L'Etat mécène – Période authoritaire du Second Empire (1851–1860)," *Gazette des beaux-arts,* May–June 1968, pp. 303–48.

20 For the situation in the late 1860s, see Part III of Patricia Mainardi, *Art and Politics of the Second Empire: The Universal Expositions of 1855 and 1867* (New Haven, CT: Yale University Press, 1987).

21 Ibid., pp. 190–93.

22 See Blanc's 1871 "Rapport." He also served as directeur des beaux-arts under the Second Republic from April 5, 1848, to April 20, 1850, the only two-term administrator in the century. For an earlier statement of Blanc's program, see his "Rapport au citoyen ministre de

l'intérieur, sur les arts du dessin et sur leur avenir dans la République,"
Le Moniteur universel, October 10, 1848, pp. 2763–64.

23 See Blanc's 1871 "Rapport."

24 The announcement that the Salon of 1872 would be greatly reduced in size was contained in "Ministère de l'instruction publique: Direction des beaux-arts," *Journal officiel,* December 29, 1871, p. 5314; the explanation was that the Ministère des finances was occupying the Palais de l'Industrie and so there was less space available for the Salon.

25 Castagnary, "Salon de 1872," *Salons,* vol. 2, p. 8.

26 The regulations specifying the totals for each jury were published in the 1872 Salon catalogue and also in Blanc's 1871 "Rapport."

27 See Geneviève Lacambre, "Les Institutions du Second Empire et le Salon des refusés," in Francis Haskell, ed., *Saloni, gallerie, musei e loro influenza sullo sviluppo dell'arte dei secoli XIX e XX: Atti del XXIV Congresso internationale di storia dell'arte* (Bologna: CLUEB, 1981), pp. 163–75.

28 Ten copies of the artists' petition are contained in AN F21 534, entitled "A Monsieur le Président de la République." It was apparently forwarded to Thiers by the deputy from Indre et Loire on February 23, 1872, and bears a handwritten note on the cover letter: "M. Ch. Blanc fournissez-moi une réponse."

29 The petition is in the dossier "Salon-1872" in AN F21 535, undated and addressed to Jules Simon, minister of public instruction. Pierre Vaisse pointed out that Salons des refusés were held in 1873, 1875, 1876, 1886, and possibly 1885, and ranged from quasi-official to independent in status. See his "Salons, expositions et sociétés d'artistes en France 1871–1914," in Haskell, ed., *Saloni,* pp. 148, 154, n. 41. See also *Exposition des oeuvres d'art refusées à l'Exposition officielle de 1873 (Champs Elysées): Catalogue* (Paris: E. Martinet, 1873); and Albert Boime, "The Salon des Refusés and the Evolution of Modern Art," *Art Quarterly* 32 (1969): 411–26.

30 For brief synopses of the politics and aesthetic preferences of many figures prominent in the Third Republic art administration, see Levin, *Republican Art.*

31 "Notice Sommaire," Exposition universelle internationale de 1878 à Paris, *Catalogue officiel publié par le commissariat général,* vol. 1: *Oeuvres d'art,* 2nd ed. (Paris: Imprimerie nationale, 1878), p. 6. The evaluations expressed in the speeches of the ministers of public instruction at the annual Salon awards ceremonies echo this chronological evolution. See, for example, Batbie in 1873, Cumont in 1874, Wallon in 1875, Waddington in 1876, and Bardoux in 1878. In 1877, however, the minister was absent, and Chennevières, who made the traditional speech, complained about the absence of well-known artists. Each speech was included in the catalogue for the following year's Salon.

32 See Waddington's speech at the 1876 awards ceremony, reprinted in the 1877 Salon catalogue, pp. v–xiii, esp. p. vii.

33 For a thoughtful investigation of the problem, see Joel Isaacson, *The Crisis of Impressionism 1878–1882* (Ann Arbor: University of Michigan Museum of Art, 1980).

34 John Rewald, *The History of Impressionism,* 4th rev. ed. (New York: Museum of Modern Art, 1973), p. 486; Ambroise Vollard, *Renoir, an Intimate Record,* trans. Harold L. Van Doren and Randolph T. Weaver (New York: Knopf, 1925), pp. 62–63; Isaacson, *Crisis,* p. 23.

35 Blanc, 1871 "Rapport."

36 See Charles Blanc, "De l'Etat des beaux-arts en France à la veille du Salon de 1874, I: Peinture," *Le Temps,* April 7, 1874, as well as his "Rôle," April 30, May 1, 1870.

37 Batbie's speech, November 3, 1873, was included in the catalogue for the 1874 Salon, pp. v–xi.

38 Ibid.

39 See Albert Boime, "Le Musée des copies," *Gazette des beaux-arts,* October 1964, pp. 237–47. Blanc's report of October 26, 1871, proposing the museum, is in AN F21 572.

40 Blanc, "De l'Etat."

41 See "Assemblée nationale, séance du mardi 10 décembre 1872," *Journal officiel,* December 11, 1872, pp. 7685–88. Buisson, the deputy from l'Aude, attacked the 1873 budget appropriation (chap. 40), for Blanc's Musée européen, as the Musée des copies was officially called. Buisson pointed out that the appropriation for *encouragements aux arts* was intended to commission originals, not copies.

42 The *Journal officiel* announced the museum's closing on January 6, 1874, p. 131. Chennevières's report to de Fourtou asking for permission to dismantle the Musée des copies was published under "Actes officiels," in *La Chronique des arts et de la curiosité,* January 10, 1874, p. 11.

43 See, for example, Blanc, "De l'Etat."

44 MacMahon's inaugural address is quoted in Chapman, *The Third Republic of France,* p. 44.

45 See Chennevières, *Souvenirs;* and Roos, "Aristocracy." There is very little scholarship on Eugène Guillaume's career, but although he did not write his memoirs, he did publish some of his writings. See Eugène Guillaume, *Allocations et discours* (Paris: L.-H. May, 1899), and *Etudes d'art antique et moderne* (Paris: Perrin et Cie, 1888). For a cursory biography, see Henry Roujon, *Artistes et amis des arts* (Paris: Hachette, 1912), pp. 114–32.

46 See Paris, Exposition universelle internationale de 1878 à Paris, *Catalogue officiel publié par le commissariat général* (Paris: Imprimerie nationale, 1878), vol. 1, p. 6.

47 Marius Vachon, "Etudes administratives: Le Salon," *Gazette des beaux-arts,* February 1, 1881, pp. 121–34; esp. p. 130.

48 See Mainardi, *Art and Politics,* pt. 3.

49 The Commission des beaux-arts was established on December 27, 1873, and was renamed the Conseil supérieur des beaux-arts by decree on May 22, 1875. See "Arrêté du ministre de l'instruction publique instituant une commission des beaux-arts auprès de la direction des beaux-arts et en nommant les membres, 27 décembre 1873," *La Chronique des arts et de la curiosité,* January 3, 1873, p. 3; also Paul Dupré and Gustave Ollendorff, *Traité de l'administration des beaux-arts* (Paris: P. Dupont, 1885), vol. 1, p. 61. For a discussion of the conseil, see Genet-Delacroix, "Art et État," which focuses on this body. For a brief summary of the politics surrounding the establishment of the conseil and the 1870s in general, see Roos, "Aristocracy"; and Tucker, "The First Impressionist Exhibition."

50 "Assemblée nationale," *Journal officiel,* December 16, 1873, p. 7822. There was an official government architect attached to each diocese in France, the *architects diocésains,* who were to oversee restoration and

repairs, primarily on the cathedral, which was classified as a historic monument.

51 "Rapport au ministre de l'instruction publique, des cultes et des beaux-arts," May 16, 1874, signed by Chennevières; it was followed by an *arrêté* of the same date establishing the prize, signed by de Fourtou. See *La Chronique des arts et de la curiosité*, May 23, 1874, p. 208–9. The arrêté (but not the report) was published in the catalogue of the Salon of 1875, p. xvi.

52 See "Salon de 1874," *La Chronique des arts et de la curiosité*, May 30, 1874, pp. 217–18, which announced that the Academicians and Prix de Rome winners on the jury were angry over the institution of the prize and had not awarded it. A. Louvrier de Lajolais later announced that the minister of public instruction had awarded the prize; see his "Le Prix du Salon," *La Chronique des arts et de la curiosité*, June 10, 1874, p. 221. This was corrected in "Nouvelles," *La Chronique des arts et de la curiosité*, June 20, 1874, p. 233, to state that the minister did not award it but that Lehoux received it. Lehoux's name appeared in the preceding articles on the Prix du Salon and in the 1875 Salon catalogue in the list of 1874 awards. See also "Concours et expositions," *La Chronique des arts et de la curiosité*, March 13, 1875, p. 89.

53 See Gerald M. Ackerman, *The Life and Work of Jean-Léon Gérôme* (London: Sotheby, 1986), p. 96.

54 The decree of May 22, 1875, establishing the Conseil supérieur des beaux-arts, was published in *La Chronique des arts et de la curiosité*, "Actes et documents officiels: Conseil supérieur des beaux-arts," May 29, 1875, p. 193. The procès-verbaux of its first meeting are in AN F21 4712(6), Conseil supérieur des beaux-arts, séance du 5 juin 1875.

55 On the Conseil supérieur des beaux-arts, see Genet-Delacroix, "Art et État."

56 For the 1875 decision, see "Le Salon," *La Chronique des arts et de la curiosité*, November 20, 1875, p. 321. For the reaction of artists and critics, see Albert Wolff, "Le Scandale du jour," *Le Figaro*, November 16, 1875, "Les Martyrs de l'art," *Le Figaro*, November 17, 1875, and "19 contre 8," *Le Figaro*, November 20, 1875. Also Charles Laurent, "Un Salon annuel!" *La France*, November 18, 1875, and "Le Salon annuel," *La France*, November 20, 1875.

57 See AN F21 4088, Direction générale des beaux-arts, service des expositions des beaux-arts, "Note sur les expositions nationales," dated Paris, November 16, 1883. This memo by the commissioner general of the 1883 Triennale, Georges Lafenestre, recounted the history of the double exhibition proposal under the Third Republic.

58 Edmond Turquet and Senator Lambert de Sainte-Croix also were present; see AN F21 558, Conseil supérieur des beaux-arts 1875–1878, procès-verbaux, November 13, December 18, 23, 1878; and "Commission supérieur des beaux-arts," in *La Chronique des arts et de la curiosité*, December 7, 1878, pp. 299–300. The article originally appeared under the byline of Armand Landrin, "Commission supérieure des beaux-arts," *Le XIXe siècle*, December 4, 1878, p. 1. See also "Conseil supérieur des beaux-arts," *La Chronique des arts et de la curiosité*, November 21, 1878, pp. 281–82; "Règlements comparatifs de l'exposition annuelle et de l'exposition triennale," *La Chronique des arts et de la curiosité*, December 28, 1878, pp. 322–23.

59 See Chennevières, "Les Expositions annuelles et la Société des artistes français," in his *Souvenirs,* vol. 4, pp. 69–118, esp. p. 109.

60 See "Courrier," in *Le Siècle,* February 9, 1879. Victor Champier identified the author as Castagnary; see Champier, *Les beaux-arts en France et à l'étranger: L'Année artistique 1879* (Paris: A. Quantin, 1880), p. 3.

61 Agénor Bardoux, "Rapport au Président de la République française," December 30, 1878, in AN F21 4087, Conseil supérieur des beaux-arts: Rapport, décrets et règlements concernant l'Exposition triennale, décembre 1878. Dossier 1: Règlement. It was published under "Partie officielle," in *Journal officiel,* December 31, 1878, p. 12513, and in "Documents officiels," *La Chronique des arts et de la curiosité,* January 4, 1879, p. 1 (the decree), and January 11, 1879, pp. 9–11 (the regulations). MacMahon's decree and the regulations were attached to Bardoux's report. MacMahon introduced his decree by noting that it had been made "on the report of the ministre de l'instruction publique, des cultes et des beaux-arts; in view of the minutes of the deliberations of the Conseil supérieur des beaux-arts of 1875, and 18 and 23 December 1878." There are minor differences between the manuscript in the AN and the published version. The regulations for the Triennale were summarized in Edmond Turquet's "Rapport au ministre de l'instruction publique et des beaux-arts," followed by the regulations for the 1880 Salon, published in *Journal officiel,* January 2–3, 1880, pp. 34–36, and in "Documents officiels," *La Chronique des arts et de la curiosité,* January 10, 1880, pp. 9–13.

62 Ibid.

CHAPTER 3. NATIONAL EDUCATION AND INDUSTRIAL PROSPERITY

1 Victor Champier, *Les Beaux-arts en France et à l'étranger: L'Année artistique 1881–1882* (Paris: A. Quantin), 1882, p. 1.

2 The five fine arts administrations were headed by Guillaume, Turquet, Proust, Mantz, and Kaempfen; see the Appendix for dates.

3 Turquet's official title was sous-secrétaire d'état des beaux-arts; see the Appendix.

4 For a thorough study of the theoretical bases of Republican aesthetics, see Miriam R. Levin, *Republican Art and Ideology in Late Nineteenth Century France* (Ann Arbor, MI: University Microfilms International Research Press, 1986).

5 See Sanford Elwitt, *The Making of the Third Republic: Class and Politics in France, 1868–1884* (Baton Rouge: Louisiana State University Press, 1975), p. 142.

6 "Actes et documents officiels," *La Chronique des arts et de la curiosité,* March 21, 1874, pp. 115–16. The project was actually begun in 1877. See "Nouvelles," *La Chronique des arts et de la curiosité,* March 24, 1877, pp. 110–11. The Panthéon had been returned to religious status as the church of Sainte-Geneviève in 1851 and was not laicized until the occasion of Victor Hugo's funeral in 1885.

7 See Chennevières's report to Bardoux, "Rapport au ministre de l'instruction publique, des cultes et des beaux-arts," dated January 30, 1878, in *La Chronique des arts et de la curiosité,* February 9, 1878, pp. 42–43.

8 On the Paris projects, see the exhibition catalogues *Le Triomphe des*

mairies: *Grands décors républicains à Paris 1870–1914,* Musée du Petit Palais, Paris, 1986; and *Quand Paris dançait avec Marianne 1879–1889,* Daniel Imbert and Guénola Groud, eds., Musée du Petit Palais, Paris, 1989.

9 See "Séance de la Chambre des Députés," *Journal officiel,* August 11, 1876, pp. 6236–37, August 12, 1876, pp. 6291–97. "La Commission du budget," *Le Temps,* November 4, 1878, and "Chambre des Députés – Annexe no. 877, séance du 8 novembre 1878. Rapport fait au nom de la commission du budget sur le budget des dépenses de l'exercice 1879. Ministère de l'instruction publique, des cultes et des beaux-arts, partie relative au service des beaux-arts, par M. Antonin Proust, député," *Journal officiel,* November 28, 1878, pp. 11121–42; esp. p. 11121. For later attacks, see "Chambre des Députés, 2ème législature, séance de 1879, séance du lundi 28 juillet 1879, 2ème section, beaux-arts et musées," *Journal officiel,* July 29, 1879, pp. 7697; and "Chambre des Députés – Annexe no. 2752, séance du 17 juin 1880. Rapport fait au nom de la commission du budget chargée d'examiner le projet de loi portant fixation du budget général des dépenses et des recettes de l'exercice 1881 (Ministère de l'instruction publique et des beaux-arts, 2e section, beaux-arts), par M. Edouard Lockroy, député," *Journal officiel,* July 20, 1880, pp. 8426–32; esp. p. 8428, chap. 41.

10 "Chambre des Députés, Annexe no. 3608, séance du 12 avril 1881. Rapport fait au nom de la commission du budget chargée d'examiner le projet de loi portant fixation du budget général des dépenses et des recettes de l'exercice 1882 (Ministère de l'instruction publique et des beaux-arts, 2e section, beaux-arts), par M. Edouard Lockroy, député, *Journal officiel: Débats et documents parlémentaires, Chambre des Députés, annexes aux procès-verbaux des séances, projets et propositions de loi, exposés des motifs et rapports, session 1881,* pp. 843–61; esp. p. 843.

11 Pierre Vaisse, "La Troisième République et ses peintres: Recherches sur les rapports des pouvoirs publics et de la peinture en France de 1870 à 1914" (thèse, doctorat d'état, Université de Paris IV, 1980).

12 Antonin Proust, *Edouard Manet: Souvenirs* (Paris: G. Charpentier et E. Fasquelle, 1913), p. 94.

13 Claude Lantier began his picture in Chapter 8 of the novel, and it continued as the main focus of his work until his suicide. He painted the small flower pictures in Chapter 11. See Emile Zola, *L'Oeuvre,* originally published in Paris, 1886. On the resemblance to Manet, see Robert J. Niess, *Zola, Cézanne, and Manet: A Study of L'Oeuvre* (Ann Arbor: University of Michigan Press, 1968), pp. 120–21.

14 See Philippe de Chennevières, "Le Treizième Bulletin des beaux-arts," in Chennevières, *Souvenirs d'un directeur des beaux-arts* (Paris: Arthena, 1979, originally 1883–89), p. 27.

15 Marius Vachon, "Etudes administratives: Le Salon," *Gazette des beaux-arts,* February 1, 1881, pp. 121–34, esp. p. 130.

16 Bardoux's speech was included in the 1879 Salon catalogue, pp. v–viii.

17 Ferry's speech at the awards ceremony of the 1879 Salon, July 27, 1879, was included in the 1880 Salon catalogue, pp. v–xiv.

18 Ibid.

19 "Concours et expositions," *La Chronique des arts et de la curiosité,* June 14, 1879, p. 184.

20 Edmond About, "Le Deuxième Salon triennal," *Le XIXe Siècle,* December 18, 1883.

21 See London, Great Exhibition of Works of Industry of All Nations, 1851. Exposition universelle de 1851, *Travaux de la commission française sur l'industrie des nations, publiés par ordre de l'Empereur,* vol. 8: Léon de Laborde, *Application des arts à l'industrie* (Paris, 1856) (hereafter cited as Laborde).

22 Prosper Mérimée repeated Léon de Laborde's warnings in his report on the decorative arts at the 1862 English International Exposition. Demanding reforms in France's high art and industrial art schools, he identified England as the chief competitor of France and the school of design established at South Kensington after the 1851 Great Exposition as the cause of English progress. See Prosper Mérimée, "Considérations sur les applications de l'art à l'industrie à l'Exposition universelle," London, International Exhibition, 1862. Exposition universelle de Londres de 1862, *Rapports des membres de la section française du jury international sur l'ensemble de l'exposition et documents officiels publiés sous la direction de Michel Chevalier,* 7 vols. (Paris: Chaix, 1862–64), vol. 6, pp. 248–62. Although the 1867 Universal Exposition could be seen as a paean to heavy industry, most typified by the Saint-Simonian Michel Chevalier's "Introduction to the Jury Reports," individual reports revealed apprehension over foreign competition and France's lack of industrial design training. See Exposition universelle de 1867, *Rapports du jury international: Introduction par M. Michel Chevalier* (Paris: P. Dupont, 1868), pp. 111–31; and for contrast, E. Guichard, "Considérations sur l'art dans ses applications à l'industrie," Exposition universelle de 1867 à Paris, *Rapports du jury international publiés sous la direction de M. Michel Chevalier,* (Paris: P. Dupont, 1868), vol. 3, pp. 5–17. In his 1875 government report Edouard Charton also pointed out that France was being left behind by other countries in Europe and needed both professional design schools and decorative arts museums. See Edouard Charton, "Rapport fait au nom de la commission des services administratifs sur la direction des beaux-arts au ministère de l'instruction publique, des cultes et des beaux-arts," *La Chronique des arts et de la curiosité,* January 22, 1876, pp. 29–32, esp. p. 29.

23 "Chambre des Députés – Annexe no. 877," *Journal officiel,* November 28, 1878, pp. 11121–42, esp. p. 11121. For a similar statement, see Exposition universelle internationale de 1878 à Paris, *Rapports du jury international: Introduction par M. Jules Simon, rapporteur général* (Paris: Imprimerie nationale, 1880), p. 243.

24 The 1878 jury did report on sculpture, architecture, engraving, and lithography. The *Gazette des beaux-arts'* two-volume anthology of articles on the 1878 Universal Exposition opened with a survey of large-scale decorative painting projects (which were not in the exposition) and then included a second volume devoted to the decorative arts. See Louis Gonse, ed., *Exposition universelle de 1878: Les Beaux-arts et les arts décoratifs,* 2 vols. (Paris: Gazette des beaux-arts, 1879). The president of the International Painting Jury published a chatty unofficial study that included an appendix of relevant official documents; see Tullo Massarani, *L'Art à Paris,* 2 vols. (Paris: H. Loones, 1880). For a list of the fine arts awards at the exposition, see the preceding book or *La Chronique des arts et de la curiosité,* November 2, 1878.

25 See Clément Jugler, "L'Art et l'industrie," *La Chronique: Politique des*

arts et de la curiosité, March 6, 1870, pp. 37–38; and Clément Jugler, "L'Art et l'industrie en Angleterre," *La Chronique: Politique des arts et de la curiosité,* April 17, 1870, pp. 61–62. Charles Blanc cited the same statistics; see his "Le Rôle d'un gouvernement dans les arts," *Le Temps,* May 1, 1870.

26 See, for example, Marius Vachon, *Nos Industries d'art en péril: Un musée municipal d'études d'art industriel* (Paris: L. Baschet, 1882); and Ministère de l'instruction publique et des beaux-arts, Direction des beaux-arts, bureau de l'enseignement, *Commission d'enquête sur la situation des ouvriers et des industries d'art instituée par décret en date du 24 décembre 1881* (Paris: A. Quantin, 1884).

27 Exposition universelle internationale de 1878 à Paris, *Rapports du jury international: Introduction par M. Jules Simon, rapporteur général* (Paris: Imprimerie national, 1880), p. 244. The nations Simon mentioned here were England, Austria, Russia, and Belgium, but other reporters discussed the United States and Germany as well. See also "Les Meubles à bon marché et les meubles de luxe, ouvrages du tapissier et du décorateur par MM. Tronquois et Lemoine," in Exposition universelle internationale de 1878 à Paris, *Rapports du jury international,* vol. 1, p. 8.

28 Nikolaus Pevsner, *Academies of Art Past and Present* (New York: Da Capo Press, 1973), pp. 140–89.

29 See "Nouvelles," *La Chronique des arts et de la curiosité,* August 20, 1874, p. 273.

30 Marius Vachon, *Rapports à M. Edmond Turquet, sous-secrétaire d'état sur les musées et les écoles d'art industriel et sur la situation des industries artistiques en Allemagne, Autriche-Hongrie, Italie et Russie* (Paris: A. Quantin, 1885), p. 77. The statement also appeared on the cover of the report. Vachon's report was excerpted (including the inflammatory remarks attributed to the prince imperial) as "Les Industries d'art à l'étranger," *La Chronique des arts et de la curiosité,* December 12, 1885, pp. 306–7.

31 See "Les Meubles à bon marché et les meubles de luxe, ouvrages du tapissier et du décorateur par MM. Tronquois et Lemoine," in Exposition universelle internationale de 1878 à Paris, *Rapports du jury international,* vol. 1, p. 8. On French fears, see Koenraad Swart, *The Sense of Decadence in Nineteenth Century France* (The Hague: Nijhoff, 1964), pp. 213–57.

32 Gambetta's report to the president of the Republic, dated November 14, 1881, proposing the Ministère des arts, was published by Louis Gonse, "Le Ministère des arts," *La Chronique des arts et de la curiosité,* November 19, 1881, pp. 185–86. On the Ministère des arts, see also Ministère de l'instruction publique et des beaux-arts, Direction des beaux-arts, bureau de l'enseignement, *Commission d'enquête sur la situation des ouvriers et des industries d'art instituée par décret en date du 24 décembre 1881* (Paris: A. Quantin, 1884), p. xx; and Antonin Proust, *L'Art sous la République* (Paris: G. Charpentier et E. Fasquelle, 1892), p. 3.

33 Proust discussed all aspects of his career in administration in his *L'Art sous la République;* on his involvement with the Union centrale, see pp. 183–276.

34 "L'Exposition du Musée des arts décoratifs," *La Chronique des arts et de la curiosité,* January 11, 1879, p. 12; the museum opened on January 6, 1879, in the Pavillon de Flore in the Louvre.

35 According to Albert Elsen, Jules Ferry gave Rodin the commission on August 16, 1880. See Albert E. Elsen, *The Gates of Hell by Auguste Rodin* (Stanford, CA: Stanford University Press, 1985), pp. 3–11. *La Chronique des arts et de la curiosité* claimed that Turquet had given it to him; see "Nouvelles," November 26, 1881, pp. 294–95.

36 Philippe de Chennevières's introduction to the first issue laid out the program; see *Revue des arts décoratifs* 1 (1880–81): 1–4. On Blanc's course, see "Nouvelles," *La Chronique des arts et de la curiosité,* January 10, 1880, p. 14.

37 Yolande Amic, "Débuts de l'U.C.A.D. et du Musée des arts décoratifs," *Cahiers de l'U.C.A.D.* [Union centrale des arts décoratifs], no. 1, 2e semestre 1978, pp. 52–54. Proust actually resigned the presidency in despair over the state's unwillingness to support the museum; see Proust, *L'Art sous la République,* pp. 252–55.

38 "Enseignement du dessin," *La Chronique des arts et de la curiosité,* May 25, 1878, pp. 161–62. The arrêté establishing instruction in design was dated May 21, 1878 and signed by Bardoux.

39 Institut de France, *Rapport sur l'ouvrage de M. le comte de Laborde,* pp. 6–7, 27.

40 See Laborde, vol. 8, p. 224.

41 Ibid.

42 Blanc, "Rôle," May 1, 1870.

43 Charles Clément, "Variétés: Le Ministère des beaux-arts," *Journal des débats,* February 12, 1870.

44 The letter was published in "Chambre des Députés – Annexe no. 877," *Journal officiel,* November 28, 1878, p. 11122; and reproduced in Exposition universelle internationale de 1889 à Paris, *Rapports du jury international publiés sous la direction de M. Alfred Picard. Classe 5 bis – Enseignement des arts du dessin. Rapport de M. Paul Colin* (Paris: Imprimerie nationale, 1890), pp. 104–05.

45 Exposition universelle internationale 1889 à Paris, *Rapport de M. Paul Colin,* p. 11. Jules Ferry made similar comments in 1884; see France, Ministère de l'instruction publique et des beaux-arts, *Commission d'enquête . . . 1881* (Paris: A Quantin, 1884), p. xxxvi. Others who expressed the same sentiments included Eugène Guillaume, *Idée générale d'un enseignement élémentaire des beaux-arts appliqués à l'industrie: Conférence faite à l'Union centrale des beaux-arts appliqués à l'industrie, le 23 mai 1866, à propos de la dernière exposition des écoles de dessin* (Paris: Union centrale, 1866); and Henry Havard, *Lettre sur l'enseignement des beaux-arts* (Paris: A. Quantin, 1879), p. 17.

46 "Rapport sur l'instruction publique, fait, au nom du comité de Constitution, par M. Talleyrand-Périgord, ancien évêque d'Autun, administrateur du département de Paris. Première annexe à la séance de l'assemblée nationale du samedi, 10 septembre 1791, au matin," in J. Mavidal and E. Laurent, eds., *Archives parlementaires de 1787 à 1860: Recueil complet des débats législatifs & politiques des chambres françaises,* première série (1787 à 1799), vol. 30 du 28 août du 17 septembre 1791 (Paris: Librairie administrative de P. Dupont, 1888), pp. 447–511.

47 Guillaume, *Idée générale,* p. 55. Guillaume's official title was inspecteur générale de l'enseignement du dessin.

48 Exposition universelle internationale de 1889 à Paris, *Rapport de M. Paul Colin,* pp. 16–21. On Lecoq de Boisbaudran, see Petra ten-Doesschate Chu, "Into the Modern Era: The Evolution of Realist and

Naturalist Drawing," in Gabriel P. Weisberg, ed., *The Realist Tradition: French Painting and Drawing 1830–1900* (Cleveland: Cleveland Museum of Art, 1980), pp. 21–38. For a consideration of the effects of the Republican drawing program, see Albert Boime, "The Teaching of Fine Arts and the Avant-Garde in France During the Second Half of the Nineteenth Century," *Arts Magazine,* December 1985, pp. 46–57; Molly Nesbit, "Ready-made Originals: The Duchamp Model," *October* 37 (Summer 1986): 53–64; Molly Nesbit, "La Langue de l'industrie," in Benjamin Buchloh, ed., *Langage et modernité* (Villeurbanne: Le Nouveau musée, 1991), pp. 53–81.

49 Guillaume, *Idée générale,* p. 8.

50 Ibid., p. 55.

51 Exposition universelle internationale de 1889 à Paris, *Rapports du jury international publiés sous la direction de M. Alfred Picard. Classe 5 bis – Enseignement des arts du dessin. Rapport de M. Paul Colin* (Paris: Imprimerie nationale, 1890), pp. 16–21.

52 Guillaume, *Idée générale,* p. 53.

53 When Blanc died, Guillaume replaced him at the Collège de France by the decree of June 6, 1882; see "Nouvelles," *La Chronique des arts et de la curiosité,* June 10, 1882, p. 170.

54 Maurice Agulhon, *La République de Jules Ferry à François Mitterrand, 1880 à nos jours* (Paris: A. Colin, 1990), p. 22.

55 The department store Bon Marché installed electric lights in 1880; see "Les Agrandissements du Bon Marché," *L'Illustration,* October 2, 1880, pp. 245–46. Nord dates its widespread use in department stores to 1883; see Philip G. Nord, *Paris Shopkeepers and the Politics of Resentment* (Princeton, NJ: Princeton University Press, 1986), p. 74; on electric lights in the 1877 Salon, see "Nouvelles du Jour," *Le Temps,* May 28, 1877; and "Nouvelles," *La Chronique des arts et de la curiosité,* June 9, 1877, p. 211.

56 See "Nouvelles," *La Chronique des arts et de la curiosité,* March 1, 1879, p. 66.

57 Jules Claretie, *La Vie à Paris 1880* (Paris: V. Havard, 1881), pp. 97–98.

58 Ibid., p. 204.

59 Ibid., p. 98.

60 "Chambre des Députés, séance du mardi 18 mai 1880, Discussion de l'interpellation de M. Robert Mitchell sur la direction donnée aux beaux-arts," *Journal officiel,* May 19, 1880, pp. 5389–96, esp. p. 5391.

61 "Chronique des beaux-arts," *L'Illustration,* April 17, 1880, p. 260.

62 "Chronique du jour," *Le Charivari,* May 7, 1880.

63 See, for example, "Le Salon nocturne par Draner" and "Au Salon," *La Caricature,* May 29, 1880, cover and pp. 1–2.

64 Champier, *Les Beaux-arts . . . 1879,* p. 71.

65 Turquet announced these reforms in his "Salon de 1880. Rapport au ministre de l'instruction publique et des beaux-arts," which preceded the Salon's regulations; *Journal officiel,* January 2–3, 1880, pp. 34–36; also "Documents officiels," *La Chronique des arts et de la curiosité,* January 10, 1880, pp. 9–13. They were discussed in "Chambre des Députés, séance du mardi 18 mai 1880," *Journal officiel,* May 19, 1880, pp. 5389–96, esp. pp. 5394–95. See also Champier, *Les Beaux-arts . . . 1880–1881,* p. 78.

66 Details of the circumstances surrounding the 1879–81 Salon events can be found in Champier, *Les Beaux-arts . . . 1879,* pp. 575–78; and

Les Beaux-arts . . . 1880–1881, pp. 63–74; "Chambre des Députés, séance du mardi 18 mai 1880, Discussion de l'interpellation de M. Robert Mitchell sur la direction donnée aux beaux-arts," *Journal officiel,* May 19, 1880, pp. 5389–96. The text of the jurors' report is in Chennevières, "Les Expositions annuelles et la Société des artistes français," *Souvenirs,* vol. 4, pp. 104–05; accounts critical of Turquet are in "L'Administration des beaux-arts devant la chambre," *La Chronique des arts et de la curiosité,* May 22, 1880, pp. 164–65; and "Nouvelles," *La Chronique des arts et de la curiosité,* May 29, 1880, pp. 174–75. *La Chronique* followed the events closely and reported the developments in "Nouvelles," April 17, 1880, p. 126; Louis Gonse, "Le Salon de 1880," May 1, 1880, p. 141; A. Louvrier de Lajolais, "A propos du règlement du Salon," May 1, 1880, p. 142; and "Nouvelles," May 29, 1880, pp. 174–75. Although *La Chronique* was generally critical of Turquet, *L'Illustration* defended his reforms. See the following articles, all in *L'Illustration:* Stéphane Loysel, "Le Salon de 1880," May 1, 1880, p. 286; "Chronique des beaux-arts," January 10, 1880, p. 31; April 17, 1880, p. 260; and May 29, 1880, p. 356.

67 Baudry's resignation letter of May 23, 1880, and a letter from the jury dated May 24, 1880, defending its actions, are in the "Salon de 1880" dossier in AN F21 535.

68 See "L'Administration des beaux-arts devant la chambre," *La Chronique des arts et de la curiosité,* May 22, 1880, pp. 164–65; "Nouvelles," *La Chronique,* May 29, 1880, pp. 174–75; Emile Zola, "Le Naturalisme au Salon," *Le Voltaire,* June 18, 20, 1880, reprinted in Emile Zola, *Salons,* ed. F. W. J. Hemmings and Robert J. Niess (Geneva: Droz, 1959), pp. 233–54.

69 Good descriptions of the installation are given by Stéphane Loysel, "Le Salon de 1880," *L'Illustration,* May 1, 1880, p. 286; and Zola, "Le Naturalisme."

70 Zola, "Le Naturalisme."

71 See John Rewald, *The History of Impressionism,* 4th rev. ed. (New York: Museum of Modern Art, 1973), pp. 443–44. Renoir's proposal was published in *La Chronique des tribunaux,* May 23, 1880, and reprinted in P. Gachet, *Deux amis des impressionistes – le docteur Gachet et Murer* (Paris: Editions des musées nationaux, 1956), pp. 165–67.

72 See "Nos gravures," *Le Journal Illustré,* June 6, 1880, p. 179.

73 "Chambre des Députés, séance du mardi 18 mai 1880," *Journal officiel,* May 19, 1880, p. 5395. The committee for Christian schools circular is reproduced in Philippe de Chennevières, "Les Expositions annuelles et la Société des artistes français," in *Souvenirs,* vol. 4, pp. 69–118, esp. pp. 105–06.

74 Baudry's letter is in AN F21 535 and was published in various journals; the text was included in Victor Champier, *Les Beaux-arts . . . 1880–1881,* pp. 67–68; and in Chennevières's *Souvenirs,* vol. 4, pp. 104–05.

75 The article in *Le Rappel* was reported in "Encore de jury," *Le Charivari,* June 2, 1880.

76 Ibid.

77 Un Parisien, "Les Tablettes d'un parisien: Un Jury sur la sellette," *Le Charivari,* May 27, 1880.

78 On the issue of secular education in the early Third Republic, see Françoise Mayeur, *De la Révolution à l'école républicaine 1789–1930,*

vol. 3 of Louis-Henri Parias, ed., *Histoire générale de l'enseignement et de l'éducation en France* (Paris: Nouvelle Librairie de France, 1981), pp. 523–69; Mona Ozouf, *L'Ecole, l'église et la République 1871–1914* (Paris: A. Colin, 1963), pp. 56–65.

79 See Ozouf, *L'Ecole,* pp. 59–65.

80 "Chronique du jour," *Le Charivari,* May 19, 1880.

81 See "Chambre des Députés, séance du mardi 18 mai 1880, Discussion de l'interpellation de M. Robert Mitchell sur la direction donnée aux beaux-arts," *Journal officiel,* May 19, 1880, pp. 5389–96, esp. p. 5392.

82 On the *nouvelles couches sociales,* see Elwitt, *The Making of the Third Republic,* pp. 53–55.

83 See "Chambre des Députés, séance du mardi 18 mai 1880, Discussion de l'interpellation de M. Robert Mitchell sur la direction donnée aux beaux-arts," *Journal officiel,* May 19, 1880, pp. 5389–96, esp. p. 5392.

84 Ibid., p. 5293.

85 A. Lajeune-Vilar, "La Question du Salon: Une Entrevue avec M. Turquet," *Le Gaulois,* December 22, 1880, p. 1.

86 "Chambre des Députés, séance du mardi 18 mai 1880, Discussion de l'interpellation de M. Robert Mitchell sur la direction donnée aux beaux-arts," *Journal officiel,* May 19, 1880, pp. 5389–96, esp. p. 5392.

87 See "Récompenses du Salon," *La Chronique des arts et de la curiosité,* June 12, 1880, p. 182. Apparently the jury met to vote on and distribute prizes, but there were no speeches or official ceremony. The 1881 Salon catalogue, which usually reprinted the article from *Journal officiel* giving the texts of official speeches, listed the awards only.

88 For example, around three hundred artists met to form a Société libre des artistes, shortly after the Salon ended; see "Fondation d'une société libre des artistes," *La Chronique des arts et de la curiosité,* June 26, 1880, pp. 193–94. "Conseil supérieur des beaux-arts," *La Chronique des arts et de la curiosité,* December 18, 1880, pp. 319–20; A. Louvrier de Lajolais, "Concours et expositions: La Question du Salon," *La Chronique des arts et de la curiosité,* December 25, 1880, pp. 325–26.

89 See Institut de France, Académie des beaux-arts, *Séance publique annuelle du samedi 30 octobre 1880, présidée par M. J. Thomas* (Paris: Firmin-Didot, 1880), p. 5. The fear was repeated the following year; see Institut de France, Académie des beaux-arts, *Séance publique annuelle du samedi 22 octobre 1881, présidée par M. Questel* (Paris: Firmin-Didot, 1881), p. 5.

90 See "Au jour le jour: Conseil supérieur des beaux-arts," *Le Temps,* December 1, 1880; "Conseil supérieur des beaux-arts," *La Chronique des arts et de la curiosité,* December 4, 1880, pp. 302–3. Proust's intention to include the decorative arts in the 1881 Salon was discussed again in "Salon des arts décoratifs," *La Chronique des arts et de la curiosité,* November 12, 1881, p. 278. For the history of the government's involvement in the decorative arts in the later 1880s and 1890s, see Debora L. Silverman, *Art Nouveau in Fin-de-Siècle France: Politics, Psychology, and Style* (Berkeley and Los Angeles: University of California Press, 1989). It was not until 1891, at the Salon of the newly formed Société nationale des beaux-arts, that the decorative arts were included in any fine arts Salon. See Marie Jeannine Aquilino, "The Decorating Campaigns at the Salon du Champ-de-Mars and the Salon des Champs-Elysées in the 1890s," *Art Journal,* Spring 1989, pp. 78–84.

91 "Conseil supérieur des beaux-arts," *La Chronique des arts et de la curios-*

ité, December 18, 1880, pp. 319–20. *La Chronique* had been following very closely the discussion in the conseil, reporting weekly on its progress in establishing the 1881 regulations. The final decision was made, seemingly suddenly, by a subcommittee that met with Ferry who then, on December 27, published the arrêté announcing the decision.

92 Champier, *Les Beaux-arts . . . 1880–1881*, p. 70.

93 The decree was published under "Rapport au ministre de l'instruction publique et des beaux-arts, 24 décembre 1880," *Journal officiel*, December 28, 1880, p. 12944; and under "Concours et expositions: Le Salon de 1881," *La Chronique des arts et de la curiosité*, January 1, 1881, p. 1.

94 See "La Commission du Salon," *La Chronique des arts et de la curiosité*, January 22, 1881, p. 25. The conseil had already decided this; see "Conseil supérieur des beaux-arts," *La Chronique des arts et de la curiosité*, December 4, 1880, pp. 302–3; and "Au jour le jour: Conseil supérieur des beaux-arts," *Le Temps*, December 1, 1880. Lafenestre confirmed this in his "Note sur les expositions nationales," dated Paris, November 16, 1883, in AN F21 4088, Direction générale des beaux-arts, service des expositions des beaux-arts.

95 See Jean-Marie Mayeur and Madeleine Rebérioux, *The Third Republic from Its Origins to the Great War 1871–1914*, trans. J. R. Foster (Cambridge: Cambridge University Press, 1984), pp. 72–100. See also René Rémond, *Les Droites en France* (Paris: Aubier Montaigne, 1982), p. 145.

96 Emile Zola, "Causerie," *La Tribune*, December 20, 1868, p. 7.

97 Zola, "Le Naturalisme."

98 Ferry's speech at the 1879 awards ceremony was reproduced in the 1880 Salon catalogue, pp. v–xiv.

99 Zola, "Le Naturalisme."

100 Lajeune-Vilar, "La Question du Salon," p. 2.

101 "Chambre des Députés, 2ème législature, session de 1879, séance du lundi 28 juillet 1879, 2ème section, beaux-arts et musées," *Journal officiel*, July 29, 1879, pp. 7696–701.

102 "Chambre des Députés, 2ème législature, session de 1879, séance du mardi 29 juillet 1879, Ministère des beaux-arts, chapitre 43," *Journal officiel*, July 30, 1879, pp. 7749–51.

103 "Chambre des Députés, Annexe no. 3608, séance du 12 avril 1881, Rapport fait au nom de la commission du budget chargée d'examiner le projet de loi portant fixation du budget général des dépenses et des recettes de l'exercice 1882 (Ministère de l'instruction publique et des beaux-arts, 2e section, beaux-arts), par M. Edouard Lockroy, député," *Journal officiel: Débats et documents parlementaires, Chambre des Députés, annexes aux procès-verbaux des séances, projets et propositions de loi, exposés des motifs et rapports, session 1881*, pp. 843–61. See also "Le Budget des beaux-arts," *La Chronique des arts et de la curiosité*, June 17, 1881, pp. 184–85.

104 Chambre des Députés, Annexe no. 3608.

105 Ibid.

106 "Conseil supérieur des beaux-arts," *La Chronique des arts et de la curiosité*, December 18, 1880, pp. 319–20.

107 Ibid. The conseil concluded that the shows should be held every four years, the first in 1882.

108 Joséphin Péladan, "L'Esthétique à l'Exposition nationale des beaux-arts," *L'Artiste,* October 1883, p. 259. Péladan was no Republican, and so he followed this statement with "and so it is worth doing."

109 See "Concours et expositions," *La Chronique des arts et de la curiosité,* May 14, 1881, p. 158; and June 25, 1881, pp. 190–91.

110 See Vaisse, "La Troisième République," p. 259.

111 Renoir to Durand-Ruel, March 1881, published in Lionello Venturi, *Les Archives de l'impressionisme* (Paris: Durand-Ruel, 1939), vol. 1, p. 115.

112 See "Les Comptes du Salon de 1881," *La Chronique des arts et de la curiosité,* November 19, 1881, p. 288; "Le Budget des beaux-arts," *La Chronique des arts et de la curiosité,* June 11, 1881, pp. 184–85.

113 Marius Vachon, "Etudes administratives: Le Salon," *Gazette des beaux-arts,* February 1, 1881, pp. 121–34, esp. p. 134.

114 The Société des artistes français was legally founded on June 15, 1882, and its statutes were approved by government decree on May 11, 1883, when it was granted *utilité publique* status. They were published in each subsequent Salon catalogue, beginning in 1883. On the Indépendants, see Pierre Angrand, *Naissance des artistes indépendants, 1884* (Paris: Nouvelles Editions Debresse, 1965). On the 1890 Salon split, see Aquilino, "The Decorating Campaigns"; and Constance Cain Hungerford, "Meissonier and the Founding of the Société Nationale des Beaux-Arts," *Art Journal,* Spring 1989, pp. 71–77.

115 The 1882 date was the choice of the conseil, which then decided to hold it every four years; see "Conseil supérieur des beaux-arts," *La Chronique des arts et de la curiosité,* December 18, 1880, p. 319.

116 See A. Louvrier de Lajolais, "Les Artistes et le Salon triennal," *La Chronique des arts et de la curiosité,* March 18, 1882, pp. 81–82. While the group was being formed, it was called the Société libre des artistes français. On receiving official recognition it became the Société des artistes français, to avoid confusion with Baron Taylor's Association des artistes; see "Nouvelles," *La Chronique des arts et de la curiosité,* May 19, 1883, p. 159.

117 "Nouvelles," *La Chronique des arts et de la curiosité,* May 19, 1883.

118 A. Louvrier de Lajolais, "Les Artistes et le Salon triennal."

119 The letter is in F21 4088, headed "Paris, le 17 juin 1882. A Monsieur le ministre de l'instruction publique et des beaux-arts."

120 The regulations, dated July 28, 1882, were published in "Partie officielle," *Journal officiel,* August 6, 1882, pp. 4258–59; and in "Concours et expositions," *La Chronique des arts et de la curiosité,* August 19, 1882, pp. 205–6. They were also included in the Triennale catalogue; see Ministère de l'instruction publique et des beaux-arts, Direction des beaux-arts, Exposition nationale de 1883, *Catalogue officiel des ouvrages de peinture, sculpture, architecture, gravure et lithographie des artistes vivants exposés au Palais des Champs-Elysées le 15 septembre 1883* (Paris: Imprimeries réunies, 1883), pp. v–x.

121 Gustave Ollendorff, "L'Exposition nationale de 1883," *Revue des deux-mondes,* November 15, 1883, pp. 436–53, esp. p. 441. Paul Mantz was directeur des beaux-arts while these decisions were being made; see the Appendix. Ollendorff's official title was chef du bureau des musées.

122 For the earlier regulations, see "Documents officiels," *La Chronique des arts et de la curiosité,* January 11, 1879, pp. 9–11.

177

123 The budget for the 1883 Exposition nationale triennale is in AN F21 4087; a profit of 125,000 francs was anticipated. See "Loi portant ouverture au ministère de l'instruction publique et des beaux-arts d'un crédit extraordinaire pour l'organisation de l'exposition nationale des ouvrages des artistes vivants pour l'année 1883," *Journal officiel,* August 5, 1883, p. 4058.

124 See A. Hustin, "A Côté du Salon triennal," *Moniteur des arts,* October 5, 1883, p. 299.

125 In Bardoux's "Rapport" and "Règlement" of December 30, 1878, the show is entitled "Exposition triennale des ouvrages des artistes vivants." This was the title used until the regulations of July 1882 changed it to "Exposition nationale des ouvrages des artistes vivants pour l'année 1883." On the change of title, see Péladan, "L'Esthétique à l'exposition," October 1883, p. 259.

126 See Georges Lafenestre's "Note sur les expositions nationales," dated Paris, November 16, 1883, in AN F21 4088, p. 7. Lafenestre's official title was "commissaire général des expositions."

127 See Marius Vachon, "Autrefois, aujourd'hui," *La France,* December 22, 1882. A shorter notice mainly giving the text of the protest was published under "Concours et expositions," *La Chronique des arts et de la curiosité,* December 23, 1882, pp. 305–6. The official title, Exposition nationale, has caused a century of confusion between this exhibition and the annual Salon, as libraries and scholars have tended to conflate the two shows and their catalogues.

CHAPTER 4. AESTHETIC PURITY

1 The regulations, dated July 28, 1882, were published in "Partie officielle," *Journal officiel,* August 6, 1882, pp. 4258–59; and "Concours et expositions," *La Chronique des arts et de la curiosité,* August 19, 1882, pp. 205–6. They were also included in the Triennale catalogue; see Exposition nationale de 1883, *Catalogue officiel des ouvrages de peinture, sculpture, architecture, gravure et lithographie des artistes vivants exposés au Palais des Champs-Elysées le 15 septembre 1883* (Paris: Imprimeries réunies, 1883), pp. v–x.

2 Edmond Jacques, "Le Salon d'état," *L'Intransigéant,* September 15, 1883. See also Albert Wolff, "L'Exposition nationale des beaux-arts," *Le Figaro-Salon, supplément du Figaro,* September 15, 1883; Léon Millet, "Chronique, le Salon officiel," *La Justice,* September 17, 1883.

3 For Nieuwerkerke's reorganization of the Salon jury in 1857, see Patricia Mainardi, *Art and Politics of the Second Empire: The Universal Expositions of 1855 and 1867* (New Haven, CT: Yale University Press, 1987), pp. 114–16; on the Salon des refusés, see Albert Boime, "The Salon des Refusés and the Evolution of Modern Art," *Art Quarterly* 32 (1969): 411–26.

4 The composition of the juries was published in each annual Salon catalogue; see *Explication des ouvrages de peinture, sculpture, . . . exposés au Palais des Champs-Elysées le Ier mai 1883* (Paris, 1883), p. cxxvii.

5 The appointed members of the Triennale painting jury included the entire current painting section of the Academy: Baudry, Bonnat, Bouguereau, Boulanger, Cabanel, Cabat, Delauney, Gérôme, Hé-

bert, Lenepveu, Müller, Meissonier, Robert-Fleury, and Signol. As
several had been prominent in protests against the exhibition, they
probably served with greater (Meissonier) or lesser (Bouguereau) de-
grees of enthusiasm. The appointed members of the painting jury in-
cluded Etienne Arago, Jules Breton, Clément, Français, Guillaumet,
Harpignies, Havard, Henner, Laurens, J.-P. Lefebvre, Paul Mantz,
Gustave Moreau, Puvis de Chavannes, and Philippe Rousseau. Among
them, Breton, Français, Henner, Laurens, Lefebvre, and Moreau
eventually became Academicians. See Exposition nationale de 1883,
Catalogue, pp. xi–xiv.

6 Ibid., pp. v–xx. The composition of the jury and the regulations were
published in the Triennale catalogue.

7 Paul Lefort, "L'Exposition nationale de 1883," *Gazette des beaux-arts,*
October 1, 1883, pp. 273–78.

8 Several critics commented that the show's title, "Exposition nation-
ale," should be instead "Exposition officielle." See Félix Fénéon, "Ex-
position nationale des beaux-arts (15 septembre–31 octobre 1883)," in
Jean Paulhan, ed., *Oeuvres* (Paris: Gallimard, 1948), pp. 89–96 (origi-
nally *La Libre Revue,* October 1883); and Wolff, "Exposition nation-
ale." Some critics titled their reviews "Le Salon officiel"; see Millet,
"Chronique"; and Thomas Grimm, "Le Salon officiel," *Le Petit Jour-
nal,* September 16, 1883. Burty questioned the title of "national" in
the face of so many absences; see Philippe Burty, "Exposition nation-
ale de 1883," *La République française,* September 16, 1883, pp. 2–3.

9 For the progress of the submissions, see "Concours et expositions,"
La Chronique des arts et de la curiosité, April 28, 1883, pp. 134–35; May
26, 1883, pp. 167–68; and June 23, 1883, p. 182; the submission dead-
line was extended from July 20 to August 10. The limit to fifteen
hundred works was contained in the regulations.

10 Joséphin Péladan, "L'Esthétique à l'Exposition nationale des beaux-
arts," *L'Artiste,* October 1883, pp. 257–304, esp. p. 260.

11 See Nicholas Green, "Dealing in Temperaments: Economic Transfor-
mation of the Artistic Field in France During the Second Half of the
Nineteenth Century," *Art History* 10 (March 1987): 59–78.

12 See the exhibition catalogue of Galerie Georges Petit, Paris, *Exposition
internationale de peinture, deuxième année 1883 du 11 mai au 10 juin.*

13 Lionello Venturi, *Les Archives de l'impressionisme* (Paris: Durand-Ruel,
1939), vol. 1, p. 63.

14 On exhibitions organized by dealers and private societies, see Jean-
Paul Bouillon, "Sociétés d'artistes et institutions officielles dans la sec-
onde moitié du XIXe siècle," *Romantisme* 54 (1986): 89–113; Tamar
Garb, "Revising the Revisionists: The Formation of the Union des
Femmes Peintres et Sculpteurs," *Art Journal,* Spring 1989, pp. 63–70;
and Martha Ward, "Impressionist Installations and Private Exhibi-
tions," *Art Bulletin,* December 1991, pp. 599–622.

15 Ferry's speech was reprinted in the Exposition nationale de 1883, *Cat-
alogue,* pp. xv–xix; see also "Concours et expositions," *La Chronique
des arts et de la curiosité,* April 28, 1883, pp. 134–35.

16 Ferry's speech at the awards ceremony of the 1879 Salon was reprinted
in the 1880 Salon catalogue, pp. v–xiv, esp. p. vii.

17 Péladan, "L'Esthétique," October 1883, p. 261.

18 Ibid., p. 260.

19 See AN F21 4087, dossier 9: Ministère de l'instruction publique et des beaux-arts, Direction des beaux-arts, Exposition nationale de 1883, "Liste des ouvrages presentés sur notices: Peinture," and "Liste générale des ouvrages admis d'office."

20 See "A Côté du Salon triennal," *Moniteur des arts,* September 14, 1883, p. 283; see also Millet, "Chronique."

21 "A Côté du Salon triennal." See also the registers ("Liste des ouvrages") in AN F21 4087, dossier 9.

22 "A Côté du Salon triennal."

23 See Perdican, "Courrier de Paris," *L'Illustration,* December 22, 1883, p. 387.

24 See Péladan, "L'Esthétique," October 1883, pp. 260–61.

25 See the registers ("Liste des ouvrages") in AN F21 4087, dossier 9.

26 The remark was attributed to him by Péladan in "L'Esthetique," October 1883, p. 260.

27 Meissonier did, however, show at the 1878 Exposition universelle and in private exhibitions. On his career during this period, see Constance Cain Hungerford, "Meissonier and the Founding of the Société Nationale des Beaux-Arts," *Art Journal,* Spring 1989, pp. 71–77. For his role in the Triennale, see Firmin Javel, "L'Exposition nationale," *L'Evénement,* September 1, 1883; Wolff, "L'Exposition nationale"; Roger Marx, "Le Salon triennal inédit: Meissonier," *Le Voltaire,* September 23, 1883; and Perdican, "Courrier de Paris," *L'Illustration,* September 22, 1883, p. 179.

28 See Albert Wolff, "Le Mot de la fin," *Le Figaro-Salon, supplément du Figaro,* September 15, 1883.

29 Perdican, "Courrier de Paris," *L'Illustration,* September 22, 1883; also see Marx, "Meissonier"; and Wolff, "L'Exposition nationale."

30 Gustave Ollendorff, "L'Exposition nationale de 1883," *Revue des deux-mondes,* November 15, 1883, pp. 436–53, esp. p. 445.

31 See Théodore Véron, *Exposition nationale de 1883,* vol. 2 of his *Dictionnaire Véron,* 2 vols. (Paris: M. Bazin, 1883), vol. 2, pp. 14–15.

32 Ibid., vol. 2, p. 119; also Ernest Chesneau, "Salon de 1883," in F.-G. Dumas, ed., *Annuaire illustré des beaux-arts et catalogue illustré de l'Exposition nationale: Revue artistique universelle* (Paris: L. Baschet, 1883), pp. 275–77; Péladan, "L'Esthétique," October 1883, pp. 275–77.

33 On this painting, see Constance Cain Hungerford, "Meissonier's *Siège de Paris* and *Ruines des Tuileries,*" *Gazette des beaux-arts,* November 1990, pp. 201–12.

34 Critics who commented that most of the works had already been shown at recent Salons include Arthur Hustin, "Salon triennal," *Moniteur des arts,* September 14, 1883, pp. 275–76; Adolphe Tavernier, "Le Vernissage," *L'Evénement,* September 16, 1883; Georges Goepp, "L'Exposition nationale des beaux-arts en 1883," *La Revue libérale* 5 (1883): 358; Lefort, "L'Exposition nationale de 1883," October 1, 1883, pp. 273–78.

35 Péladan, "L'Esthétique," October 1883, p. 260.

36 Marius Vachon, "Etudes administratives: Le Salon," *Gazette des beaux-arts,* February 1, 1881, pp. 121–34, esp. pp. 131–32.

37 Ibid., p. 132.

38 For an excellent survey of installations of the period, see Ward, "Impressionist Installations."

39 Firmin Javel, "L'Exposition nationale." For similar praise of the in-stallation, see Hustin, "Salon triennal," *Moniteur des arts,* September 7, 14, 1883; Jules Comte, "Le Salon national," *L'Illustration,* September 22, 1883, pp. 182–86; Jehan Valter, "L'Exposition triennale des beaux-arts," *Le Figaro,* September 8, 1883; Jehan Valter, "Autour du Salon," *Le Figaro-Salon, supplément du Figaro,* September 15, 1883; Véron, *Dictionnaire Véron,* vol. 2, p. vii; Tavernier, "Le Vernissage."

40 Tavernier, "Le Vernissage."

41 On the 1699 Salon, see Thomas E. Crow, *Painters and Public Life in Eighteenth-Century Paris* (New Haven, CT: Yale University Press, 1985), pp. 37–38; and on the significance of the 1883 use of tapestries, see the report of Jacques de Biez's lecture in "Chronique des expositions," *Le Courrier de l'art,* October 18, 1883, p. 502.

42 Tavernier, "Le Vernissage"; Wolff, "Exposition nationale."

43 Critics commenting on the official quality of the show included Fé-néon, "Exposition nationale," pp. 89–96; Wolff, "Exposition nation-ale"; Millet, "Chronique"; and Grimm, "Le Salon officiel."

44 Roger Marx, "Le Salon triennal," *Le Voltaire,* September 12, 1883; a similar description, comparing the Triennale with a private gallery, appeared in "Nos Gravures," *Le Journal illustré,* September 23, 1883, pp. 306–7.

45 See Comte, "Le Salon national," p. 183; Hustin, "Salon triennial," *Moniteur des arts,* September 14, 1883, p. 275.

46 See Ward, "Impressionist Installations," on the development of fine arts installations in the later nineteenth century. For an overview of the shift to modern attitudes stressing the preciosity of art, see Rémy Saisselin, *The Bourgeois and the Bibelot* (New Brunswick, NJ: Rutgers University Press, 1984).

47 For a thorough analysis of the rise of "interiority," see Debora L. Silverman, *Art Nouveau in Fin-de-Siècle France: Politics, Psychology, and Style* (Berkeley and Los Angeles: University of California Press, 1989).

48 See Saisselin, *The Bourgeois and the Bibelot.*

49 Valter, "L'Exposition triennale"; Roger Marx, "Le Salon triennal," *Le Voltaire,* September 15, 1883.

50 For typical praise of the catalogue, see Marx, "Le Salon triennal," September 15, 1883; Lefort, "L'Exposition nationale de 1883," p. 275. Most Salon catalogues that have found their way into libraries have been bound with the offending advertising material removed.

51 See Saisselin, *The Bourgeois and the Bibelot.*

52 See Marie Jeannine Aquilino, "The Decorating Campaigns at the Sa-lon du Champs-de-Mars and the Salon des Champs-Elysées in the 1890s," *Art Journal,* Spring 1989, pp. 78–84. On Meissonier's role in the split, see Hungerford, "Meissonier and the Founding of the So-ciété Nationale des Beaux-Arts."

53 This is Sanford Elwitt's thesis in *The Making of the Third Republic: Class and Politics in France, 1868–1884* (Baton Rouge: Louisiana State University Press, 1975), in which he contrasts the liberal Republican bourgeoisie of small producers with the national grande bourgeoisie of bankers and big industrialists. Herman Lebovics further explored this problem in *The Alliance of Iron and Wheat in the Third French Republic 1860–1914: Origin of the New Conservatism* (Baton Rouge: Lou-isiana State University Press, 1988).

54 Emile Zola, "Après une promenade au Salon," *Le Figaro,* May 23, 1881.

55 Paul Girard, "Chronique du Jour," *Le Charivari,* September 28, 1883; also see Gustave Goepp, "L'Exposition nationale des beaux-arts en 1883," *La Revue libérale* 5 (1883): 357–73, 557–64, esp. p. 358.

56 See Edmond About, "Le Deuxième Salon triennal," *Le XIXe Siècle,* December 18, 1883.

57 Goepp, "L'Exposition nationale," p. 358.

58 The two arrêtés extending the exhibition to November 30 are in AN F21 4087, one dated November 13 and the other October 24. The extension was also made in order to increase the receipts so that the show would meet its expenses; see "Chronique des expositions," *Le Courrier de l'art,* November 22, 1883, p. 559.

59 See "Nouvelles," *La Chronique des arts et de la curiosité,* December 8, 1883, p. 306; and "Lettres, sciences, beaux-arts," *La République,* December 4, 1883. The unpublished report of receipts, in AN F21 4088, dossier 1, shows a diminishing attendance even with the extensions past the period of vacations and hunting: September 15–30: Fr 45,477; October 15–November 4: Fr 24,552; November 5–28: Fr 17,220; November 29–30: Fr 1,452; total receipts: Fr 88,701, slightly less than the published total. The 1883 Salon receipts were reported in "Nouvelles," *La Chronique des arts et de la curiosité,* June 23, 1883, p. 183.

60 For the budget appropriation, see "Projet du budget," December 27, 1882, in AN F21 4087, dossier 2, Budget. This initial projection was for a forty-seven-day show with 150,000 francs in total receipts. The 100,000-franc appropriation was announced in "Loi portant ouverture au ministre de l'instruction publique et des beaux-arts d'un crédit extraordinaire pour l'organisation de l'exposition nationale des ouvrages des artistes vivants, pour l'année 1883," *Journal officiel,* August 5, 1883, p. 4058. The loss was noted by Kaempfen in his "Rapport à Monsieur le ministre de l'instruction et des beaux-arts," dated Palais-Royal, December 12, 1883, when in urging the minister to schedule the 1886 Triennale, he noted that although 1883 had brought in a total of only 90,000 francs, this was because it had been scheduled in the autumn; his report is in AN F21 4088. In the dispute over the 1886 Triennale, this loss was acknowledged by most critics; see, for example, "La Société des artistes français et l'Exposition triennale," *Le Temps,* May 15, 1885; and Albert Wolff, "Courrier de Paris," *Le Figaro,* May 9, 1885.

61 Emile Hervet, "Beaux-arts," *La Patrie,* December 25, 1883.

62 Emile Cardon, "Salon triennal: Architecture," *Moniteur des arts,* October 5, 1883, p. 297. Also see Hustin, "Salon triennal," September 14, 1883, p. 275.

63 Goepp, "L'Exposition nationale," pp. 359–60.

64 Hustin, "Salon triennal," September 14, 1883, p. 275.

65 Institut de France, Académie des beaux-arts, *Séance publique annuelle du samedi 20 octobre 1883, présidée par M. Ch. Gounod* (Paris: Firmin-Didot, 1883), pp. 3–9; also published as "Institut de France," *Journal officiel,* October 22, 1883, pp. 5496–97. Zola criticized these works in his "Une Exposition de tableaux à Paris," originally published in *Le Messager de l'Europe,* June 1875; see Emile Zola, *Salons,* ed. F. W. J. Hemmings and Robert J. Niess (Geneva: Droz, 1959), pp. 147–68.

66 Lefort, "L'Exposition nationale de 1883," p. 387.

67 The first chapter in Daniel Halévy's *The End of the Notables* is entitled "On the Origins of Our Confusing Times."

68 See Joel Isaacson, *The Crisis of Impressionism 1878–1882* (Ann Arbor: University of Michigan Museum of Art, 1980), pp. 7–8.

69 Ibid.

70 Monet to Durand-Ruel, February 10, 1882, in Daniel Wildenstein, *Claude Monet: Biographie et catalogue raisonné,* 2 vols. (Lausanne: Daniel Wildenstein, 1979), vol. 2, p. 214, no. 238. Translation quoted from Joel Isaacson, "The Painters Called Impressionists," in Charles S. Moffett, ed., *The New Painting: Impressionism 1874–1886* (San Francisco: The Fine Arts Museums of San Francisco, 1986), pp. 373–95, esp. p. 373.

71 No. 104, Pissarro to de Bellio, March 26, 1882, in Janine Bailly-Herzberg, ed., *Correspondance de Camille Pissarro, 1865–1885* (Paris: Presses universitaires de France, 1980), vol. 1, pp. 161–63. Translation quoted from Isaacson, *The New Painting,* p. 373.

72 See Lebovics, *The Alliance of Iron and Wheat,* p. 68.

73 Lefort, "L'Exposition nationale de 1883," p. 387.

74 G. Dargenty, "Le Salon national," *L'Art* 35 (1883): 26–40.

75 Paul Girard, "Chronique du jour," *Le Charivari,* September 28, 1883. Also see Wolff, "Le Mot de la fin."

76 "Exposition des arts incohérents: Règlement," *Le Journal des arts,* August 31, 1883, p. 3. On the Incoherents, see the brief article by Philippe Robert-Jones, "Les Incohérents et leur expositions," *Gazette des beaux-arts,* October 1958, pp. 231–36; and Catherine Charpin, *Les Arts incohérents (1882–1893)* (Paris: Syros Alternatives, 1990).

77 Edmond Deschaumes, "Causerie," *La Chronique parisienne,* October 21, 1883.

78 "Courrier de Paris," *L'Illustration,* October 20, 1883, p. 243.

79 The descriptions of works are taken from Félix Fénéon, "Les Arts incohérents (Exposition du 15 octobre au 15 novembre 1883)" (originally *La Libre Révue,* November 1883), in his *Oeuvres,* ed. Jean Paulhan (Paris: Gallimard, 1948), pp. 97–99; and from "Courrier de Paris," *L'Illustration,* October 20, 1883, p. 243.

80 "Courrier de Paris," *L'Illustration,* October 20, 1883. p. 243.

81 Ibid.

CHAPTER 5. INDEPENDENTS AND INDEPENDENCE

1 Paul Girard, "Chronique du jour," *Le Charivari,* September 28, 1883; Albert Wolff, "Courrier de Paris," *Le Figaro,* May 9, 1885.

2 AN F21 4088: "Note sur les expositions nationales," signed by Georges Lafenestre, November 16, 1883, and addressed to Albert Kaempfen, the director of fine arts.

3 Ibid. Someone, probably Kaempfen, put a large question mark in the margin next to this request. Lafenestre meant, of course, history painting.

4 See Gustave Ollendorff, "L'Exposition nationale de 1883," *Revue des deux-mondes,* November 15, 1883, pp. 436–53, esp. p. 453. Ollendorff's official title was chef du bureau des musées. Edmond About, both art critic and editor of *Le XIXe Siècle,* as well as a member of the

Conseil supérieur des beaux-arts and the Triennale jury, published a similar article; see his "Le Deuxième Salon triennal," *Le XIXe Siècle,* December 18, 1883.

5 See AN F21 4088: "Rapport à M. le ministre de l'instruction publique et des beaux-arts," dated Palais-Royal, December 12, 1883, and signed by A. Kaempfen, directeur des beaux-arts.

6 "Concours et expositions," *La Chronique des arts et de la curiosité,* December 15, 1883, p. 313.

7 "Décret décidant qu'une exposition nationale des ouvrages des artistes vivants aura lieu au palais des Champs-Elysées en 1886 du Ier mai au 15 juin," dated December 13, 1883, in *Journal officiel,* December 16, 1883, p. 6491; "Concours et expositions," *La Chronique des arts et de la curiosité,* December 22, 1883, p. 323.

8 See "Partie officielle," *Journal officiel,* January 15, 1884, p. 234. The arrêté is dated January 12, 1884, and signed by A. Fallières, ministre de l'instruction publique et des beaux-arts, on the proposal of A. Kaempfen, directeur des beaux-arts. Details of the regulations filtered into the press; see "Concours et expositions," *La Chronique des arts et de la curiosité,* January 5, 1884, p. 1; January 12, 1884, p. 9; and January 19, 1884, pp. 19–20. The ever-smaller show was a traditional conservative desire; Paul Lefort, for example, suggested that perhaps five hundred pictures would constitute a "more serious" exhibition and ended up stating that because there were not more than forty or fifty worthy pictures, perhaps that would be the best number; see Paul Lefort, "L'Exposition nationale de 1883," *Gazette des beaux-arts,* October 1, 1883, pp. 273–78.

9 See "Concours et expositions," *La Chronique des arts et de la curiosité,* December 22, 1883, pp. 323–24; and "Paris, 21 décembre: Dernières Nouvelles: Intérieur," *La Patrie,* December 22, 1883.

10 For Fallières's reassurance, see "Concours et expositions," *La Chronique des arts et de la curiosité,* December 22, 1883, pp. 323–24. The Société des artistes français petition was published under "Le Salon national," in *L'Evénement,* March 13, 1884. There were several weeks between the SAF committee's first visit to the minister and its return with the petition. For an ongoing account, see Emile Hervet, "Beaux-arts," *La Patrie,* December 18, 25, 1883; January 15, 1884; January 22, 1884; and May 16, 1885.

11 Hervet, "Beaux-arts," January 15, 1884.

12 On the Indépendants, see Pierre Angrand, *Naissance des artistes indépendants, 1884* (Paris: Nouvelles Editions Debresse, 1965).

13 Edmond Jacques, "Beaux-arts," *L'Intransigéant,* May 24, 1884; Jacques uses the word *tachisme* to refer to the pointillists.

14 David d'Angers, "Quelques idées sur les expositions," *Journal des artistes,* vol. 1, March 25, 1838, pp. 156–58.

15 The Indépendants' spring 1884 exhibition was held at the Cour du Carrousel in the Tuileries in temporary buildings constructed for the city of Paris. Their December 1884 and all subsequent exhibitions were held in the Pavilion of the city of Paris on the Champs-Elysées. See Angrand, *Naissance des artistes indépendants;* and "Concours et expositions. Le Salon des Indépendants," *La Chronique des arts et de la curiosité,* May 3, 1884, p. 143.

16 Angrand, *Naissance des artistes indépendants,* p. 34. The Indépendants' opening date was May 15, 1884; the show was planned to coincide

with the annual Salon of the Société des artistes français, which had opened on May 1.

17 See "Concours et expositions," *La Chronique des arts et de la curiosité*, January 12, 1884, p. 9; and "Nouvelles," *La Chronique des arts et de la curiosité*, January 10, 1885, p. 10.

18 The letter from Turquet to René Goblet, the ministre de l'instruction publique, is in AN F21 4088, dated Paris, May 5, 1885, and headed "Ministère de l'instruction publique, des beaux-arts et des cultes, Cabinet du sous-secrétaire d'état." It was published as "Rapport adressé au ministre de l'instruction publique, des beaux-arts et des cultes" in *Journal officiel*, May 14, 1885, p. 2508. *La Chronique des arts et de la curiosité* conveyed the news to artists on May 16; see "Concours et expositions," p. 155. Also see Chambre des Députés, Annexe no. 3869, June 20, 1885, "Rapport présenté au nom de la commission du budget chargée d'examiner le projet de loi portant fixation du budget général de l'exercice 1886 (Ministère de l'instruction publique, des beaux-arts et des cultes, 2e section, beaux-arts)" in *Annales de la Chambre des Députés (nouvelle série), Documents parlémentaires, session ordinaire de 1885*, vol. 2 (June 6–August 6, 1885), Paris, 1886, pp. 130–44, esp. chap. 27.

19 See "La Société des artistes français et l'Exposition triennale," *Le Temps*, May 15, 1885. Others who approved included Albert Wolff, "Le Salon des artistes et la Triennale," *Le Figaro*, May 14, 1885; Hervet, "Beaux-arts," May 16, 1985.

20 "La Société des artistes français."

21 The pros and cons of the 1883 Triennale were discussed by most critics when reporting the cancellation of the 1886 show. Partisans of the show continued to blame the financial losses on the season. See also "Suppression du Salon triennal," in *Le Moniteur universel*, May 15–16, 1885, in which the annual Salon catalogue was, in contrast, labeled as too commercial, "avec des annonces parfois ridicules."

22 Ibid.

23 See "La Suppression du Salon triennal," in *Le Télégraphe*, May 14, 1885; "Concours et expositions," *La Chronique des arts et de la curiosité*, May 16, 1885, p. 155. See also the Chamber of Deputies Budget Committee's Report, Annexe no. 3869, June 20, 1885, chap. 27. The report was presented in May but not deposited and published until June.

24 "Reception du ministre des arts," *La Chronique des arts et de la curiosité*, November 26, 1881, pp. 296–97.

25 See "Concours et expositions," *La Chronique des arts et de la curiosité*, May 16, 1885, p. 155.

26 See Sanford Elwitt, *The Making of the Third Republic: Class and Politics in France, 1868–1884* (Baton Rouge: Louisiana State University Press, 1975), chap. 1.

27 Albert Wolff, "Courrier de Paris," *Le Figaro*, May 9, 1885. There is a clipping of this article in AN F21 4088 to which is attached a government memo headed "Note pour M. le sous-secrétaire d'état" [Turquet] from the directeur des beaux-arts [Kaempfen]. It attempts to answer Wolff's attack point by point and suggests starting a campaign in various journals to counter Wolff's charges; it is marked "Approuvé."

28 See Emile Hervet, "Beaux-arts: Suppression de l'Exposition trien-

nale," *La Patrie,* May 16, 1885. Hervet had pointed out in his earlier article, "Beaux-arts," *La Patrie,* December 25, 1883, that government support for the Triennale was limited to the fine arts section of the administration.

29 Michel Crozier, *La Société bloquée* (Paris: Editions du Seuil, 1970), pp. 94–126.

30 See Marie-Claude Genet-Delacroix, "Art et État sous la IIIe République" (thèse, doctorat d'état, Université Panthéon-Sorbonne Paris I, 1988–89), in which she makes this point through a detailed examination of the biographies of successive administrators; see esp. vol. 2, p. 139.

31 See Emile Hervet, "Beaux-arts," *La Patrie,* January 29, 1884, in which he maintains that contemporary official art is still religious art, thus obliquely attacking the conseil as clerical. In 1873 the Conseil supérieur des beaux-arts was then still called the Commission des beaux-arts.

32 The phrase is Emile Hervet's; see his "Beaux-arts," *La Patrie,* January 22, 1884, and May 16, 1885.

33 See About, "Le Deuxième Salon triennal." He was called "le porte-parole du conseil des beaux-arts" by Arthur Hustin, in "Le Prochain Salon triennal," *Moniteur des arts,* December 21, 1883, p. 386.

34 Wolff, "Courrier de Paris."

35 Harrison C. White and Cynthia A. White, *Canvases and Careers: Institutional Change in the French Painting World* (New York: Wiley, 1965), pp. 42–43.

36 See "Distribution des récompenses du Salon," *La Chronique des arts et de la curiosité,* July 11, 1885, p. 195.

37 Alfred Cobban, *A History of Modern France,* vol. 3: *France of the Republics 1871–1962* (Baltimore: Penguin Books, 1965), pp. 23–24. The various shifts in the French legislative system are clearly set forth by Martin-Pannetier.

38 Institut de France, Académie des beaux-arts, *Séance publique annuelle du samedi 20 octobre 1883, présidée par M. Ch. Gounod* (Paris: Firmin-Didot, 1883), pp. 3–9. Gounod's speech was also published in "Institut de France," *Journal officiel,* October 22, 1883, pp. 5496–97.

39 Emile Zola, "Le Naturalisme au Salon," *Le Voltaire,* June 18, 1880.

CHAPTER 6. THE REPUBLIC OF THE ARTS

1 Harrison C. White and Cynthia A. White, *Canvases and Careers: Institutional Change in the French Painting World* (New York: Wiley, 1965), p. 160.

2 See Lorne Huston, "Le Salon et les expositions d'art: Réflexions à partir de l'expérience de Louis Martinet (1861–1865)," *Gazette des beaux-arts,* July–August 1990, pp. 45–50.

3 See the letter from Renoir to Durand-Ruel, March 1881, published in Lionello Venturi, *Les Archives de l'impressionnisme* (Paris: Durand-Ruel, 1939), vol. 1, p. 115. On the later situation, see Nicholas Green, "Dealing in Temperaments: Economic Transformation of the Artistic Field in France During the Second Half of the Nineteenth Century," *Art History,* March 1987, pp. 59–78.

4 After 1892 there were also the smaller Salons de la Rose + Croix, which continued until 1898.

5 See Arno J. Mayer, *The Persistence of the Old Regime: Europe to the Great War* (New York: Pantheon, 1981).

6 See Kenneth E. Silver, *Esprit de Corps: The Art of the Parisian Avant-Garde and the First World War, 1914–1925* (Princeton, NJ: Princeton University Press, 1989); and Laurence Bertrand Dorléac's forthcoming study of art under Vichy.

7 Sanford Elwitt, *The Making of the Third Republic: Class and Politics in France, 1868–1884* (Baton Rouge: Louisiana State University Press, 1975), p. 206.

8 Mayer, *The Persistence of the Old Regime*, p. 262.

9 For a recent study of the Left's ambivalence in dealing with high culture, see Herman Lebovics, *True France: The Wars over Cultural Identity, 1900–1945* (Ithaca, NY: Cornell University Press, 1992).

10 See AN F21 4088, Direction générale des beaux-arts, service des expositions des beaux-arts, "Note sur les expositions nationales," dated Paris, November 16, 1883, and signed by Georges Lafenestre, the commissioner general of the 1883 Triennale. Also see Lafenestre's article, "Les Expositions d'art: Les Indépendants et les aquarellistes," *Revue des deux-mondes*, May 15, 1879, pp. 478–85, esp. p. 478.

11 See Edmond About, "Le Deuxième Salon triennal," *Le XIXe Siècle*, December 18, 1883. Both Miriam R. Levin, *Republican Art and Ideology in Late Nineteenth Century France* (Ann Arbor, MI: University Microfilms International Research Press, 1986) and Marie-Claude Genet-Delacroix, "L'Art et État sous la IIIe République" (thèse, doctorat d'état, Université Panthéon-Sorbonne Paris I, 1988–89) discuss at length the Republican ideology of art as education.

12 General Boulanger, a popular army general and minister of war, nearly led a coup d'état in 1889. See Jean-Marie Mayeur and Madeleine Rebérioux, *The Third Republic from Its Origins to the Great War 1871–1914*, trans. J. R. Foster (Cambridge: Cambridge University Press, 1984), pp. 125–37.

13 Gustave Ollendorff, "L'Exposition nationale de 1883," *Revue des deux-mondes*, November 15, 1883, pp. 436–53.

14 See Debora L. Silverman, *Art Nouveau in Fin-de-Siècle France: Politics, Psychology, and Style* (Berkeley and Los Angeles: University of California Press, 1989); and Miriam R. Levin, *When the Eiffel Tower Was New: French Visions of Progress at the Centennial of the Revolution* (South Hadley, MA: Mount Holyoke Art Museum, 1989); Levin, *Republican Art and Ideology*.

15 Levin, *Republican Art and Ideology*, pp. 182–96, and Silverman, *Art Nouveau in Fin-de-Siècle France*, pp. 224–27, do attempt to identify a Republican style in the fine arts. Levin cites Henner, Puvis, and Roll, and Silverman cites Besnard as examples of Third Republican painting style. These artists' works were, however, typical of the *juste milieu* styles of the period.

16 For an interesting discussion of the Impressionists' business principles, see Joel Isaacson, *The Crisis of Impressionism 1878–1882* (Ann Arbor: University of Michigan Museum of Art, 1980), pp. 8–10. His argument confirms my thesis that in fact the Impressionists were typical of the small shopkeepers in the Third Republic.

17 Jean-Paul Bouillon, "Sociétés d'artistes et institutions officielles dans la seconde moitié du XIXe siècle," *Romantisme* 54 (1986): 89–113.

18 For early criticism of the Salon as a market or bazaar, see Léon Rosenthal, *Du Romantisme au réalisme: La Peinture en France de 1830 à 1848* (Paris: MACULA, 1987), p. 60; for the continuation of that tradition, see Patricia Mainardi, "The Eviction of the Salon from the Louvre," *Gazette des beaux-arts*, July–August 1988, pp. 31–40. For "la Babel officielle," see, for example, Lafenestre, "Les Expositions d'art," p. 478; Ernest Chesneau, "Salon de 1883," in F.-G. Dumas, ed., *Annuaire illustré des beaux-arts et catalogue illustré de l'Exposition nationale: Revue artistique universelle* (Paris: L. Baschet, 1883), p. 275.

19 Maurice Agulhon, *Le Cercle dans la France bourgeoise 1810–1848* (Paris: A. Colin, 1977), p. 17. See also Charles Yriarte, *Les Cercles de Paris 1828–1864* (Paris: Dupray de La Mahérie, 1864).

20 See, for example, "Expositions," *La Chronique des arts et de la curiosité*, June 20, 1874, p. 231.

21 "Causerie artistique: Le Cercle de l'union artistique, "*La Paix: Journal républicain quotidien*, February 16, 1883.

22 "La Nouvelle Salle d'Exposition de la rue de Sèze," *La Vie parisienne*, February 25, 1882, p. 119.

23 Ibid.

24 Ibid.

25 Emile Zola, *L'Oeuvre*, chap. 10, first published in Paris, 1886.

26 Emile Zola, "Une Exposition de tableaux à Paris," originally published in *Le Messager de l'Europe*, June 1875; see Zola, *Salons*, ed. F. W. J. Hemmings and Robert J. Niess (Geneva: Droz, 1959), pp. 147–68.

27 As an example, compare the coverage of the Impressionist show of 1881 in "Concours et expositions," *La Chronique des arts et de la curiosité*, April 16, 1881, pp. 126–27, and April 23, pp. 134–35, with that given to that year's exhibitions of the Cercle artistique de la rue Volney ("Concours et expositions," *La Chronique des arts et de la curiosité*, February 12, 1881, p. 49), or the Cercle artistique de la place Vendôme, ("Concours et expositions," *La Chronique des arts et de la curiosité*, February 5, 1881, p. 42).

28 See Martha Ward, "Impressionist Installations and Private Exhibitions," *Art Bulletin*, December 1991, pp. 599–622.

29 "La Nouvelle Salle d'exposition de la rue de Sèze," *La Vie parisienne*, February 25, 1882, p. 119.

30 Charles Blanc, *Grammaire des arts décoratifs: Décoration intérieure de la maison*, 2e édition augmentée d'une introduction sur les lois générales de l'ornement (Paris: Veuve J. Renouard, 1882), p. xl.

31 Ibid., p. 136.

32 Lafenestre, "Les Expositions d'art," p. 478.

33 See Turquet's *Rapport* in Victor Champier, *Les Beaux-Arts en France et à l'étranger: L'Année artistique 1879* (Paris: A. Quantin, 1880), pp. 575–78; the concept of such installations was praised by Albert Wolff, "Courrier de Paris," *Le Figaro*, May 9, 1885.

34 See Emile Hervet, "Le Salon triennal," *La Patrie*, September 17, 1883. Ferry commented on sculpture in his speech at the 1879 Salon awards ceremony, included in the 1880 Salon catalogue, pp. v–xiv, esp. p. ix.

35 Maurice Du Seigneur, "Les Expositions particulières depuis une année 1882–1883," *L'Artiste*, August 1883, pp. 119–32.

36 On the collaboration between critics and dealers in the production of books and catalogues, see Green, "Dealing in Temperaments."

37 Philip G. Nord, *Paris Shopkeepers and the Politics of Resentment* (Princeton, NJ: Princeton University Press, 1986), pp. 84–86.

38 Ibid., p. 91.

39 Alfred Darcel, "Peintures de MM. H. Lévy et D. Maillart dans les galeries du *Bon Marché*," *La Chronique des arts et de la curiosité,* March 27, 1875, p. 105.

40 Nord, *Paris Shopkeepers,* pp. 69, 150, 165; Nord discusses complaints about shoddy mass-produced goods on pp. 143–204. See also Michael B. Miller, *The Bon Marché: Bourgeois Culture and the Department Store 1869–1920* (Princeton, NJ: Princeton University Press, 1981), p. 192.

41 Nord, *Paris Shopkeepers,* p. 180.

42 Ibid., p. 42.

43 A. Lajeune-Vilar, "La Question du Salon: Une Entrevue avec M. Turquet," *Le Gaulois,* December 22, 1880.

44 Gustave Larroumet, *L'Art et l'état en France* (Paris: Hachette, 1895), p. 92. Larroumet served as directeur des beaux-arts from June 12, 1888, to October 20, 1891.

45 See D. W. Brogan, *The Development of Modern France 1870–1939,* rev. ed. (London: H. Hamilton, 1967), p. 179. Silverman, in *Art Nouveau,* discusses at length the cultural manifestations of the *ralliement* in fin-de-siècle France.

46 Larroumet, *L'Art et l'état,* p. 292. On Second Empire official eclecticism, see Patricia Mainardi, *Art and Politics of the Second Empire: The Universal Expositions of 1855 and 1867* (New Haven, CT: Yale University Press, 1987).

47 Ferry's speech at the 1879 Salon awards ceremony, on July 27, 1879, was published in the 1880 Salon catalogue, pp. v–xiv.

48 Larroumet, *L'Art et l'état,* pp. 18–19.

49 Ibid., p. 19.

50 Ibid., p. 94.

51 Ibid., pp. 17–18.

52 On "individualism," see Koenraad W. Swart, " 'Individualism' in the Mid-XIXth Century (1826–1860)," *Journal of the History of Ideas,* January–March 1962, pp. 77–90.

53 "Chambre des Députés, séance du lundi 24 novembre 1890," *Journal officiel, Annales de la Chambre des Deputés, 5e législature, débats parlémentaires, session extraordinaire de 1890, 20 octobre-24 décembre 1890* (Paris: Firmin-Didot, 1891), pp. 625–51, esp. p. 634.

54 On Second Empire eclecticism, see Mainardi, *Art and Politics,* Part 2.

55 See Silver, *Esprit de corps,* for an account of this later classical revival.

APPENDIX: THE THIRD REPUBLIC FINE ARTS ADMINISTRATION

1 Two publications that are helpful in understanding the structure of the French government – although neither includes the fine arts administration – are Andrée Martin-Pannetier, *Manuel: Institutions et vie politique françaises de 1789 à nos jours,* 2nd ed. (Paris: Librairie générale de droit et de jurisprudence, 1989); and La Société d'histoire moderne:

Série des instruments de travail, *Les Ministères français (1789–1911)* (Paris: Edouard Cornély et Cie, 1911).

2 See Louis Gonse, "La Démission de M. Paul Mantz," *La Chronique des arts et de la curiosité,* November 25, 1882, p. 277; and "La Direction des beaux-arts," *La Chronique des arts et de la curiosité,* December 2, 1882, p. 281.

3 See Albert Boime, "The Salon des Refusés and the Evolution of Modern Art," *Art Quarterly* 32 (1969): 411–26. The artists' petition is in AN F21 535, dossier "1872-Salon," addressed to Jules Simon, and notated "M. Ch. Blanc. Je vous prie d'examiner cela avec attention. Pour moi j'incline à leur accorder une telle exposition."

4 Gustave Larroumet, *L'Art et l'état en France* (Paris: Hachette, 1895), p. 304.

SELECT BIBLIOGRAPHY

I. ARCHIVES

Archives du Louvre, Paris. Série X: Salons.
Archives nationales, Paris. AF IV 1050: Rapports du ministre de l'intérieur, instruction publique, sciences et arts, an VIII–1814.
Archives nationales, Paris. C981/982: Budget de 1850.
Archives nationales, Paris. F21 495A: Papiers de Charles Blanc.
Archives nationales, Paris. F21 496: Administration générale, 1815–73.
Archives nationales, Paris. F21 534/535: Salons ou expositions des artistes vivants, an II–1879.
Archives nationales, Paris. F21 558: Conseil supérieur des beaux-arts, 1875–78.
Archives nationales, Paris. F21 572: Musée européen, 1867–87.
Archives nationales, Paris. F21 4087/4088: Exposition nationale triennale, 1883–86.
Archives nationales, Paris. F21 4711: Direction générale des arts et lettres, organisation de l'administration des beaux-arts, 1873–1941.
Archives nationales, Paris. F21 4712(6): Conseil supérieur des beaux-arts, 1875–1936.
Bibliothèque nationale, Paris. Deloynes Collection, Cabinet des estampes.
Institut de France, Paris. Archives de l'Académie des beaux-arts, procès-verbaux.

2. PRIMARY SOURCES

About, Edmond. "Le Deuxième Salon triennal." Le XIXe Siècle, December 18, 1883.
Académie des beaux-arts. See France, Institut de France.
"A Côté du Salon triennal." Moniteur des arts, September 14, 1883, p. 283.
"L'Administration des beaux-arts devant la Chambre." La Chronique des arts et de la curiosité, May 22, 1880, pp. 164–65.
"A M. le Directeur du Journal des artistes." Journal des artistes, October 7, 1827, pp. 633–66.
Bardoux, Agénor. "Rapport au Président de la République française." In "Partie officielle." Journal officiel, December 31, 1878, p. 12513; also in "Documents officiels." La Chronique des arts et de la curiosité, January 4, 1879, p. 1; January 11, 1879, pp. 9–11; and in AN F21 4087.

"Beaux-arts. Séance royale pour la clôture du Salon de 1831." *L'Artiste* 2 no. 3 (1831): 25–26.

Beulé, Charles-Ernest. *Causeries sur l'art.* Paris: Didier, 1867.

Blanc, Charles. "Rapport au citoyen ministre de l'intérieur, sur les arts du dessin et sur leur avenir dans la république." *Le Moniteur universel,* October 10, 1848, pp. 2763–64.

"Société des arts-unis." *Gazette des beaux-arts,* June 1, 1860, pp. 257–65.

Grammaire des arts du dessin. Paris: Veuve J. Renouard, 1867.

"Salon de 1868." *Le Temps,* May 12, 1868.

Ingres, sa vie et ses ouvrages. Paris: Veuve J. Renouard, 1870.

"Le Rôle d'un gouvernement dans les arts." *Le Temps,* April 30, May 1, 1870.

Le Cabinet de M. Thiers. Paris: Veuve J. Renouard, 1871.

"Rapport au ministre de l'instruction publique, des cultes et des beaux-arts, sur l'Exposition nationale de 1872." *Journal officiel,* December 19, 1871, pp. 5070–1; *La Chronique des arts et de la curiosité,* December 24, 1871, pp. 27–29.

"De l'Etat des beaux-arts en France à la veille du Salon de 1874. I: Peinture." *Le Temps,* April 7, 1874.

Grammaire des arts décoratifs: Décoration intérieure de la maison. 2e édition, augmentée d'une introduction sur les lois générales de l'ornement. Paris: H. Loones, 1882.

Boissard, Fernand. "De la condition des artistes et des moyens de l'améliorer." *L'Artiste,* February 1, 1850, pp. 100–2; March 1, 1850, pp. 136–38.

Borel, Petrus. "Exposition, Galerie Colbert. Au Bénéfice des indigens." *La Liberté: Journal des arts,* no. 1 (1832): 30–32.

Burty, Philippe. "Exposition nationale de 1883." *La République française,* September 16, 1883, pp. 2–3.

Cardon, Emile. "Salon triennal: Architecture." *Moniteur des arts,* October 5, 1883, pp. 297–98.

Castagnary, Jules-Antoine. *Salons.* 2 vols. Paris: Charpentier, 1892.

Castellan, A. L. "Beaux-arts: Salon de 1812." *Le Moniteur universel,* December 22, 1812, pp. 1411–12.

Chamber of Deputies. See France, Chambre des Députés.

Champier, Victor. *Les Beaux-arts en France et à l'étranger: L'Année artistique 1879.* Paris: A. Quantin, 1880.

Les Beaux-arts en France et à l'étranger: L'Année artistique 1880–1881. Paris: A. Quantin, 1881.

Les Beaux-arts en France et à l'étranger: L'Année artistique 1881–1882. Paris: A. Quantin, 1882.

Charton, Edouard. "Rapport fait au nom de la commission des services administratifs sur la direction des beaux-arts au ministère de l'instruction publique, des cultes et des beaux-arts." *La Chronique des arts et de la curiosité,* January 8, 1876, pp. 11–13; January 15, 1876, pp. 20–22; January 22, 1876, pp. 29–32.

Chaussard, Pierre-Jean-Baptiste. "Beaux-arts: Exposition des ouvrages de peinture, sculpture, architecture, gravure, dans les salles du Muséum, premier thermidor an VI." *La Décade philosophique* 18, no. 32 (20 thermidor an VI [1798]): 274–82.

"Beaux-arts. Exposition des ouvrages de peinture, sculpture, architecture, gravure, dessins, modèles, composés par les artistes vivans, et exposés dans le salon du Musée central des arts, le Ier fructidor, an VII

de la République. *La Décade philosophique* 22, no. 36 (30 fructidor an VII [1799]): 542–52.

"Beaux-arts: Fin du compte-rendu de l'exposition des ouvrages composés par les artistes vivans." *La Décade philosophique* 23, no. 4 (10 brumaire an VIII [1799]): 212–28.

Chennevières, Philippe de. *Lettres sur l'art français en 1850*. Argentan: Barbier, 1851.

"Rapport au ministre de l'instruction publique, des cultes et des beaux-arts." *La Chronique des arts et de la curiosité*. May 23, 1874, pp. 208–9.

Souvenirs d'un directeur des beaux-arts. Paris: Arthena, 1979 [originally 1883–89].

Claretie, Jules. *La Vie à Paris: 1880*. Paris: V. Havard, 1881.

Clément, Charles. "Variétés: Le Ministère des beaux-arts." *Journal des débats*, February 12, 1870.

Colin, Paul. *Exposition universelle de 1889: Beaux-arts: L'Enseignement des arts du dessin*. Paris: Imprimerie des journaux officiels 1889.

"La Commission du budget," *Le Temps*, November 4, 1878.

Comte, Jules. "Le Salon national." *L'Illustration*, September 22, 1883, pp. 182–86; October 6, 1883, pp. 215–18; October 13, 1883, pp. 231–34.

Coup d'oeil sur le Sallon du Louvre, de l'an 5ème de la République. Deloynes Collection, Bibliothèque nationale, Paris, vol. 18, no. 486.

D'Angers, David. "Quelques idées sur les expositions." *Journal des artistes*, March 25, 1838, pp. 156–58.

"Le Jury." *L'Artiste*, April 11, 1847, pp. 92–94.

Darcel, Alfred. "Peintures de MM. H. Lévy et D. Maillart dans les galeries du *Bon Marché*." *La Chronique des arts et de la curiosité*, March 27, 1875, p. 105.

Darchez, V. *Nouveaux Exercices de dessin à main levée d'après les derniers programmes officiels: Cours élémentaire*. Paris: Veuve E. Belin et fils, 1883.

Dargenty, G. "Le Salon national." *L'Art* 35 (1883): 26–40.

Decamps, Alexandre. *Le Musée: Revue du Salon de 1834*. Paris: Everat, 1834.

Delaborde, Henri. *L'Académie des beaux-arts depuis la fondation de l'Institut de France*. Paris: E. Plon, Nourrit et Cie, 1891.

Ingres, sa vie, ses travaux, sa doctrine. Paris: H. Plon, 1870.

"A Propos du Salon de 1872." *La Chronique des arts et de la curiosité*, May 12, 1872, pp. 257–60.

Delécluze, E.-J. "Beaux-arts: Ecole française, Salon de 1822." *Le Moniteur universel*, May 3, 1822, pp. 673–74.

[D.]. "Beaux-arts: Salon de 1824." *Le Moniteur universel*, September 8, 1824, p. 1225.

Louis David, son école et son temps. Paris: MACULA, 1983 [originally Paris, 1855].

Detournelle, Athanase. *Aux armes et aux arts! Journal de la Société populaire et républicaine des arts*. Paris, 1794.

"La Direction des beaux-arts." *La Chronique des arts et de la curiosité*, December 2, 1882, p. 281.

Dumas, François-Guillaume, ed. *Annuaire illustré des beaux-arts et catalogue illustré de l'Exposition nationale: Revue artistique universelle*. Paris: L. Baschet, 1883.

Dupré, Paul, and Gustave Ollendorff. *Traité de l'administration des beaux-arts*. 2 vols. Paris: P. Dupont, 1885.

Duranty, Edmond. "Post-scriptum au salon de peinture." *Gazette des beaux-arts*, October 1, 1877, pp. 355–67.

Du Seigneur, Maurice. *L'Art et les artistes au Salon de 1880*. Paris: Paul Ollendorff, 1880.

"Les Expositions particulières depuis une année 1882–1883." *L'Artiste*, August 1883, pp. 119–32.

Emeric-David, Toussaint-Bernard. *Musée olympique de l'école vivante des beaux-arts, ou considérations sur la nécessité de cet établissement, et sur les moyens de le rendre aussi utile qu'il peut l'être*. Paris: Plassan, an IV (1796).

[T.] "Beaux-arts: Salon." *Le Moniteur universel*, July 10, 1817, pp. 755–56.

Enault, Louis. *Paris–Salon triennal 1883*. Paris: E. Bernard et Cie, 1883.

"Exposition des arts incohérents: Règlement." *Le Journal des arts*, August 31, 1883, p. 3.

Fénéon, Félix. "Exposition nationale des beaux-arts (15 septembre–31 octobre 1883)." In *Oeuvres*, ed. Jean Paulhan. Paris: Gallimard, 1948, pp. 89–96.

"Les Arts incohérents (Exposition du 15 octobre au 15 novembre 1883). In *Oeuvres*, ed. Jean Paulhan. Paris: Gallimard, 1948, pp. 97–99.

Fiaux, Louis. *Portraits politiques contemporains*. 5 vols. Paris: C. Marpon et E. Flammarion, 1881–85. Vol. 3: *Charles Blanc*. Paris, 1882.

Fouché, Jean-Louis. "L'Opinion d'Ingres sur le Salon: Procès-verbaux de la commission permanente des beaux-arts (1848–1849)." *La Chronique des arts et de la curiosité*, March 14, 1908, pp. 98–99; April 4, 1908, pp. 129–30.

France, "Arrêté du ministre de l'instruction publique instituant une commission des beaux-arts auprès de la direction des beaux-arts et en nommant les membres, 27 décembre 1873." *La Chronique des arts et de la curiosité*, January 3, 1873, p. 3.

France, "Chambre des Députés – Annexe no. 877, séance du 8 novembre 1878. Rapport fait au nom de la commission du budget sur le budget des dépenses de l'exercice 1879. Ministère de l'instruction publique, des cultes et des beaux-arts, partie relative au service des beaux-arts, par M. Antonin Proust, député." *Journal officiel*, November 28, 1878, pp. 11121–42.

"Chambre des Députés – Annexe no. 2752, séance du 17 juin 1880. Rapport fait au nom de la commission du budget chargée d'examiner le projet de loi portant fixation du budget général des dépenses et des recettes de l'exercice 1881 (Ministère de l'instruction publique et des beaux-arts, 2e section, beaux-arts), par M. Edouard Lockroy, député." *Journal officiel*, July 20, 1880, pp. 8426–32.

"Chambre des Députés – Annexe no. 3249, séance du 21 janvier 1881. Projet de loi portant fixation du budget général de l'exercice 1882, présenté au nom de M. Jules Grévy, Président de la République française, par M. J. Magnin, ministre des finances. Ministère de l'instruction publique et des beaux-arts, IIe partie, 2e section, service des beaux-arts." *Journal officiel: Débats et documents parlementaires, Chambre des Députés, 1881*, pp. 1–13.

"Chambre des Députés – Annexe no. 3608, séance du 12 avril 1881. Rapport fait au nom de la commission du budget chargée d'examiner le projet de loi portant fixation du budget général des dépenses et des recettes de l'exercice 1882 (Ministère de l'instruction publique et des beaux-arts, 2e section, beaux-arts), par M. Edouard Lockroy, député." *Journal officiel: Débats et documents parlementaires, Chambre des*

Députés, annexes aux procès-verbaux des séances, projets et propositions de loi, exposés des motifs et rapports, session 1881, pp. 843–61.

"Chambre des Députés – Annexe no. 3869. "Rapport présenté au nom de la commission du budget chargée d'examiner le projet de loi portant fixation du budget général de l'exercice 1886 (Ministère de l'instruction publique, des beaux-arts et des cultes, 2e section, beaux-arts)." *Journal officiel: Annales de la Chambre des Députés (nouvelle série). Documents parlementaires, session ordinaire de 1885,* vol. 2 (June 6–August 6, 1885), Paris, 1886, June 20, 1885, pp. 130–44.

"Chambre des Députés, séance du mardi 18 mai 1880. Discussion de l'interpellation de M. Robert Mitchell sur la direction donnée aux beaux-arts." *Journal officiel,* May 19, 1880, pp. 5389–96.

"Chambre des Députés, séance du lundi 24 novembre 1890." *Journal officiel: Annales de la Chambre des Députés, 5e législature, débats parlementaires, session extraordinaire de 1890, 20 octobre–24 décembre 1890,* pp. 625–51.

France, Institut de France, Académie des beaux-arts. *Rapport sur l'ouvrage de M. le comte de Laborde membre de l'Institut intitulé: De l'Union des arts et de l'industrie, adressé à LL. EE. les ministres de l'état de la maison de l'Empereur, de l'instruction publique et des cultes, de l'agriculture, du commerce et des travaux publics.* Paris: Firmin-Didot, 1858.

Séance publique annuelle du samedi 9 novembre 1872, présidée par M. Ambroise Thomas. Paris: Firmin-Didot, 1872.

Séance publique annuelle du samedi 24 octobre 1874, présidée par M. Cavelier. Paris: Firmin-Didot, 1874.

Séance publique annuelle du samedi 30 octobre 1880, présidée par M. J. Thomas. Paris: Firmin-Didot, 1880.

Séance publique annuelle du samedi 22 octobre 1881, présidée par M. Questel. Paris: Firmin-Didot, 1881.

Séance publique annuelle du samedi 20 octobre 1883, présidée par M. Ch. Gounod. Paris: Firmin-Didot, 1883.

France, Institut de France. *Rapports et discussions de toutes les classes de l'Institut de France sur les ouvrages admis au concours pour les Prix décennaux.* Paris: Baudouin et Cie, 1810.

France. "Loi portant ouverture au ministère de l'instruction publique et des beaux-arts d'un crédit extraordinaire pour l'organisation de l'exposition nationale des ouvrages des artistes vivants, pour l'année 1883." *Journal officiel,* August 5, 1883, p. 4058.

France, Ministère de l'instruction publique et des beaux-arts. Direction des beaux-arts. Michelez, Charles, ed. *Ouvrages commandés ou acquis par l'administration des beaux-arts: Salon de 1883 et Exposition nationale.* Paris: Imprimerie nationale, 1884.

France, Ministère de l'instruction publique et des beaux-arts. Direction des beaux-arts, bureau de l'enseignement. *Commission d'enquête sur la situation des ouvriers et des industries d'art instituée par décret en date du 24 décembre 1881.* Paris: A. Quantin, 1884.

France, Ministère de l'instruction publique et des beaux-arts. *Rapport présenté à M. le ministre au nom de la commission de l'imagerie scolaire par M. Henry Havard.* Paris: Imprimerie nationale, 1883.

Frémine, Charles. "Le Salon national." *Le Rappel,* September 16, 1883.

Galichon, Emile. "L'Art et l'industrie considérés au point du vue économique." *La Chronique: Politique des arts et de la curiosité,* January 30, 1870, pp. 17–18.

Girard, Paul. "Chronique du Jour." *Le Charivari*, September 28, 1883.

Goepp, Gustave. "L'Exposition nationale des beaux-arts en 1883." *La Revue libérale* 5 (1883): 357–73, 557–64.

Gonse, Louis, ed. *Exposition universelle de 1878: Les Beaux-arts et les arts décoratifs*. 2 vols. Paris: Gazette des beaux-arts, 1879.

Gonse, Louis. "Le Salon de 1880." *La Chronique des arts et de la curiosité*, May 1, 1880, p. 141.

——— "Le Ministère des arts." *La Chronique des arts et de la curiosité*, November 19, 1881, pp. 285–86.

——— "La Démission de M. Paul Mantz." *La Chronique des arts et de la curiosité*, November 25, 1882, p. 277.

Gonzague-Privat [Louis de Gonzague Privat]. "Projets de réformes pour les expositions artistiques." *L'Evénement*, April 12, 1876.

Grimm, Thomas. "Le Salon officiel." *Le Petit Journal*, September 16, 1883.

Guillaume, Eugène. *Idée générale d'un enseignement élémentaire des beaux-arts appliqués à l'industrie: Conférence faite à l'Union centrale des beaux-arts appliqués à l'industrie, le 23 mai 1866, à propos de la dernière exposition des écoles de dessin*. Paris: Union centrale, 1866.

——— *Etudes d'art antique et moderne*. Paris: Perrin et Cie, 1888.

——— *Allocations et discours*. Paris: L.-H. May, 1899.

Halévy, Daniel. *The End of the Notables*. Trans. Alain Silvera and June Guicharnaud. Middletown, CT: Wesleyan University Press, 1974 [originally *La Fin des notables*. Paris, 1930].

——— *La République des ducs*. Paris: B. Grasset, 1937.

Havard, Henry. *Lettre sur l'enseignement des beaux-arts*. Paris: A. Quantin, 1879.

——— *Rapport présenté à M. le ministre au nom de la commission de l'imagerie scolaire*. See France, Ministère de l'instruction publique et des beaux-arts.

——— *L'Art dans la maison*. Paris: E. Rouveyre et G. Blond, 1884.

Hervet, Emile. "Le Salon triennal." *La Patrie*, September 17, 1883.

——— "Beaux-Arts." *La Patrie*, December 18, 25, 1883; January 15, 22, 29, 1884; May 16, 1885.

Hustin, Arthur. "Salon triennal, Exposition nationale." *Moniteur des arts*, September 7, 1883; September 14, pp. 275–76; September 21, pp. 288–89; September 28, pp. 289–90; October 5, pp. 297–98, p. 299; October 19, 1883, pp. 313–14; December 21, 1883, p. 386.

Institut de France. See France, Institut de France.

Jacques, Edmond. "Le Salon d'état." *L'Intransigéant*, September 15, 1883.

——— "Beaux-arts: Salon des Indépendants." *L'Intransigéant*, May 24, 1884.

Jal, Auguste. *L'Artiste et le philosophe. Entretiens critiques sur le Salon de 1824*. Paris: Pontieu, 1824.

——— *Esquisses, croquis, pochades, ou tout ce qu'on voudra sur le Salon de 1827*. Paris: A. Dupont, 1828.

Javel, Firmin. "L'Exposition nationale." *L'Evénement*, September 1, 1883.

Jugler, Clément. "L'Art et l'industrie." *La Chronique: Politique des arts et de la curiosité*, March 6, 1870, pp. 37–38.

——— "L'Art et l'industrie en Angleterre." *La Chronique: Politique des arts et de la curiosité*, April 17, 1870, pp. 61–62.

Laborde, Léon de. *Application des arts à l'industrie*. See Vol. 8 of London, Great Exhibition of Works of Industry of All Nations, 1851. Exposition universelle de 1851, *Travaux de la commission française sur l'industrie des nations*.

Lacroix, Sigismond, ed. *Actes de la Commune de Paris pendant la Révolution.* 2e série. Vol. 4. Paris: L. Cerf, 1905.

Lafenestre, Georges. "Les Expositions d'art: Les Indépendans et les aquarellistes." *Revue des deux-mondes,* May 15, 1879, pp. 478–85.

"Le Salon et ses vicissitudes." *Revue des deux-mondes,* May 1, 1881, pp. 104–35.

"Les Magasins du Printemps réédifiés par M. Paul Sedille." *Gazette des beaux-arts,* March 1, 1883, pp. 239–53.

Lajeune-Vilar, A. "La Question du Salon. Une Entrevue avec M. Turquet." *Le Gaulois,* December 22, 1880.

Larroumet, Gustave. *L'Art et l'état en France.* Paris: Hachette, 1895.

Laurent, Charles. "Un Salon annuel!" *La France,* November 18, 1875.

"Le Salon annuel." *La France,* November 20, 1875.

Le Breton, Joachim. *Beaux-arts.* Ed. Udolpho van de Sandt. Vol. 5 of *Rapports à l'Empereur sur le progrès des sciences, des lettres et des arts depuis 1789.* 5 vols. Paris: Belin, 1989 [originally Paris, 1808].

L. D. "Amélioration de l'enseignement artistique en France." *La Chronique des arts et de la curiosité,* August 20, 1874, pp. 267–71.

Lefort, Paul. "L'Exposition nationale de 1883." *Gazette des beaux-arts,* October 1, 1883, pp. 273–78; November 1, 1883, pp. 384–406; December 1, 1883, pp. 457–71.

Lenormant, Charles. *Les Artistes contemporains.* 2 vols. Paris: A. Mesnier, 1833.

London, Great Exhibition of Works of Industry of All Nations, 1851. *Exposition universelle de 1851. Travaux de la commission française sur l'industrie des nations, publiés par ordre de l'Empereur.* 16 vols. Paris: Imprimerie impériale, 1856–73.

London, International Exhibition, 1862. *Exposition universelle de Londres de 1862. Rapports des membres de la section française du jury international sur l'ensemble de l'exposition et documents officiels publiés sous la direction de Michel Chevalier.* 7 vols. Paris: Chaix, 1862–64.

Louvrier de Lajolais. A. [A. de L.]. "A propos du règlement du Salon." *La Chronique des arts et de la curiosité,* May 1, 1880, p. 142.

"Les Artistes et le Salon triennal." *La Chronique des arts et de la curiosité,* March 18, 1882, pp. 81–82.

Loysel, Stéphane. "Le Salon de 1880." *L'Illustration,* May 1, 1880, p. 286.

Malaval, L. *Le Vrai Dessin: Cours complet, théorique et pratique de dessin géometrique.* 2e édition, Rodez: L. Loup fils, 1881.

Mantz, Paul. "L'Exposition nationale." *Le Temps,* September 19, 1883.

Marx, Roger. "Le Salon triennal." *Le Voltaire,* September 12, 15, 1883.

"Le Salon triennal inédit: Meissonier." *Le Voltaire,* September 23, 1883.

Massarani, Tullo. *L'Art à Paris.* 2 vols. Paris: H. Loones, 1880.

Mérimée, Prosper. "Considérations sur les applications de l'art à l'industrie à l'Exposition universelle." London, International Exhibition, 1862. *Exposition universelle de Londres de 1862. Rapports des membres de la section française du jury international sur l'ensemble de l'exposition et documents officiels publiés sous la direction de Michel Chevalier.* 7 vols. Paris: Chaix, 1862–64, vol. 6, pp. 248–62.

Millet, Léon. "Chronique: Le Salon officiel." *La Justice,* September 17, 1883.

Müntz, E. "Le Salon: Essai de statistique." *La Chronique des arts et de la curiosité,* May 31, 1873, pp. 213–16.

"La Nouvelle Salle d'exposition de la rue de Sèze." *La Vie parisienne*, February 25, 1882, p. 119.

Ollendorff, Gustave. "L'Exposition nationale de 1883." *Revue des deux-mondes*, November 15, 1883, pp. 436–53.

Paris. *Catalogue des ouvrages de peinture, sculpture, gravure, lithographie et architecture refusés par le jury de 1863 et exposés par décision de S. M. l'Empereur, au Salon annexe, Palais des Champs-Elysées le 15 mai 1863.* Paris: Les Beaux-arts, 1863.

Paris. *Explication des ouvrages de peinture, sculpture, architecture, gravure et lithographie des artistes vivants . . .* [official Salon catalogues]. 1789–1889.

Paris. *Exposition libre des oeuvres d'art refusées au Salon de 1875.* Paris: Typographie veuve Edouard Vert, 1875.

Paris. *Exposition des oeuvres d'art refusées à l'Exposition officielle de 1873 (Champs Elysées): Catalogue.* Paris: E. Martinet, 1873.

Paris, Exposition nationale de 1883. *Catalogue officiel des ouvrages de peinture, sculpture, architecture, gravure et lithographie des artistes vivants exposés au Palais des Champs-Elysées le 15 septembre 1883.* Paris: Imprimeries réunies, 1883.

Paris, Exposition universelle de 1867 à Paris. *Rapports du jury international publiés sous la direction de M. Michel Chevalier.* 13 vols. Paris: P. Dupont, 1868.

Paris, Exposition universelle internationale de 1878 à Paris. *Catalogue officiel publié par le commissariat général.* 8 vols. Paris: Imprimerie nationale, 1878.

Rapports du jury international publiés sous la direction de Jules Simon. 56 vols. and Introduction. Paris: Imprimerie nationale, 1879–82.

Paris, Exposition universelle internationale de 1889 à Paris. *Rapport général par M. Alfred Picard.* 10 vols. Paris: Imprimerie nationale, 1890–92.

Rapports du jury international publiés sous la direction de M. Alfred Picard. 46 vols. Paris: Imprimerie nationale, 1890–93.

Paris, Galerie Georges Petit. *Cents Chefs-d'oeuvre: Galerie Georges Petit, 8 rue de Sèze et 12 rue Godot de Mauroy.* Paris: Georges Petit, 1883.

Exposition internationale de peinture, deuxième année 1883 du 11 mai au 10 juin. Paris: Georges Petit, 1883.

Paris. Salon des artistes indépendants 1884. *Catalogue officiel et complet des ouvrages de peinture, sculpture, dessins et gravures exposés aux Tuileries, autorisé par le ministre des beaux-arts et la ville de Paris.* Paris: Santier, L. Baillet, 1884.

Paris, Société d'aquarellistes français. *1879: Première Exposition, rue Laffitte, 16, Catalogue.* Paris: D. Jouaust, 1879.

Ouvrage d'art publié avec le concours artistique de tous les sociétaires: Texte par les principaux critiques d'art. 2 vols. Paris: Launette, 1883.

Peisse, Louis. "Le Salon." *Revue des deux-mondes*, April 1, 1843, pp. 85–109.

Péladan, Joséphin. "L'Esthétique à l'Exposition nationale des beaux-arts." *L'Artiste*, October 1883, pp. 257–304; November 1883, pp. 353–86; December 1883, pp. 433–75.

Perdican. "Courrier de Paris." *L'Illustration*, September 22, 1883, p. 179; December 22, 1883, p. 387.

Pérignon, Alexis-Joseph. *Deux expositions des beaux-arts.* Paris: Dubuisson, 1866; deuxième édition, Paris: Firmin-Didot, 1881.

Lettre de M. Pérignon sur la nécessité de transformer l'organisation de l'exposition des beaux-arts. Paris: Chaix, 1866.

Planche, Gustave. "Beaux-arts: La Quatrième Classe de l'Institut." *L'Artiste* 4, no. 11 (1832): 117–18.

"Le Salon et le budget." *L'Artiste* 4, no. 13 (1832): 142–43.

Etudes sur l'école française (1831–1852). Peinture et sculpture, 2 vols. Paris: Michel Lévy frères, 1855.

Polyscope. "Beaux-arts: Observations de Polyscope sur le Salon de peinture, sculpture, etc. de l'an V." *La Décade philosophique, littéraire et politique* 11, no. 2 (20 vendémiaire an V [1796]): 91–95.

Proust, Antonin. *L'Art sous la République.* Paris: G. Charpentier et E. Fasquelle, 1892.

Quatremère de Quincy, Antoine-Chrysostôme. *Considérations sur les arts du dessin en France, suivies d'un plan d'Académie, ou d'école publique, et d'un système d'encouragemens.* Paris: Desenne, 1791.

Raimbaud, Jules. "Union et liberté." *La Liberté: Journal des arts,* no. 2, 1832, pp. 13–16.

"Reception du ministre des arts." *La Chronique des arts et de la curiosité,* November 26, 1881, pp. 296–97.

"Règlement concernant les commandes et acquisitions d'oeuvres d'art," *Le Temps,* November 8, 1878.

Renoux. "De l'Exposition." *La Liberté: Journal des arts,* September 1832, pp. 127–28.

R. L. F. "Un mot sur le concours du Salon." *Nouvelles des arts* 1, an X [1801–2], pp. 49–50.

Roujon, Henry. *Artistes et amis des arts.* Paris: Hachette, 1912.

"La Société des artistes français et l'Exposition triennale." *Le Temps,* May 15, 1885.

Talleyrand-Périgord, Charles Maurice de. "Rapport sur l'instruction publique, fait, au nom du comité de Constitution, par M. Talleyrand-Périgord, ancien évêque d'Autun, administrateur du département de Paris." Première annexe à la séance de l'assemblée nationale du samedi, 10 septembre 1791, au matin. In J. Mavidal and E. Laurent, eds., *Archives Parlementaires de 1787 à 1860: Recueil complet des débats législatifs & politiques des chambres françaises.* Première série (1787 à 1799). Vol. 30 du 28 août au 17 Septembre 1791. Paris: Librairie administrative de P. Dupont, 1888, pp. 447–511.

Tavernier, Adolphe. "Le Vernissage." *L'Evénement,* September 16, 1883.

Turquet, Edmond. "Salon de 1880. Rapport au ministre de l'instruction publique et des beaux-arts." *Journal officiel,* January 2–3, 1880, pp. 34–36; also in "Documents officiels." *La Chronique des arts et de la curiosité,* January 10, 1880, pp. 9–13.

"Rapport au ministre de l'instruction publique et des beaux-arts, 24 décembre 1880." *Journal officiel,* December 28, 1880, p. 12944.

"Rapport adressé au ministre de l'instruction publique, des beaux-arts et des cultes." *Journal officiel,* May 14, 1885, p. 2508.

Un Parisien. "Les Tablettes d'un parisien: Un Jury sur la sellette." *Le Charivari,* May 27, 1880.

Vachon, Marius. "Etudes administratives: Le Salon." *Gazette des beaux-arts,* February 1, 1881, pp. 121–34.

"Les Industries d'art à l'étranger." *La Chronique des arts et de la curiosité,* December 12, 1885, pp. 306–7.

Nos Industries d'art en péril: Un Musée municipal d'études d'art industriel. Paris: L. Baschet, 1882.

Rapports à M. Edmond Turquet, sous-secrétaire d'état sur les musées et les écoles

d'art industriel et sur la situation des industries artistiques en Allemagne, Autriche-Hongrie, Italie et Russie. Paris: A. Quantin, 1885.

"Le Salon triennal." *La France,* September 15, 1883.

Valter, Jehan. "L'Exposition triennale" des beaux-arts." *Le Figaro,* September 8, 1883, p. 2.

"Autour du Salon," *Le Figaro-Salon, supplément du Figaro,* September 15, 1883.

Venturi, Lionello. *Les Archives de l'impressionisme.* 2 vols. Paris: Durand-Ruel, 1939.

Véron, Eugène. "L'Académie nati »nale des artistes français." *La Chronique des arts et de la curiosité,* Dece1 1ber 26, 1874, pp. 389–90.

Véron, Théodore. *Dictionnair Véron.* 2 vols. Paris: M. Bazin, 1883.

Viel-Castel, Comte Horace de. "Beaux-arts: Des Beaux-arts." *L'Artiste* 1, no. 24 (1831): 289–91.

Wolff, Albert. "Le Scandale du jour." *Le Figaro,* November 16, 1875.

"Les Martyrs de l'art." *Le Figaro* November 17, 1875.

"19 contre 8." *Le Figaro,* November 20, 1875.

"L'Exposition nationale des beaux-arts." *Le Figaro-Salon, supplément du Figaro,* September 15, 1883.

"Le Mot de la fin." *Le Figaro-Salon, supplément du Figaro,* September 15, 1883.

"Courrier de Paris." *Le Figaro,* May 9, 1885.

"Le Salon des artistes et la triennale." *Le Figaro,* May 14, 1885.

XX. "Sur l'Exposition publique du 15 fructidor an X." *Journal des arts, des sciences et de littérature,* no. 208, 20 prairial an X (1802): 371–72.

Yriarte, Charles. *Les Cercles de Paris 1828–1864.* Paris: Dupray de La Mahérie, 1864.

Zola, Emile. "Causerie." *La Tribune,* December 20, 1868, p. 7.

"Le Naturalisme au Salon." *Le Voltaire,* June 18, 1880.

"Après une promenade au Salon." *Le Figaro,* May 23, 1881.

Salons. Ed. F. W. J. Hemmings and Robert J. Niess. Geneva: Droz, 1959.

3. SECONDARY SOURCES

Ackerman, Gerald M. *The Life and Work of Jean-Léon Gérôme.* London: Sotheby, 1986.

Agulhon, Maurice. *Le Cercle dans la France bourgeoise 1810–1848.* Paris: A. Colin, 1977.

La République de Jules Ferry à François Mitterrand: 1880 à nos jours. Paris: Hachette, 1990.

Althusser, Louis. "Ideology and Ideological State Apparatuses (Notes Towards an Investigation)." In Louis Althusser, *Lenin and Philosophy and Other Essays.* New York: Monthly Review Press, 1971, pp. 127–86.

Amic, Yolande. "Débuts de l'U.C.A.D. et du Musée des arts décoratifs." *Cahiers de l'U.C.A.D.* [Union centrale des arts décoratifs], no. 1, 2e semestre 1978, pp. 52–54.

Angrand, Pierre. *Naissance des artistes indépendants, 1884.* Paris: Nouvelles Editions Debresse, 1965.

"L'Etat mécène – Période authoritaire du Second Empire (1851–1860)." *Gazette des beaux-arts,* May–June 1968, pp. 303–48.

Aquilino, Marie Jeannine. "The Decorating Campaigns at the Salon du Champ-de-Mars and the Salon des Champs-Elysées in the 1890s." *Art Journal,* Spring 1989, pp. 78–84.

Bazin, Germain. "Le Salon de 1830 à 1900." In Mario Salmi, ed., *Scritti di storia dell'arte in onore di Lionello Venturi.* 2 vols. Rome: De Luca, 1956, vol. 2, pp. 117–23.

Benjamin, Walter. "Paris – The Capital of the Nineteenth Century." In Harry Zohn, trans., *Charles Baudelaire: A Lyric Poet in the Era of High Capitalism.* London: NLB, 1973, pp. 157–76.

"The Work of Art in the Age of Mechanical Reproduction." In Francis Frascina and Charles Harrison, eds., *Modern Art and Modernism: A Critical Anthology.* New York: 1987, Harper & Row, pp. 217–20.

Benoit, François, *L'Art français sous la Révolution et l'Empire: Les doctrines, les idées, les genres.* Paris: L.-H. May, 1897.

Boime, Albert. *The Academy and French Painting in the Nineteenth Century.* London: Phaidon, 1971.

"Le Musée des copies." *Gazette des beaux-arts,* October 1964, pp. 237–47.

"The Salon des Refusés and the Evolution of Modern Art." *Art Quarterly* 32 (1969): 411–26.

"The Teaching of Fine Arts and the Avant-Garde in France During the Second Half of the Nineteenth Century." *Arts Magazine,* December 1985, pp. 46–57.

"The Teaching Reforms of 1863 and the Origins of Modernism in France." *Art Quarterly,* Autumn 1977, pp. 1–39.

Bordes, Philippe, and Régis Michel, eds. *Aux Armes & aux arts! Les Arts de la Révolution 1789–1799.* Paris: Adam Biro, 1988.

Bouillon, Jean-Paul. "Sociétés d'artistes et institutions officielles dans la seconde moitié du XIXe siècle." *Romantisme* 54 (1986): 89–113.

Bourdieu, Pierre. *Distinction: A Social Critique of the Judgement of Taste.* Trans. Richard Nice, Cambridge, MA: Harvard University Press, 1984.

Boyer, Ferdinand. "Napoléon et l'attribution des grands prix décennaux (1810–1811)." *Bulletin de la Société de l'histoire de l'art français,* 1947–1948, pp. 66–72.

Brogan, Denis William. *The Development of Modern France (1870–1939).* Rev. ed. London: H. Hamilton, 1967.

Butterfield, Herbert. *The Whig Interpretation of History.* New York: Norton, 1965.

Caubisens-Lasfargues, Colette. "Le Salon de peinture pendant la Révolution." *Annales historiques de la Révolution française,* April–June 1961, pp. 193–214.

Chapman, Guy. *The Third Republic of France: The First Phase 1871–1894.* London: Macmillan, 1962.

Charpin, Catherine. *Les Arts incohérents (1882–1893).* Paris: Syros Alternatives, 1990.

Chaudonneret, Marie-Claude. "1848: 'La République des Arts.' " *Oxford Art Journal* 10, no. 1 (1987): 59–70.

Chu, Petra ten-Doesschate. "Into the Modern Era: The Evolution of Realist and Naturalist Drawing." In Gabriel P. Weisberg, ed., *The Realist Tradition: French Painting and Drawing 1830–1900.* Cleveland: Cleveland Museum of Art, 1980, pp. 21–38.

Clark, Timothy J. *The Painting of Modern Life: Paris in the Art of Manet and His Followers.* Princeton, NJ: Princeton University Press, 1984.

Cobban. Alfred. *A History of Modern France*. Vol. 3: *France of the Republics 1871–1962*. Baltimore: Penguin Books, 1965.

Crow, Thomas E. *Painters and Public Life in Eighteenth-Century Paris*. New Haven, CT: Yale University Press, 1985.

Crozier, Michel. *La Société bloquée*. Paris: Editions du Seuil, 1970.

Elsen, Albert E. *The Gates of Hell by Auguste Rodin*. Stanford, CA: Stanford University Press, 1985.

Elwitt, Sanford. *The Making of the Third Republic: Class and Politics in France, 1868–1884*. Baton Rouge, Louisiana State University Press, 1975.

Foucault, Michel. *The Order of Things: An Archaeology of the Human Sciences*. London: Routledge, 1970.

Gallini, Brigitte. "Concours et Prix d'encouragement." In Grand Palais, Paris. *La Révolution française et l'Europe 1789–1799*. 3 vols. Paris: Réunion des musées nationaux, 1989, vol. 3, pp. 830–51.

Garb, Tamar. "Revising the Revisionists: The Formation of the Union des Femmes Peintres et Sculpteurs." *Art Journal*, Spring 1989, pp. 63–70.

Genet-Delacroix, Marie-Claude. "Esthétique officielle et art national sous la IIIe République." *Le Mouvement social*, April–June 1985, pp. 105–20.

"Art et État sous la IIIe République." Thèse, doctorat d'état, Université Panthéon–Sorbonne Paris I, 1988–89.

Green, Nicholas. " 'All the Flowers of the Field': The State, Liberalism and Art in France Under the Early Third Republic." *Oxford Art Journal* 10, no. 1 (1987): 71–84.

"Dealing in Temperaments: Economic Transformation of the Artistic Field in France During the Second Half of the Nineteenth Century." *Art History*, March 1987, pp. 59–78.

Greenberg, Clement. "Modernist Painting." *Source: Art and Literature*, Spring 1965, pp. 193–201.

Guiffrey, Jules. "Les Artistes au Salon de 1791." *Nouvelles archives de l'art français*, série 3, vol. 7 (April 1891): 123–27.

Haskell, Francis, ed. *Saloni, gallerie, musei e loro influenza sullo sviluppo dell'arte dei secoli XIX e XX. Atti del XXIV Congresso internazionale di storia dell'arte*. Bologna: CLUEB 1981.

Hauptman, William. "Juries, Protests, and Counter-Exhibitions Before 1850." *Art Bulletin*, March 1985, pp. 95–109.

Heim, Jean-Francois, Claire Béraud, Philippe Heim. *Les Salons de peinture de la Révolution française (1789–1799)*. Paris: C.A.C. Sarl. edition, 1989.

Herbert, Robert L. *Impressionism: Art, Leisure, and Parisian Society*. New Haven, CT: Yale University Press, 1988.

Hoffmann, Stanley, ed. *In Search of France*. Cambridge, MA: Harvard University Press, 1963.

Hungerford, Constance Cain. "Meissonier and the Founding of the Société Nationale des Beaux-Arts." *Art Journal*, Spring 1989, pp. 71–77.

"Meissonier's *Siège de Paris* and *Ruines des Tuileries*." *Gazette des beaux-arts*, November 1990, pp. 201–12.

Huston, Lorne. "Le Salon et les expositions d'art: Réflexions à partir de l'expérience de Louis Martinet (1861–1865)." *Gazette des beaux-arts*, July–August 1990, pp. 45–50.

Isaacson, Joel. *The Crisis of Impressionism 1878–1882*. Ann Arbor: University of Michigan Museum of Art, 1980.

"The Painters Called Impressionists." In Charles S. Moffett, ed., *The New Painting: Impressionism 1874–1886*. San Francisco: The Fine Arts Museums of San Francisco, 1986, pp. 373–95.

Jameson, Frederic. *The Political Unconscious: Narrative as a Socially Symbolic Act*. Ithaca, NY: Cornell University Press, 1981.

Kelder, Diane. *Aspects of "Official" Painting and Philosophic Art 1789–1799*. New York: Garland, 1976.

Kuhn. Thomas S. *The Structure of Scientific Revolutions*. 2nd ed., enlarged. Chicago: University of Chicago Press, 1970.

Lacambre, Geneviève. "Les Institutions du Second Empire et le Salon des refusés." In Francis Haskell, ed., *Saloni, gallerie, musei e loro influenza sullo sviluppo dell'arte dei secoli XIX e XX. Atti del XXIV Congresso internazionale di storia dell'arte*. Bologna: CLUEB, 1981, pp. 163–75.

Lebovics, Herman. *The Alliance of Iron and Wheat in the Third French Republic 1860–1914: Origins of the New Conservatism*. Baton Rouge: Louisiana State University Press, 1988.

True France: The Wars over Cultural Identity, 1900–1945. Ithaca, NY: Cornell University Press, 1992.

Lelièvre, Pierre. *Vivant Denon: Directeur des beaux-arts de Napoléon: Essai sur la politique artistique du premier Empire*. Paris: Floury, 1942.

"Le Salon de 1806." *Bulletin de le Société de l'histoire de l'art français*, 1953, pp. 69–75.

Lethève, Jacques. *The Daily Life of French Artists*. Trans. Hilary E. Paddon, New York: Praeger, 1972.

Levin, Miriam R. *Republican Art and Ideology in Late Nineteenth Century France*. Ann Arbor, MI: University Microfilms International Research Press, 1986.

When the Eiffel Tower Was New: French Visions of Progress at the Centennial of the Revolution. South Hadley, MA: Mount Holyoke Art Museum, 1989.

Locquin, Jean. *La Peinture d'histoire en France de 1747 à 1785*. Paris: Laurens, 1912.

Mainardi, Patricia. "The Political Origins of Modernism." *Art Journal*, Spring 1985, pp. 11–17.

Art and Politics of the Second Empire: The Universal Expositions of 1855 and 1867. New Haven, CT: Yale University Press, 1987.

"The Eviction of the Salon from the Louvre." *Gazette des beaux-arts*, July–August 1988, pp. 31–40.

"The Double Exhibition in Nineteenth Century France." *Art Journal*, Spring 1989, pp. 23–28.

"Assuring the Empire of the Future: The 1798 Fête de la Liberté." *Art Journal*, Summer 1989, pp. 155–63.

"Some Stellar Moments in the History of Government-sponsored Exhibitions." *Art in America*, July 1990, pp. 154–59.

"Courbet's Exhibitionism." *Gazette des beaux-arts*, December 1991, pp. 253–66.

Marrinan, Michael. *Painting Politics for Louis-Philippe: Art and Ideology in Orléanist France, 1830–1848*. New Haven, CT: Yale University Press, 1988.

Martin-Pannetier, Andrée. *Manuel: Institutions et vie politique françaises de 1789 à nos jours*. 2nd ed. Paris: Librairie générale de droit et de jurisprudence, 1989.

Mayer, Arno J. *The Persistence of the Old Regime: Europe to the Great War*. New York: Pantheon, 1981.

Mayeur, Françoise. *De la Révolution à l'école républicaine 1789–1930*. Vol. 3

of Louis-Henri Parias, ed., *Histoire générale de l'enseignement et de l'éducation en France.* 4 vols. Paris: Nouvelle Librairie de France, 1981.

Mayeur, Jean-Marie, and Madeleine Rebérioux. *The Third Republic from Its Origins to the Great War 1871–1914.* Trans. J. R. Foster. Cambridge: Cambridge University Press, 1984 [originally Jean-Marie Mayeur, *Les Débuts de la Troisième République 1871–1898,* Paris, 1973].

Miller, Michael B. *The Bon Marché: Bourgeois Culture and the Department Store 1869–1920.* Princeton, NJ: Princeton University Press, 1981.

Moffett, Charles S., ed. *The New Painting. Impressionism 1874–1886.* San Francisco: The Fine Arts Museums of San Francisco, 1986.

Nesbit, Molly. "Ready-made Originals: The Duchamp Model." *October* 37 (Summer 1986): 53–64.

"La Langue de l'industrie." In Benjamin Buchloh, ed., *Langage et modernité.* Villeurbanne: Le Nouveau musée, 1991, pp. 53–81.

Niess, Robert J. *Zola, Cézanne and Manet: A Study of L'Oeuvre.* Ann Arbor: University of Michigan Press, 1968.

Nord, Philip G. "Manet and Radical Politics." *Journal of Interdisciplinary History* 19 (Winter 1989): 447–80.

Paris Shopkeepers and the Politics of Resentment. Princeton, NJ: Princeton University Press, 1986.

Ozouf, Mona. *L'Ecole, l'église et la République 1871–1914.* Paris: A. Colin, 1963.

Paret, Peter. *Art as History: Episodes in the Culture and Politics of Nineteenth-Century Germany.* Princeton, NJ: Princeton University Press, 1988.

Paris, Grand Palais. *La Révolution française et l'Europe 1789–1799.* 3 vols. Paris: Reunion des musées nationaux, 1989.

Paris, Musée du Petit Palais. *Le Triomphe des mairies: Grands décors républicains à Paris 1870–1914.* 1986.

Paris, Musée du Petit Palais. *Quand Paris dançait avec Marianne 1879–1889.* Ed. Daniel Imbert and Guénola Groud. 1989.

Pevsner, Nikolaus. *Academies of Art Past and Present.* New York: Da Capo Press, 1973.

Rémond, René. *Les Droites en France.* Paris: Aubier Montaigne, 1982.

Rewald, John. *The History of Impressionism.* 4th rev. ed. New York: Museum of Modern Art, 1973.

Post-Impressionism from Van Gogh to Gauguin. 3rd rev. ed. New York: Museum of Modern Art, 1978.

Robert-Jones, Philippe. "Les Incohérents et leurs expositions." *Gazette des beaux-arts,* October 1958, pp. 231–36.

Roos, Jane Mayo. "Within the 'Zone of Silence': Monet and Manet in 1878." *Art History,* September 1988, pp. 372–407.

"Aristocracy in the Arts: Philippe de Chennevières and the Salons of the Mid-1870s." *Art Journal,* Spring 1989, pp. 53–62.

Rosenthal, Léon. *Du Romantisme au réalisme: La Peinture en France de 1830 à 1848.* Paris: MACULA, 1987 [originally Paris, 1914].

Saisselin, Rémy G. *The Bourgeois and the Bibelot.* New Brunswick, NJ: Rutgers University Press, 1984.

Sewell, William. H., Jr. *Work and Revolution in France: The Language of Labor from the Old Regime to 1848.* Cambridge: Cambridge University Press, 1980.

Sherman, Daniel J. *Worthy Monuments: Art Museums and the Politics of Culture in Nineteenth-Century France.* Cambridge, MA.: Harvard University Press, 1989.

Silver, Kenneth E. *Esprit de Corps: The Art of the Parisian Avant-Garde and the First World War, 1914–1925*. Princeton, NJ: Princeton University Press, 1989.

Silverman, Debora L. *Art Nouveau in Fin-de-Siècle France: Politics, Psychology, and Style*. Berkeley and Los Angeles: University of California Press, 1989.

La Société d'histoire moderne, série des instruments de travail. *Les Ministères français (1789–1911)*. Paris: Edouard Cornély et Cie, 1911.

Song, Misook. *Art Theories of Charles Blanc, 1813–1882*. Ann Arbor, University Microfilms International Research Press, 1984.

Swart, Koenraad W. " 'Individualism' in the Mid-XIXth Century (1826–1860)." *Journal of the History of Ideas*, January–March 1962, pp. 77–90.

The Sense of Decadence in Nineteenth Century France. The Hague: Nijhoff, 1964.

Tucker, Paul. "The First Impressionist Exhibition in Context." In Charles S. Moffett, ed., *The New Painting: Impressionism 1874–1886*. San Francisco: The Fine Arts Museums of San Francisco, 1986, pp. 93–117.

Vaisse, Pierre. "Charles Blanc und das 'Musée des Copies.' *Zeitschrift für Kunstgeschichte*, vol. 39, 1976, Sonderdruck Deutscher Kunstverlag München, Berlin, pp. 54–66.

"La Troisième République et ses peintres: Recherches sur les rapports des pouvoirs publics et de la peinture en France de 1870 à 1914." Thèse, doctorat d'état, Université de Paris IV, 1980.

"Salons, expositions et sociétés d'artistes en France, 1871–1914." In Francis Haskell, ed. *Saloni, gallerie, musei e loro influenza sullo sviluppo dell'arte dei secoli XIX e XX: Atti del XXIV Congresso internazionale di storia dell'arte*. Bologna: CLUEB, 1981, pp. 141–55.

Van de Sandt, Udolpho. "Institutions et Concours." In Philippe Bordes and Régis Michel, eds., *Aux Armes & aux arts! Les Arts de la Révolution 1789–1799*. Paris: Adam Biro, 1988, pp. 137–65.

Ward, Martha. "Impressionist Installations and Private Exhibitions." *Art Bulletin*, December 1991, pp. 599–622.

White, Harrison C., and Cynthia A. White. *Canvases and Careers: Institutional Change in the French Painting World*. New York: Wiley, 1965.

Whiteley, Jon. "Exhibitions of Contemporary Painting in London and Paris 1760–1860." In Francis Haskell, ed., *Saloni, gallerie, musei e loro influenza sullo sviluppo dell'arte dei secoli XIX e XX: Atti del XXIV Congresso internazionale di storia dell'arte*. Bologna: CLUEB, 1981, pp. 69–87.

Yvert, Benoit, ed. *Dictionnaire des ministres de 1789 à 1989*. Paris: Perrin, 1990.

INDEX

Pages with illustrations or tables are boldface.

PHOTOGRAPHIC ACKNOWLEDGMENTS

The Art Museum, Princeton University, 43

Bibliothèque Nationale, Paris, 2, 3, 5, 11, 14, 17, 18, 23, 24,
25, 37, 38, 40, 46, 47, 48, 50, 51

Bulloz, Paris, 26, 28, 35

Courtauld Institute Galleries, London, 30

Giraudon, Paris, 34

Lauros–Giraudon, Paris, 33

The Milwaukee Art Museum, 9

Musée Marmottan, Paris, 8

Museum of Fine Arts, Boston, 10

The National Gallery, London, 44

The Philadelphia Museum of Art, 16

Reunion des musées nationaux, Paris, 4, 7, 27, 29, 31, 32, 36

SPADEM, 34

Toledo Museum of Art, 15